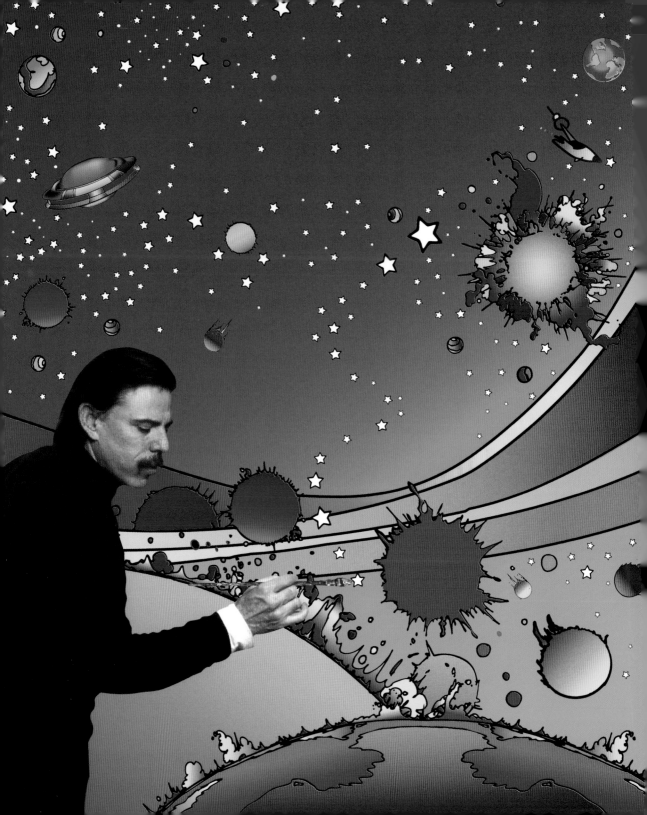

THE UNIVERSE OF
PETER MAX

PETER MAX WITH VICTOR ZURBEL

FOREWORD BY NEIL deGRASSE TYSON

HARPER
DESIGN

An Imprint of HarperCollinsPublishers

■ ■ ■ ■ ■ ■ ■ ■ ■

First published in 2013 by
Harper Design
An Imprint of HarperCollins *Publishers*
195 Broadway,
New York, NY 10007
Tel: (212) 207-7000
Fax: (212) 207 7654
www.harpercollinspublishers.com
harperdesign@harpercollins.com

Distributed throughout the world by
HarperCollins *Publishers*
195 Broadway,
New York, NY 10007
Fax: (212) 207 7654

Library of Congress Control Number: 2013940366
ISBN: 978-0-06-212139-4

Manufactured in China.
18 19 20 SCP 10 9 8 7 6 5 4 3 2

Design by Galen Smith/Hardscrabble Projects
All artwork and photographs courtesy of the author.

PAGE 2 *Peter Max Paints
the Universe*, 2013,
mixed media, 12 x 10"
PAGE 6 "Tennessee State
Museum-12 Images," 1993,
poster, 36 x 24"
PAGE 8 *Singularity Star*,
2008, mixed media,
12 x 10"

■ ■ ■ ■ ■ ■ ■ ■ ■

■ ■ ■ ■ ■ ■ ■ ■ ■

I've always had great mentors in my life: my parents, who nurtured my creativity; my nanny in China, who taught me how to hold and use a brush; the German scientist that I met in the mountains near Tibet, who first inspired my interest in space; Professor Hünick In Israel, who taught me to paint with the perception of color; Frank Reilly, my instructor at the Art Students League, who taught me to paint in the discipline of realism; and Swami Satchidananda, the renowned Yoga master, who taught me the art of letting go and being in the flow.

—PETER MAX

■ ■ ■ ■ ■ ■ ■ ■ ■

PETER MAX

A PAINTING AND POSTER RETROSPECTIVE

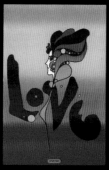

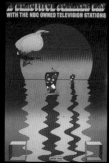
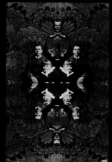

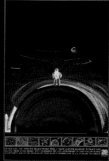

POP TO PATRIOTISM
1 9 6 7 — 1 9 9 1

MARCH 27TH
TO JUNE 6 TH
1 9 9 3

TENNESSEE
STATE
MUSEUM

THE TENNESSEE STATE MUSEUM • 505 DEADERICK STREET • NASHVILLE, TENNESSEE • (615) 741-2692

FROM LEFT TO RIGHT, TOP ROW: VIRGINIA FILM FESTIVAL 1991, GLOVE 1966, NICOLAE GALLERY 1991, CAPTAIN MIDNIGHT 1966. MIDDLE ROW: LOVE 1967, THE GRAMMYS 1989, EARTH DAY 1992, FLAG WITH HEARTLENINGRAD 1991. BOTTOM ROW: A BEAUTIFUL SUMMER DAY 1969, SIBLINGS 1966, DIFFERENT DRUMMER 1968, AIR & SPACE MUSEUM 1989. TOP RIGHT: POP TO PATRIOTISM/NEOMAN 1992. BOTTOM CENTER: SMILE 1989. ARTWORK COURTESY OF THE PETER MAX STUDIO • NYC • 212-874-6700 • © PETER MAX 1993

Contents

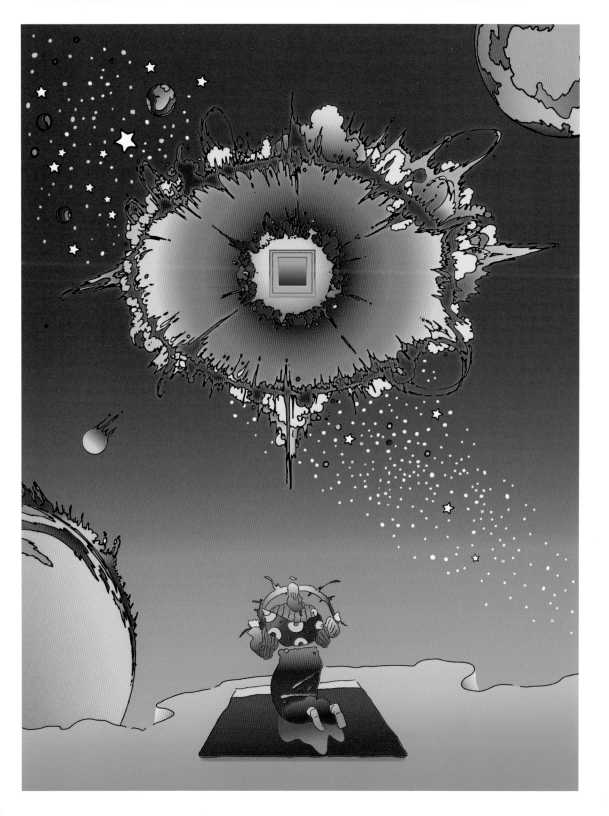

Dear Reader —

The cosmos has inspired me throughout my childhood and adult life. It is a mysterious and magical realm, with new planets, moons, suns, stars, and galaxies constantly being discovered. Physicists say that there are multiple universes, and perhaps infinite parallel universes.

To me, the universe is itself the ultimate expression of creativity. That we, as human beings, have been endowed with the ability to channel that creativity fills me with a sense of awe and wonder. When I tap into my inner cosmos—that nucleus of creativity within me—it becomes a source of ever-expanding possibilities, enabling me to go from one magical adventure to another. It is my hope that you, dear reader, will be inspired to tap into your own unique inner cosmos and embark on a creative journey of your own. May you forever be inspired by the life—and the many mysteries—that surrounds you.

In the words of the Jedi masters, "May the Force be with you."

— PETER MAX

Foreword

··

After a single glance, one does not soon forget the bold colors, brushstrokes, and compositions of artist Peter Max. For decades, his artistic expressions have over-flowed his numerous museum and gallery exhibitions to shape pop culture —from an environmental U.S. postage stamp to the fuselage of a Continental Airlines plane to the hull of a giant Norwegian Lines cruise ship.

But there's more going on here than Peter's unique commissions. If you look across Peter Max's oeuvre you will discover an enormously diverse body of work in all mediums—from the exquisite line work of his drawings to his masterful command of paint on canvas in all genres, from realism to pop to abstraction. Of course I am biased, but for me, I have always been enamored of Peter's art-ful depictions of cosmic objects and phenomena, with his iconic 1960s-clad characters flying or effortlessly leaping across planets, stars, and galaxies.

When I finally met Peter at an event hosted by the Hayden Planetarium, I was delighted to learn that the subject of space was not just an adornment to his art but also a passion as great as my own. We both have been fascinated by space since early childhood, and I was enchanted by Peter's recounted discoveries of space as a young boy growing up in China, and as a teenager in Israel, where he attended an evening course on the uni-verse at Haifa's Technion-Israel Institute of Technology.

Shortly after we first met, Peter invited me to his studio, not far from the planetarium itself, where he showed me the posters he had created for NASA and the Smithsonian National Air and Space Museum, as well as his portraits of astronauts John Glenn, Buzz Aldrin, and Anousheh Ansari, the first private female space explorer. Over lunch, we got lost in a two-hour emotionally charged conversation about the marvels of our universe.

In modern times, a scientist can communicate with the public via books, radio interviews, television documentaries, and, of course, the Internet. But one cannot assert that the messages have been absorbed into the hearts and minds of the public until artists embrace the themes. Only then has science entered culture, having become the artist's muse.

I only get to talk about this stuff. But Peter has managed to capture the soul of the cosmos on canvas and posters. You may now understand why the title for his memoir can be none other than *The Universe of Peter Max*.

Neil deGrasse Tyson
Director of the Hayden Planetarium, New York City, and author of *Space Chronicles: Facing the Ultimate Frontier*

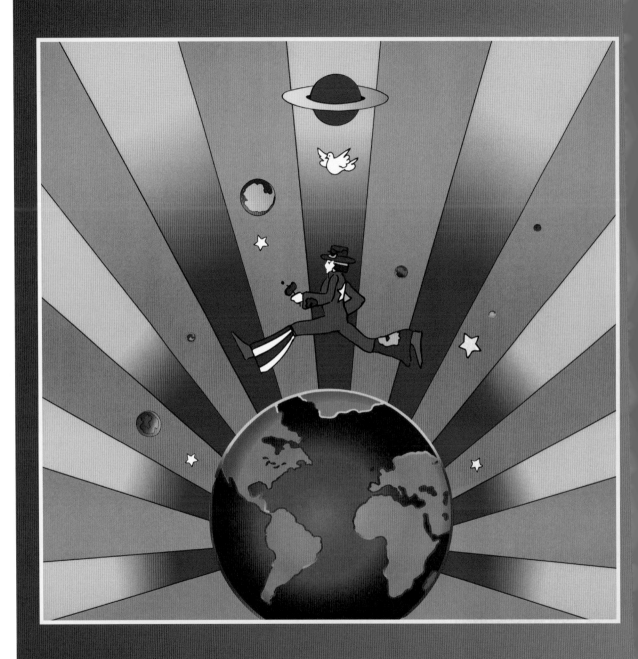

CHAPTER ONE

UNIVERSAL INFLUENCES

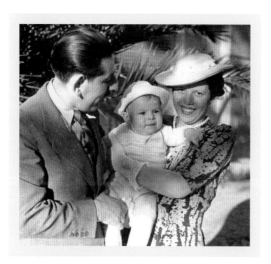

LEFT Peter Max as an
infant with mother, Salla,
and father, Jakob
BELOW Young Max
with mother and father
in Shanghai
RIGHT Max as a young boy
CHAPTER OPENER "U.S.
Environmental Protection
Agency," 1996, poster,
18 x 16"

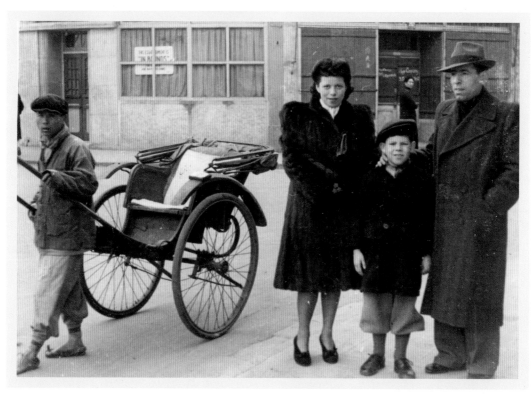

My life's journey has been an odyssey through time and space, filled with vivid moments, abundant with color, dazzling with sights, and vibrant with euphonic sounds. These moments collectively create my story, not only of who I was but also of who I was to become—an artist living in New York City, where I have been fortunate to reach a global audience with my art and philosophy.

SHANGHAI

My odyssey began in Shanghai, China, for it was there that I had the most magical, adventurous childhood. It was there that I discovered creativity.

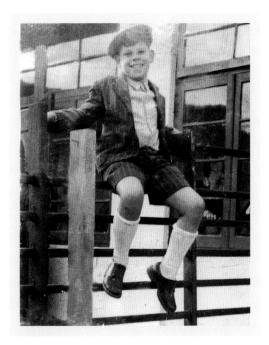

As an infant, I was carried in my parents' arms from my birthplace, Berlin, Germany, aboard a train to Marseilles, France. From there, we embarked on an Italian luxury liner, the *Conte Verde,* to the distant port of Shanghai. We lived in China until I was eleven years old, and my memories of that exotic, colorful land are embedded deep within me.

We lived in a pagoda-style house across the street from a Buddhist monastery, and I can still recollect the feeling of awe and mystery that the monks inspired in me. Each day, a gong called the monks to prayer in their temple garden. On occasion, the monks would unroll large sheets of rice paper upon which they would paint immense Chinese characters, using five-foot-long

bamboo brushes. Their movement while painting fascinated me; it was as though their brushes were not just instruments in their hands but extensions of their entire bodies. After they had completed their work, the gong was rung again, and the painting was placed above the gate to announce an auspicious event. This spectacle was like a ballet or tai chi dance with calligraphy, and I eagerly watched these performances for several years. Thrilled by the full-bodied way the monks painted, I would later emulate their graceful expressions of creativity in my own techniques.

Next to the monastery was a Sikh temple. The Sikhs were handsome, spiritual men from India who sported long beards and colorful turbans. I remember my mother remarking on their soulful, meditative eyes. Twice a day, at dawn and again at dusk, a Sikh would sing from the turret, chanting prayers to the skies above Shanghai. I loved their evocative, heartfelt chants and looked forward to hearing them at night and early in the morning, before I was fully awake. On warm summer evenings I would sleep on the balcony listening to their chanting while looking up at the tapestry of stars above.

To a young boy, Shanghai was a never-ending celebration. There were weekly parades to celebrate various events in the Chinese calendar. Colorful flags, origami, and papier-mâché objects floated gracefully in the air, accompanied by music and fireworks. The Chinese New Year parade was the most spectacular, but every event was stunning. The city was a living theater where all of life's emotions played out in vibrant fantasy. For me, the culture of China was a feast for the eyes: a continuous stream of colors, costumes, and visual arts. These influences have stayed with me for my entire life.

While I absorbed the creative stimuli of Shanghai, my parents, Jacob and Salla, were busy managing the details of our day-to-day life. My father opened a store to

OPPOSITE *Sage with Cane and Abstract Cloud,* 1988, acrylic on canvas, 20 x 16"

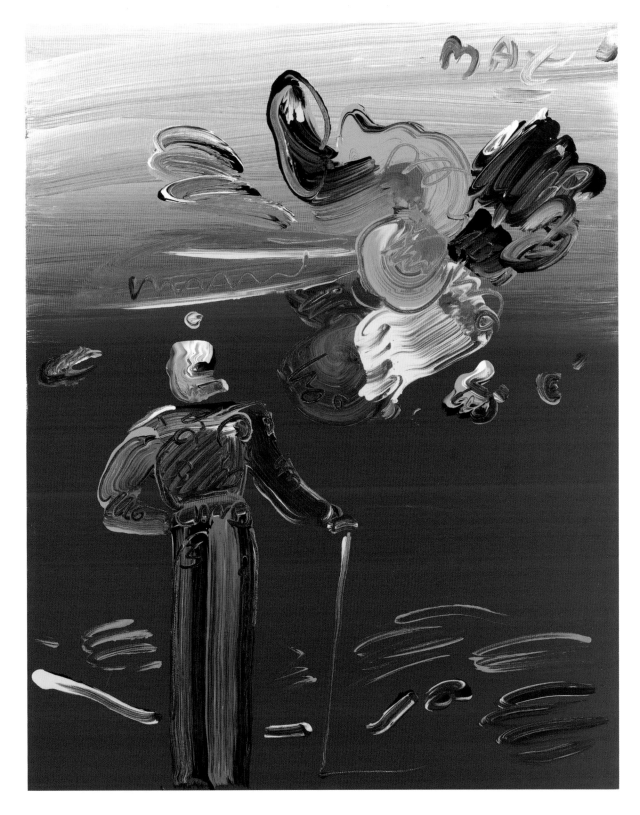

sell business suits to the European community with fabrics imported from England. It was an opportune time for such a venture, since the Chinese were just beginning to replace their Mandarin collars with Western attire. Over time the shop expanded and prospered, becoming a small department store.

My father's success enabled us to move into a larger four-tiered pagoda house in the Hongkou district—a neighborhood of European families. Our family occupied two floors, and we rented another floor to Mr. and Mrs. Lomranz and their son, Jackie. Mr. Lomranz was a joyous Hasid scholar who enjoyed discussing philosophy with my father. Jackie became my best childhood friend, and we are still good friends to this day.

On the ground floor of our building was a Viennese garden-café, where my father and mother met their friends in the early evenings for coffee and pastries while listening to a violinist play romantic songs from the land they had left behind. The community of Europeans that grew up below our house kept me connected to our roots,

ABOVE Max's mother, Salla, and father, Jakob
OPPOSITE *Lady in Blue with Vase*, 1974, serigraph, 31 x 25"
FOLLOWING PAGES *Brown Lady*, 1993, acrylic on canvas, 48 x 36"; *Dega Man*, 1983, acrylic on paper, 24 x 18"

and our family was very much at the center of that community. My parents were fabulous personalities. Ever so elegant and stylish, Salla wore clothing made by Chinese tailors who came to our house to sew outfits of her own design. Jacob was a social man who loved to have fun, dance the tango, and tell stories. Wherever we went, people would wave, calling out, "Hey, Jack!" My father was constantly surrounded by friends.

Along with the colors and images of China, these childhood impressions of my father as a successful entrepreneur and my mother as a stylish, fashionable woman helped foster my artistic sensibilities. One of my earliest memories is when my mother gave me a set of crayons and paper—I must have been around three or four years old—and sent me to play quietly in a small room used for storage. Among the miscellaneous items I found were my family's traveling trunks, the very trunks we had taken when we sailed from Europe to China. I touched the big, beautiful trunks, running my hands against their sturdy textured surfaces. I selected a crayon and ran it across the surface of one of the trunks. It made a distinct sound, a sound I remember to this day. It was a kind of "ribble." As I ran it back and forth, it went *ribble, ribble, ribble.* I liked the sound so much, and the way the crayons brightened up the trunks, that I did them all up in color. My mother was shocked when she came on me and the marked-up trunks, but when she saw me smiling with the crayons in my little hands, she picked me up, laughing and crying at the same time. "My little artist!" she exclaimed, and kissed me. You could say that this was the beginning of my calling as a creative artist. From that day forward, I always wanted a lot of vibrant color in my artwork.

Following that incident, my mother continued to foster my artistic talents by placing various art supplies on the balconies of our pagoda house. On one balcony, she would leave colored papers, scissors, and paste. On

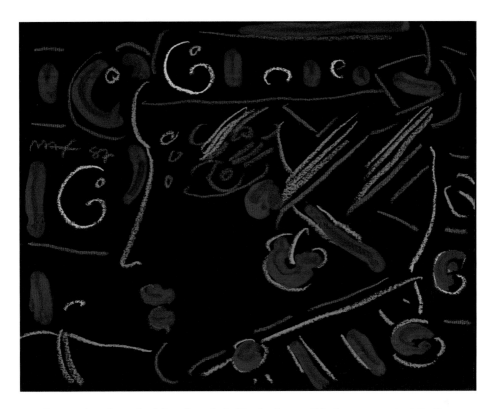

another, a sketch pad with colored chalk. And on a third, watercolors and finger paints. "Go ahead and make a big mess," she would say. "We'll clean up after you."

This sort of encouragement continued throughout my childhood. When I was three, my mother hired a very young Chinese nanny to look after me. She was six years old, only three years older than I was at the time. But she was very smart and taught me how to hold a brush and use my wrist in drawing and painting. It's amazing how to this day, every time I pick up a pen or brush and create a drawing or a painting, that coordination and movement has remained with me. Even when I sign my name to a piece of artwork—in pencil, ink, or paint—those lessons in calligraphy, taught by my young Chinese nanny, come into play.

ABOVE *Lady Profile on Black Paper,* 1987, colored pencils and acrylic on paper, 9 x 12"
FOLLOWING PAGES *Max signature,* 1991, acrylic on canvas, 5"

WOW! WHIZ! SHAZAM!

As I grew up, I absorbed all the influences of old Europe and China. However, another influence captured my imagination like no other: American pop culture.

My discovery of America happened by serendipity. My father and I were in downtown Shanghai when I saw a man selling books from a cart. But these were unlike any books I'd ever seen. The titles and exclamations practically jumped from their covers with bold typography and color. Wow! Whiz! Shazam!—the American comic book.

I had never seen anything like them! They featured superheroes such as Superman, Captain Marvel, Plastic Man, and Wonder Woman. The stories of their amazing powers were told in a dynamic, graphic way. The characters jumped out of panels, suggesting animation, and their voices shouted out in balloon shapes with bold type. At that time I had been learning to speak and read English in school, so the comic book text was perfect for me: simple, bold, and easy to read.

I wanted to have them so badly, I cried until my father succumbed and bought all twenty-five books from the man's cart. I read each one cover to cover, again and again, as I was so excited by the fantastic story lines played out in bold color spectrums. My imagination soared with the adventures of all sorts of superheroes. And the art styles were so new and fresh, unlike anything I was accustomed to seeing in China. Although my senses were in near constant stimulation from exposure

to Chinese and Japanese art, nothing stirred my imagination as much as those unique American comic books. It made me wonder: What is this amazing land called America? I did not have the vaguest idea where it was, and it seemed like Never Never Land to me.

Around this time, I also discovered American jazz via a weekly radio broadcast over the Shanghai airwaves. The program featured musicians such as Benny Goodman, Duke Ellington, Gene Krupa, and other artists of the swing era. The music was radically different from what I grew up listening to—it wasn't the violin of old Europe I heard in my neighborhood cafés, and it wasn't the Chinese harp I heard in the streets of Shanghai. Benny Goodman's clarinet was like the Pied Piper's flute. The clear and rhythmic songs beckoned me to America. "Come to me," they seemed to say. "I'm waiting for you."

Beyond comic books and jazz, there was yet another great creative import from America: the "silver screen." I had recently made a new friend whose father owned a movie theater. Once a week he showed Hollywood movies—Westerns, musicals, adventures, comedies, and cartoons. I was instantly mesmerized.

Every week, I excitedly went to the theater to be transported to a cinematic world outside of Shanghai, outside of myself. It was a magical universe where anything and everything was possible. I knew I would go to America one day. It was, after all, a place of fantasy where, as one popular swing song convinced me, "anything goes!" But before I could get there, many other adventures awaited me.

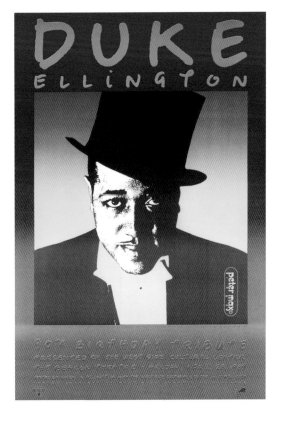

OPPOSITE "Captain Midnight," 1969, poster (detail), 36 x 24"
ABOVE "Duke Ellington," 1989, poster, 36 x 23.25"
FOLLOWING PAGES "Captain Midnight," 1969, poster, 36 x 24"; "Cleopatra," 1967, poster, 36 x 24"; "Marilyn," 1967, poster, 36 x 24"

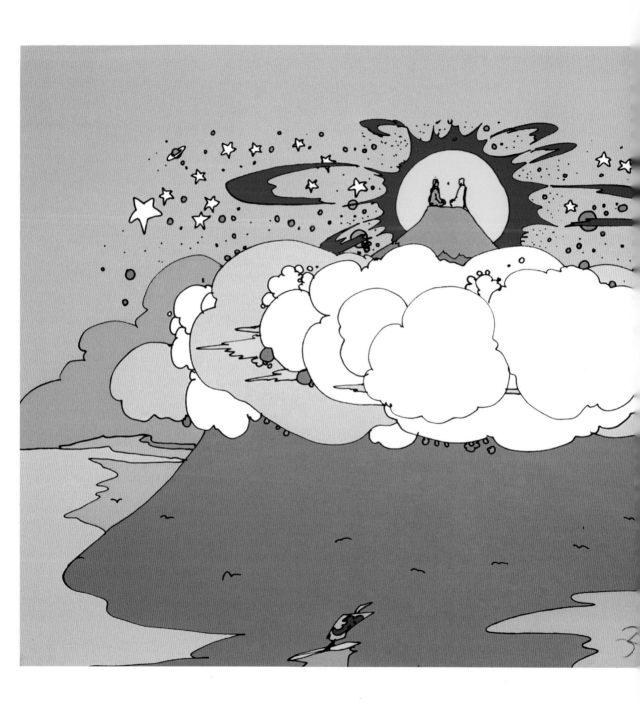

MA-P 72 -

TIBET

In 1948, when I was eleven years old, my father's Chinese business partner suggested that our family take a vacation in the western frontier of China, near the mountainous border of Tibet. For days we traveled by a train resembling the Orient Express across rice fields and jagged mountain peaks. The train brought us to our final destination—a remote Buddhist mountain camp. From there, Sherpas carried us in sedan chairs that resembled wheel-less rickshaws. We rose thousands of feet up a twisting path, our guides chanting Buddhist prayers the entire way.

Nestled in the remote mountains was a pristine white turreted hotel that had been converted from a monastery. There were other guests at the hotel, including an Indian maharaja with his three wives and eleven children. I developed a fascination with the eldest daughter—a stunning girl with long black hair and large dark eyes. (My memory of this enchanting girl's face manifested decades later in a profile drawing I did of a deva, a goddess from Hindu mythology.) The mountain air was thin and pure, the land green and lush. Silence stretched across the landscape, broken only by the gentle rustling of wind, sounds of falling water, and the distant call of birds and monkeys. We played in a natural pool with a one-hundred-foot-high waterfall. Having been polished by thousands of years of waterfall, the bottom of the pool was as smooth as eggshell. While it was incredibly—almost painfully—cold, it was here that I taught myself how to swim.

Being with Moorthi,
1972, serigraph, 22 x 30"

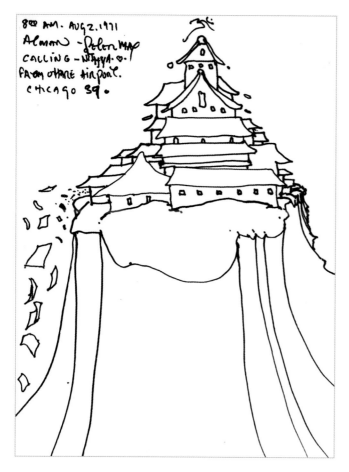

THIS PAGE "Tibetan Temple," 1971, pen and ink drawing, 15 x 12" OPPOSITE *Sage with Cane*, 1998, acrylic on paper, 22.5 x 18"

Amid all I was seeing and learning in the Himalayan mountains, however, I was most intrigued by the monks who made their solitary way along the mountain paths to and from their monasteries. Occasionally, I would see a monk contemplating the sunset or standing very still on a hill, staff in hand. The holy men exuded a sense of profound peacefulness that moved me in a very special way—my first sense of a spiritual experience. At times, I would observe them sitting in a lotus position, nodding their heads as they quietly chanted prayers, which I later learned were called mantras. Little did I know that images of these sages with canes would emerge in my artwork decades later. The Himalayan monks whom I encountered near Tibet played an important part not only in my artistic development but also in my spiritual growth. I observed and absorbed the monks' quality of silence—understanding it not as a self-imposed discipline but as a practice that enabled them to freely and peacefully commune with nature.

In addition to my images of sages with canes, I have painted other images of meditating figures, who stand or sit quietly and observe the changing phenomenon of nature. The process of painting these figures have, in themselves, become my own form of meditation; the figure is sort of a projection of myself onto a blank canvas unfolding.

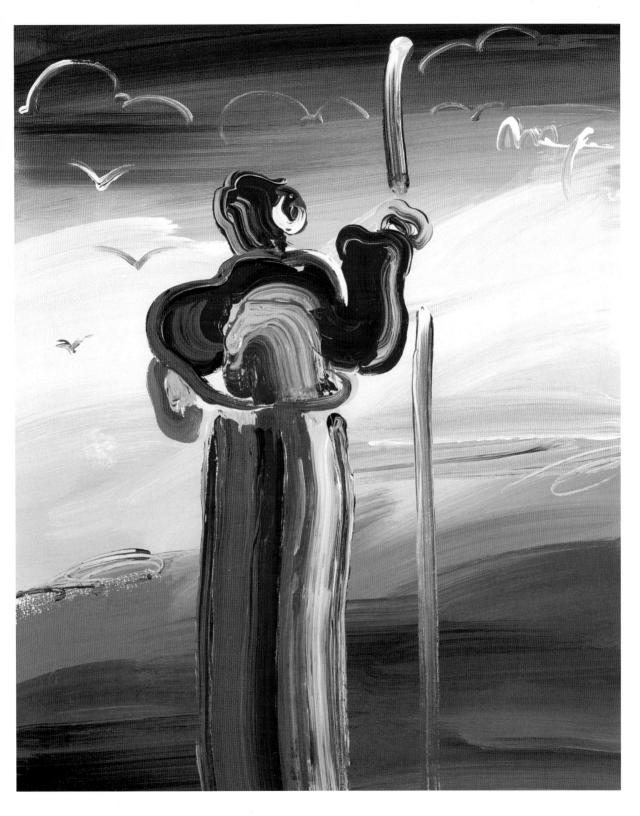

THE ASTRONOMER

There was also a facinating German gentleman staying at the hotel. Both a scientist and an astronomer, he spoke to me in German and English. One day I discovered him directing five or six Chinese people to wrap wires around a huge tree. He noticed me, and when I asked him what he was doing, he showed me a little radio and said, "You can't get any signals up here in the mountains. So I'm turning this big tree into a gigantic antenna to get short-wave radio signals." The tree was enormous when it was all set up. He managed to tune in to a few stations, mostly in Chinese, but occasionally he got a British station. Later

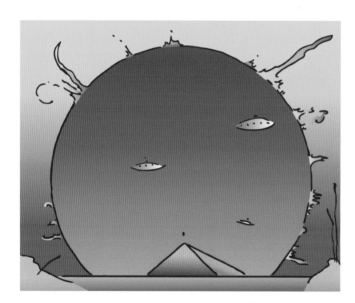

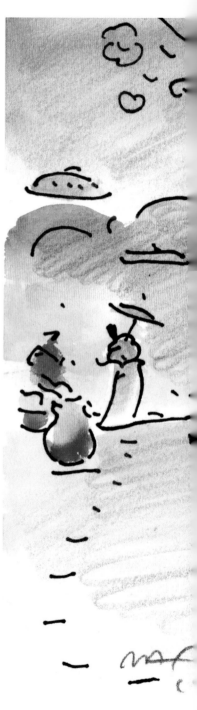

ABOVE *Giant Sun & Pyramid*, 1998, mixed media, 7 x 5"
RIGHT *Umbrella Man at Sunset*, 1995, mixed media, 12 x 10"

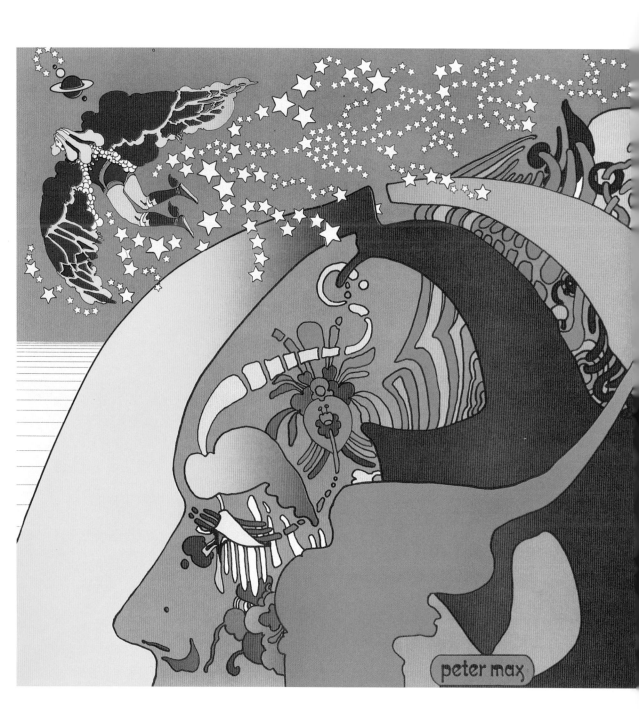

he asked me a peculiar question, one I've never forgotten: "Do you know how big the sun is?" I told him I did not know; I had never even thought of such things. He patiently yet excitedly explained that the diameter of the sun is about a hundred times bigger than the earth. This astonished me. How would I ever have known that? My parents had never told me about the size of the sun or the earth. It was a revelation. To me, the sun looked very small compared to the earth. But if the sun was so much larger than the earth, I asked myself, how big were all the stars? And how many stars could there possibly be? I couldn't even count the number of stars I could see; what about the millions of other twinkling lights I couldn't see? I was so excited, my head spun. I could hardly sleep that night. I looked up at the star-studded sky from a vantage point thousands of feet up on a mountain in western China and saw thousands of stars, imagining each one a hundred times bigger than the earth. (And now physicists tell me that there are billions or even *trillions* of stars!)

My conversations with this man were fascinating. I would get up early in the morning and look out the window to see if he was there, and if he was, I'd run down with my toys pretending to play, only to engage him in more talk about the universe and my place in it. One morning, however, he seemed agitated. He was sitting on the veranda listening to his shortwave radio, and as soon as he saw me, he asked me to quickly run up and call my parents. When they came down, he told us that he had just heard that Mao Zedong and his army were advancing on Shanghai and were only twenty kilometers away from the city. Suddenly, my parents and I were faced with a crisis.

"Instant Nutriment #2,"
1969, poster, 24 x 36"

ISRAEL

We left the mountains at once, but when we reached our home in Shanghai, we discovered that our friends were gone. My father's business partner told him that all of my father's friends had already left to take a boat to the newly formed state of Israel. He quickly explained that there might still be time to reach the boat, and he presented my father with a cube of gold bullion in payment for our house and my father's store. My parents gathered what they could from our house, and I rounded up my toys and comic books. But when I was told that we had to leave our cat behind, I was very sad. To this day, I carry a feeling of loss over what we left behind. The cat became a totem for the whole of my childhood, forever lost in the span of what felt like a few short minutes.

Down at the port, the boat to Israel was still docked. As we ran toward it, the plank was being withdrawn. People we knew on deck cried out, pleading that our family be let on board. The Italian captain said to us, "I'm sorry, there is no more room. There is nothing I can do."

"When is the next boat?" my mother pleaded.

The captain replied brusquely, "I don't know. It could be months."

My mother and I were in shock, but my father calmly asked to speak to the captain quietly and took him for a walk. I saw them pass a pile of huge crates on the dock and then disappear behind them. When they returned, the captain's arm was around my father's

Mystic Sailing, 1972,
serigraph, 22 x 30"

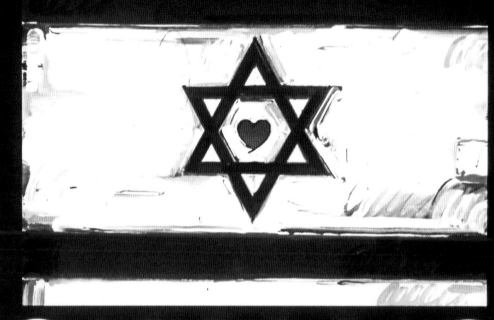

shoulder, and they were both laughing agreeably. We boarded the boat without further argument or comment. My father had used the gold bullion to buy the captain's own cabin.

It was 1948 when we sailed from Shanghai to Israel. The trip took forty-eight days. The Suez Canal was closed, which forced us to reverse course and sail around Africa, into the Mediterranean Sea. In Naples, we all crowded into two smaller boats and sailed for Haifa. I was eleven years old when we arrived in the new, independent state of Israel. We were driven in trucks to Tel Aviv, where a military-style tent camp had been set up to house new immigrants. Within weeks, we were relocated to Tiberias, northeast of Nazareth, a mountainous region overlooking a large, beautiful lake called Kinneret, or the Sea of Galilee. Tiberias, named after the Roman emperor, somehow reminded me of Tibet, with its ancient clear lakes full of blossoming underwater flowers.

We eventually moved into a nice house near Mount Carmel in Haifa on the Mediterranean coast. It was here that I learned to speak Hebrew. I also learned the importance of social popularity. I told exciting stories of my childhood to my new friends; they viewed my upbringing as exotic. I soon found it much more entertaining to be the center of attention than to do my homework. Already prone to bouts of daydreaming, I began to channel my imaginings into drawings, done at the expense of class lessons.

I had taken to drawing my own versions of futuristic cities with spiraling skyscrapers, swirling skies, and intricate buildings, inspired by photographs I had seen of New York City—the city I had yet to encounter. More than once, my teacher caught me immersed in such fantastical worlds, buried in my artwork. He finally called my parents for a conference and suggested that they send me to art school, both as a means of keeping me out of trouble and as a way to foster my talent.

OPPOSITE "Israel 50 Celebration," 1998, poster, 36 x 24"

THE PROFESSOR

I began taking private lessons from Professor Hünik, a Viennese painter who had been recommended to my mother. On my first day under his tutelage, Professor Hünik instructed me to paint a white plate, set up on the table as a still-life model. I studiously painted the white plate with a little gray tone for dimension. The professor politely asked me if he might add something to my canvas. He then added pastels in pink and yellow tones, as well as bright colors. I was puzzled. He saw my confusion and said, All those colors are in the white plate. He told me to look harder.

"Can you see a reflection of the sun?"

I squinted. "Yes, a little," I replied.

"Can you see a reflection of the flowers and plants over there?" pointing to another section of the plate.

I squinted again. I began to see it. "Yes," I said.

Then, all at once, I saw that there were colors where no colors appeared to be. Professor Hünik told me that as artists we have to exaggerate sometimes in order to heighten people's perception, to impart the gift of seeing.

Through that one simple lesson, Professor Hünik imparted more wisdom to me than had any of my teachers in elementary school. He gave me my first real education in art, and I was mesmerized by his ideas. He showed me the work of the Fauvists—Matisse, Vlaminck, Derain, and Jawlensky—whose wild use of color upset the conventional tastes of the Europeans in the early twentieth century. These aesthetic revolutionaries have inspired me throughout my career. But while I frequently study the work of these masters, it was Professor Hünik's white plate lesson that changed the course of my life and taught me the ability to see beauty and color in places no one else thinks to look.

RIGHT *Vlaminck,* 2005, acrylic on canvas, 30 x 24"

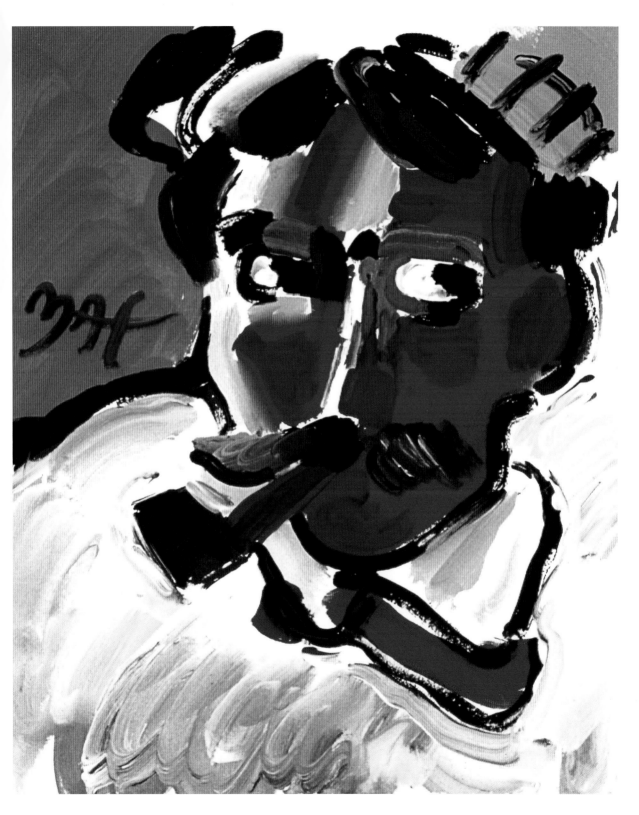

While art became a lifelong passion, I developed a dual interest in astronomy. My childhood fascination for space was reignited. My excitement bordered on obsession. My parents, ever supportive, arranged for me to sit in on special classes in astronomy at the Technion, the Israel Institute of Technology. After several classes and countless hours spent poring over astronomy books, I came to understand space—not in a scientific way but in a manner that spoke to my inner being. Somehow I could intuitively perceive the vast distances of space by visualizing immense vistas in my mind that could never be seen with the eye. I had the urge to express my new understanding visually, and I sketched images of planets with strange suns, futuristic vistas, and flying saucers hovering above land. I had gone from doodling futuristic cities in class to conceiving of huge alien landscapes that, to me, were as real as anything I could see or touch—maybe more so.

Art and astronomy loomed in my mind, but America did as well. The land of superheroes, jazz, and Hollywood movies—though it might as well have been the stuff dreams are made of—America was as untouchable to me as the moon. So when my parents told me that we were, in fact, moving to New York City, I felt as though I had just experienced liftoff: my dreams were about to come true!

But before I discovered America, I discovered another wonder—Paris.

"Statue of Seated Figure,"
1982, pen and ink on
paper, 9 x 13"

PARIS

In 1953, when I was sixteen years old, my parents and I spent six months in Paris, France, visiting family and friends. Since we had come from ancient lands, it was my first contact with the modern world. Paris was pulsating with life and culture—cars, buses, trams, cafés, galleries, and ladies and gentlemen in beautiful fashions strolling along the Champs-Élysées and by so many other wonders of Paris—the Arc de Triomphe, the Eiffel Tower, the Palais Garnier, and the River Seine.

Fostering my interest in art, my mother enrolled me in drawing classes at the Louvre.

Walking the halls of the Louvre, I gravitated toward the paintings of William-Adolphe Bouguereau, an exemplar of the French academic painting tradition. I admired his work even more than I did the Fauvists'. At the time, I was searching for realism, as if conquering it was the only way to transfer my visionary images onto paper, and Bouguereau's fidelity to rendering the real world, coupled with his mythical and fantastic subject matter, captured my own interests. Impressionism, expressionism, and abstraction held less appeal for me. It was only after I mastered my foundation in realism that I moved into contemporary art expression and bold color juxtapositions in my work and tastes.

When I was not in class, I studied the art in the city's museums, parks, and palaces. Alongside other artists with their easels, I sat in the public gardens for hours sketching the neoclassical fountains and monuments. I strove to master the perfect proportions of the statues in my drawings.

My time in Paris was too short, but I was thrilled to be departing on my greatest adventure yet. At the time, I had no way to foresee just how important America— and especially the city of New York—would ultimately be to my life as an artist. It turned out to be an adventure beyond even my wildest dreams.

THE EDUCATION OF A YOUNG MAN

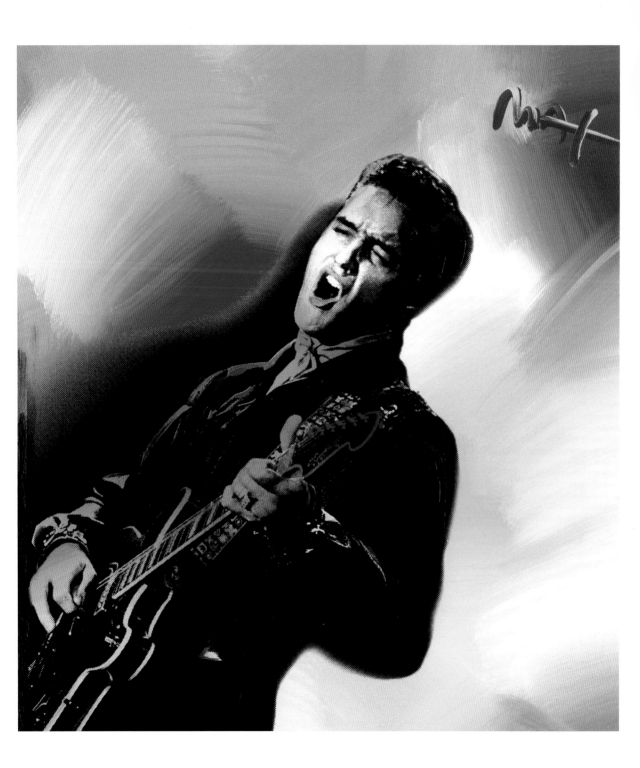

When I was sixteen, my parents and I traveled from Paris to New York on our first transatlantic flight. We arrived at Idlewild Airport (now John F. Kennedy International Airport), where we were greeted by a host of family members. Three young cousins, whom I had never met before, presented me with gifts: each held in their arms a T-shirt and a pair of blue jeans. On landing, I had acquired my first official American teenage outfit.

Outside, the air was hot and humid. It was summertime, and on the drive from the airport I marveled at the stream of beautiful cars cruising along the highway. Some were as long as boats—Caddy Eldorados and Chevy Impala convertibles with their tops down. They raced by in a dazzling array of colors, their radios blasting a new style of music I had not heard before: rock 'n' roll. On first listen, the wonderful sounds of Elvis Presley, Bill Haley & His Comets, and Fats Domino made me feel as though I had landed on another planet.

This sensation was further heightened when I first saw Manhattan, only a few days later.

Our new home was an apartment building—something else I had never seen before—in Bensonhurst, Brooklyn. Our living room was outfitted with a large radio, and I spent my time listening to real American music, shows hosted by Alan Freed and Symphony Sid. Soon after we arrived, an amazing new innovation entered our living room: a television set. There were fabulous shows of all sorts: *American Bandstand*, *I Love Lucy*, *Dragnet*, and *The Abbott and Costello Show*, as well as variety shows starring Sid Caesar, Jackie Gleason, and Ed Sullivan. Little did I know that I myself would appear on *The Ed Sullivan Show* a few decades later.

OPPOSITE *Elvis*, 1999, acrylic and silkscreen on canvas, 28 x 24"
CHAPTER OPENER "Face Drawing," 1976, pen and ink on paper, 10 x 8"

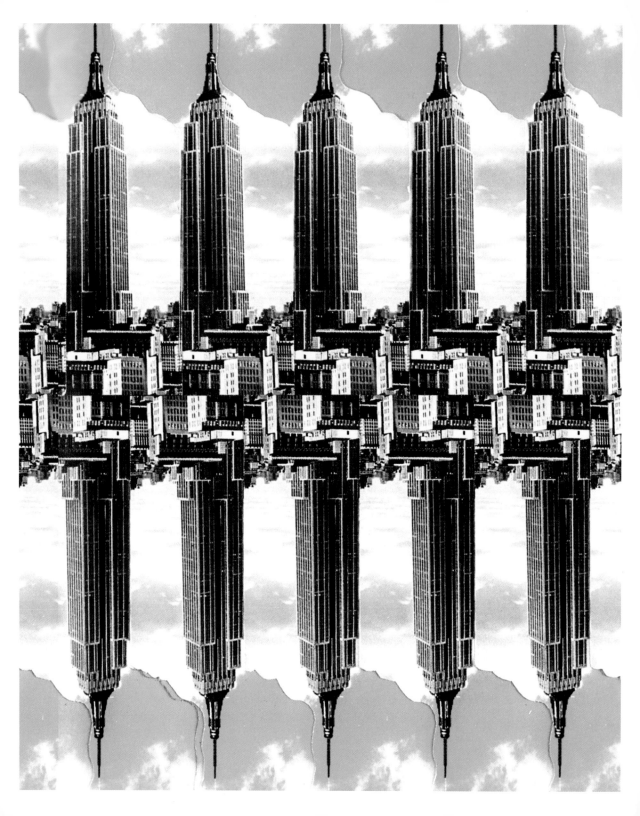

After we got settled into our apartment, we were driven across the Brooklyn Bridge into Manhattan for the first time. My heart leaped as we crossed the bridge; the skyline seemed to expand the closer we got to Manhattan. The skyscrapers looked futuristic, like architecture from another world—sleek and silver, glittering glass and steel. The Empire State Building towered above all else. From the moment I first saw it, I was enchanted. The giant billboards and shining theater marquees of Times Square were dazzling. I remember that drive as though it happened yesterday.

Throughout my early days in the city, I frequently visited the Empire State Building, taking in the size and complexity of the city offered by the spectacular view from the observation deck. Below me, New York City hummed, pulsating with frantic energy. Cars and taxis swirled by in a kaleidoscope of color. Lights glared along the avenues and crosstown streets. And standing atop the Empire State Building, I towered over everything. With its startling height and pointed antenna, the building would become an iconic reference in much of my later collage works—a symbol for the electronic age and our place in it.

But my art career had to wait, as I still had to complete high school. I had completed my first two years of high school in Haifa, and my parents enrolled me as a junior at Lafayette High School. My classmates and friends loved to kid around and pull pranks. In the gym locker room one day, a big guy sitting on the bench next to me unexpectedly stood up, threw out his arms—practically knocking me off the bench—and burst out with a loud operatic aria. Upon noticing my startled

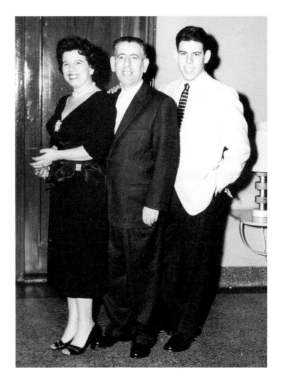

ABOVE Peter Max and parents in New York City
OPPOSITE *Empire State Building*, 1967, collage (detail), 38.5 x 22"

expression, he laughed and shook my hand, saying, "Sorry to scare you. My name is Paul—Paul Sorvino."

Years later, Paul began his career as an advertising copywriter, and then his dynamic voice led him to great success as an actor in the theater and in movies. I had two other friends in Brooklyn who went into creative advertising: Peter Petronio and Emil Dispenza, both of whom became award-winning art directors. We hung out at Famous Cafeteria most weekend nights, talking into the wee hours of the morning. We spoke about many things, but most of our conversations centered around creativity and innovation in the graphic arts. We discussed dynamic concepts for ads, book and magazine covers, record albums, and posters. Along with astronomy, conceptual graphic design became very exciting to me.

As I neared the end of my final semester in high school, I was still undecided on my choice of college. Not sure about what else to pursue, I contemplated becoming an astronomer. Then the universe of art presented itself to me: a friend, Ron Chereskin, invited me to join him in summer classes at the Art Students League. As soon as I entered the landmark building on Fifty-seventh Street, diagonally across from Carnegie Hall, I fell under its spell.

The Art Students League was home to such giants as Alexander Calder, Georgia O'Keeffe, Hans Hofmann, Mark Rothko, Jackson Pollock, Roy Lichtenstein, Ben Shahn, and Norman Rockwell, all of whom had studied or taught there. I eagerly took courses in life drawing, anatomy, and perspective, and I loved the program so much that toward the end of the summer, I asked my mother if I could stay on. She agreed. My life was about to change.

OPPOSITE *Cardinal,* 1959, oil on canvas, 24 x 18"

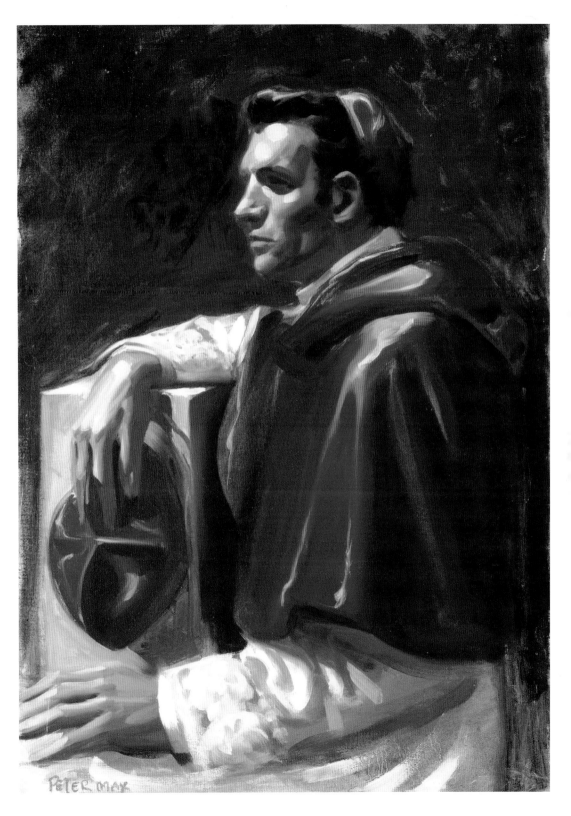

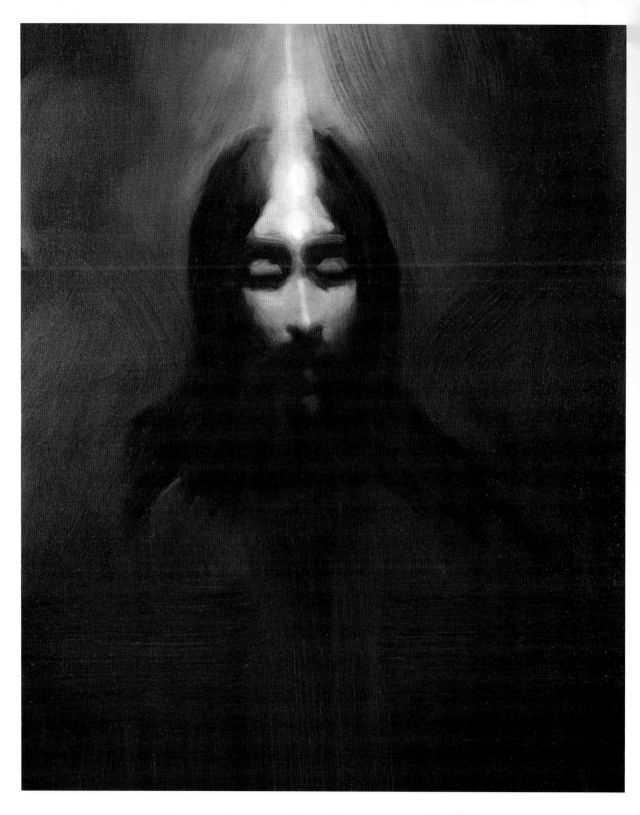

GETTING REAL

In the fall, I began my art studies under Frank Reilly, a realist who had studied alongside Norman Rockwell under the tutelage of George Bridgman, one of the great anatomists of the twentieth century. Reilly taught us Bridgman's technique of figure drawing, which uses planes, shapes, and muscle groups as the bases from which to construct figures. A master of light and shadow, Reilly would have us paint the same face in as many types of light and shadow as we could imagine. His perspective as a purist led him to rail against the Modernists, against anything that came between the object and the canvas, and that meant the artist's internal perception as well. He was interested in the purity of seeing something clearly for what it was. From him, I learned the power of observation.

Starting with an early-morning sketching class and continuing until the last class in the evening, I worked constantly, drawing live models and studying anatomy, composition, and perspective. I worked in every type of medium imaginable: oils, charcoal, ebony pencils, pen and ink—you name it. Hungry to learn, I devoured every bit of new information and practiced each new technique until I achieved a level of mastery. Because I loved what I was doing, I was unstoppable. People have often remarked on my energy and my prolific output, but it is the result of disciplined work habits that have come perfectly natural to me.

When I wasn't at school, I immersed myself in the works of the masters in museums. From Rembrandt, I studied light and shadow; from Velázquez, exquisite form; from Bouguereau, photographic perfection; and from John Singer Sargent, elegant style and innovative brushstrokes. In addition to these masters, I also admired the work of contemporary realist masters, such as Norman Rockwell, J. C. Leyendecker, and Maxfield Parrish. I loved these artists' masterful painting styles,

OPPOSITE *Brown Sage,* 1966, oil on canvas, 20 x 16"

compositions, and use of color, but I was also enchanted by their subject matter, which ranged from poignant moments of American life to the fantastic stuff of legends and other-worldly fairy tales.

After studying realism for several years at the Art Students League, I decided it was time to move on. The last realistic painting I did was for a book cover about the Old West. It was an image of a cowboy, wearing a plaid shirt, a hat, and a bandanna. His face was lit by the glow of a log fire from below and by moonlight from above. It took a long time to paint, and when it was completed, I thought, *I don't think that I can paint like this again.* I had attained the level of realism I had been striving for but felt my imagination was blocked. I felt an urge to break out of realism altogether and become more innovative.

It became obvious to me that realist art photographers were replacing the realist painters whose work had graced magazine covers for the past decade. This was mainly a result of emerging technology: new web offset presses were able to reproduce four-color photography with greater clarity and vibrancy than ever before. As I saw that the print industry was rapidly evolving, I felt that it was time that I did too.

A GRAPHIC TURN

I left the Art Students League to continue my studies at the progressive School of Visual Arts, where abstraction, composition, and out-of-the-box creativity were in vogue. Inspired by this new influence, I continued to work in realism but applied technologically innovative and dynamic concepts to my compositions.

I still did not grasp abstraction until my friend Lenny, who studied at Pratt Institute, explained it to me, saying, "It has nothing to do with subject. Just colors, brushstrokes, backgrounds, and compositions." Then he

OPPOSITE *Cowboy*, 1959, oil on canvas, 20 x 16"

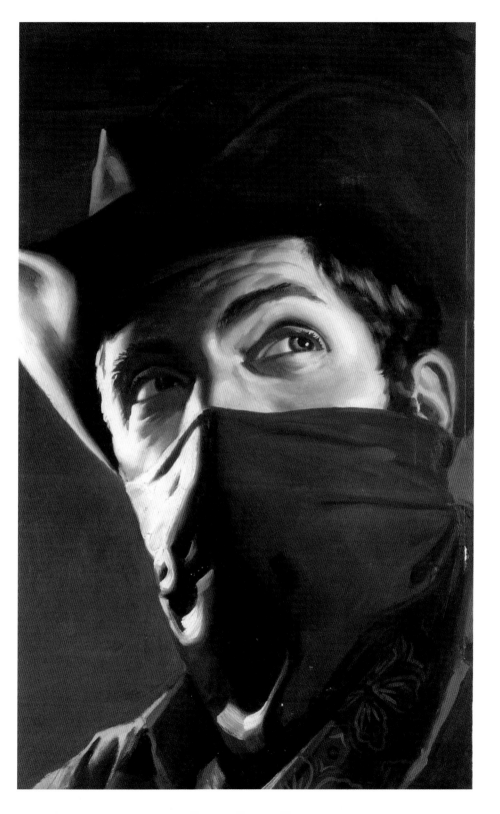

Max as a young artist, circa 1960

showed me outrageous color combinations—how the color yellow is the complement of purple, and green is the complement of red. At the League, I had been trained to use realist colors and actual skin tones. Reilly would have us mix paint and tube it so that we would have several tubes of different shades for each complexion type. Lenny's explanation and demonstration opened up my mind to a whole new perspective on color juxtaposition, and I suddenly began to appreciate the Fauves in a whole new way. I loved Vlaminck's outrageous use of color. He had the realist handle of brushstrokes but used unexpected juxtapositions of colors. His sky was green instead of blue. His clouds were purple instead of white. Suddenly, the bold color combinations taught to me by Professor Hünick, the Viennese Fauve painter whom I had studied with in Israel, began to resurface. My creativity exploded into a whole new world of color possibilities.

As I studied abstract painting, I began to look with new eyes at Bauhaus artists like Kandinsky and Klee, at Dadaists like Man Ray and Duchamp, and at surrealists like Magritte. But it was new Swiss and German graphic artists, whose work was featured in *Graphis* (the Swiss art magazine), that challenged my visual and artistic sensibilities. Their work was contemporary, dynamic, conceptual, and highly innovative.

I still regarded realists as great artists and draftsmen, but I was now moving in the direction of conception and innovation, painting abstract, offbeat compositions. I realized that instead of totally abandoning realism, I could use those skills and apply them to graphic arts to create something progressive and avant-garde.

THIS PAGE "Tennessee State Museum-Eye," 1993, poster, 36 x 20"

FOLLOWING PAGES "Toulouse-Lautrec," 1967, poster, 36 x 24"; "Beau Brummel," 1964, poster, 38.5 x 26"

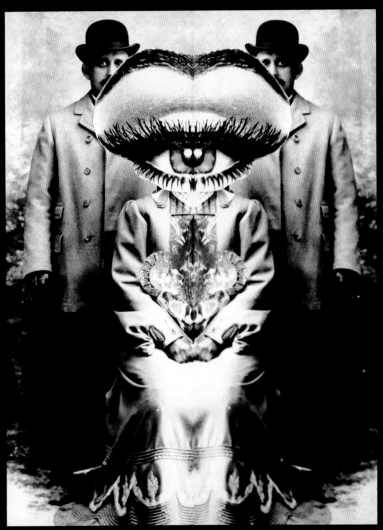

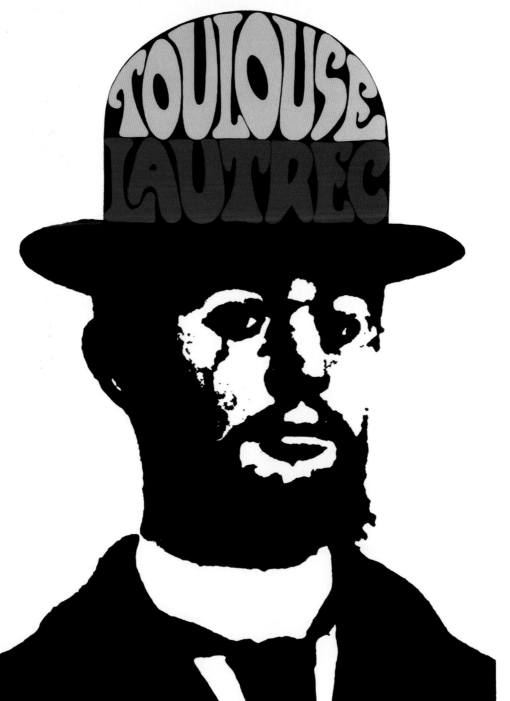

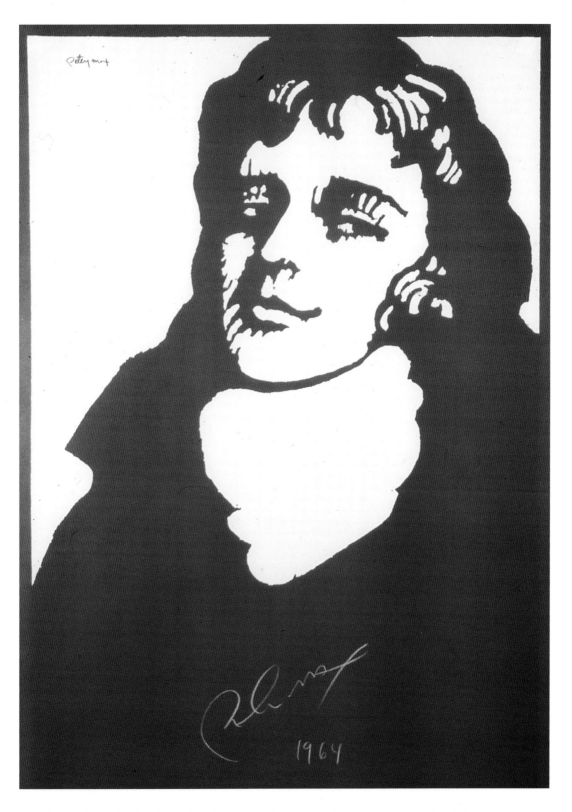

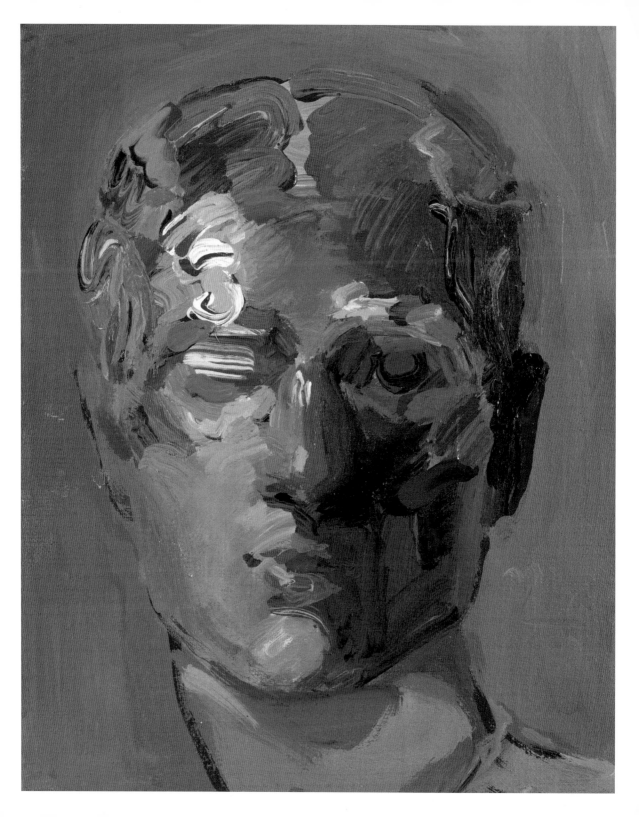

In some instances I used archival photographs as a base and made high-contrast photo prints to eliminate the gray tones, and then retouched the images with India ink. The high contrast and stark black shapes created a new form of minimalism that was possible, thanks to my skills in realism and knowledge of light and shadow. And I found I could also go in the opposite direction: I could paint a subject realistically and diffuse it, making it more impressionistic. First I saw an image with the eye of realism, but then let my feelings for innovation take over, and I just let go.

As I worked on my new technique, I knew I was breaking the rules. My teacher Frank Reilly had said to us many times, "Now, guys, don't get creative on me. You are realist painters. Don't get out there and do funny stuff, like abstraction or anything 'Picasso-esque,' you know what I mean."

I knew that I was crossing the line. I loved the tradition of realism, but I was now moved by innovation. At least I got to learn all the rules before I broke them, and I never abandoned realism. Even today, I occasionally do a realist portrait. Some have abstract brushstrokes in them and others Fauvist colors, but they still have the realist value of light and shadow. If you work in the arts, there is nothing like having a solid foundation in the classical approach. It's a strong foundation to both build upon and evolve from. Although Keith Jarrett can improvise jazz piano better than anyone, he can also play Bach masterfully at Carnegie Hall.

When the time came for me to make the transition from being a student to earning a living as a full-time artist, I put a portfolio together that included my new works along with some of my realist paintings. Through the recommendation of a friend, I made an appointment with Ken Deardorff, art director at Riverside Records. Riverside was an avant-garde record company known for their

LEFT *Neo Fauve Head,* 1982, acrylic on canvas, 36 x 30"

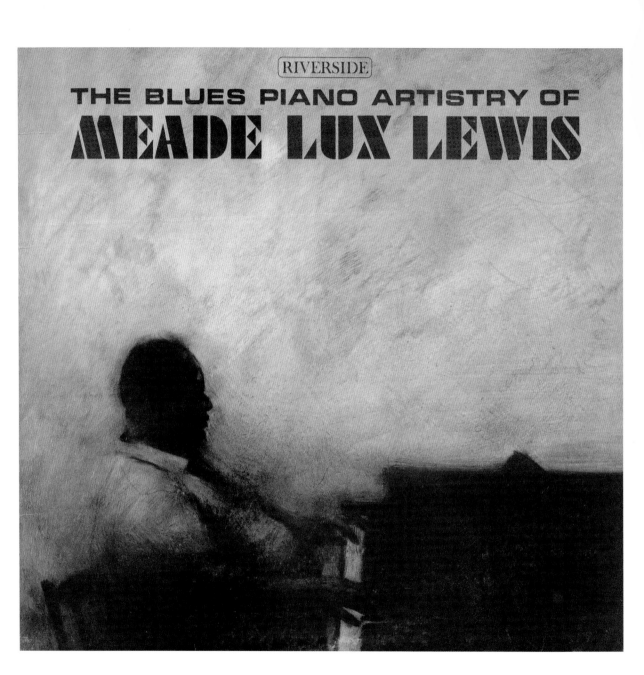

THE BLUES PIANO ARTISTRY OF
MEADE LUX LEWIS

RIVERSIDE

artistic and creative album covers, and I was hoping to get a record album commission. As Deardorff was going through my portfolio, he was impressed with my realistic paintings but then confirmed what I had just recently discovered—that stylish photographers had replaced realist painters. One of my new graphic works, however, had a look that he had not seen before. He commissioned me to create an album cover for Meade Lux Lewis, the jazz pianist. I painted Lewis in my new style, and Deardorff immediately put it into production. This album, my first mass-produced piece of art, would go on to win a gold medal at the Society of Illustrators Annual Exhibition.

TAKING FLIGHT

In 1962, John Glenn became the first American to orbit the earth. New worlds were being unveiled, and my career was also launched as people became attracted to my work and I became a sought-after artist. As new business continued to flow in, I teamed up with my buddy Tom Daly, and we opened the Daly & Max Studio. Our studio flourished, but after two years of working on book covers, record album covers, and other projects, I once again felt the urge to find a new form of expression that was not limited by the restraints of the market. Having saved up some money, I bought a large apartment on the Upper West Side where I could live and paint. This was not only a time for artistic growth but also a time for personal growth. I had recently gotten married and wanted to raise a family. Within the year, my first wife, Elizabeth, had given birth to our son, Adam Cosmo.

After attaining a full measure of artistic expression and fulfillment, I felt the need to open myself to new adventures. To allow my creativity to flourish, I had to step back from the familiar and the comfortable and retreat.

OPPOSITE "Mead Lux Lewis," 1962, record album cover, 12 x 12"

RETREAT TO DISCOVER

As I began my retreat, I accidentally discovered a new direction in which to take my passionate quest for innovation. While printing a poster one day, I noticed a skid of poster sheets with multiple images laid over one another. I was fascinated, and as I was gazing at the sheets and wondering who was printing them, I asked who was printing these sheets.

"Peter, those are runoff proofs."

"Runoff proofs?" I asked.

"After a printing job, we run sheets through the press to clear the ink off, and run each sheet through a few presses," the printer said.

I was fascinated with the accidental visual results and asked if I could take a few sheets.

"Take as many as you like," the printer said.

I took as many as I could carry and rushed back to my studio. As I laid them out on the floor, I studied them in more detail. I saw a face superimposed over a flower on one sheet, a fashion model superimposed over a building on another, and then several faces superimposed over one another. A lightbulb turned on inside me—a spark of innovation. What had occurred by accident, I wanted to create by design.

Inspired, I cut images from magazines and began to make collages, adding colors and textures from a variety of sources to create compositions that were surreal and dreamlike. On occasion, I would take a small square mirror and hold it up over a certain area, say a model's face, and when I saw a mirror image that I loved, I would mark up the original and send it to the photocopy service for a color print and a flopped (mirror-image) color print.

When both images came back from the photocopy service, I was exhilarated. I would put them together and once again send them out for another flopped print to create a kaleidoscope effect. Later, I realized that my geometric, kaleidoscopic images were similar to the ancient

OPPOSITE "Self-Portrait," 1968, poster, 36 x 24"

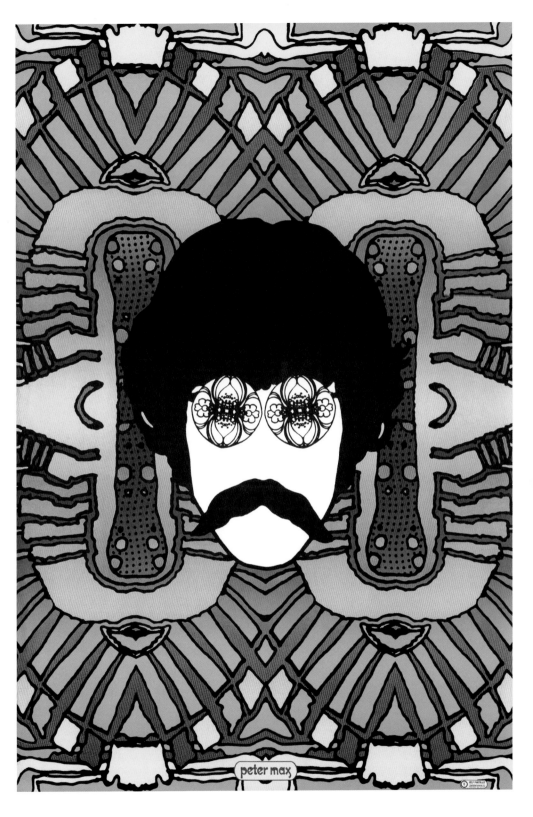

peter max

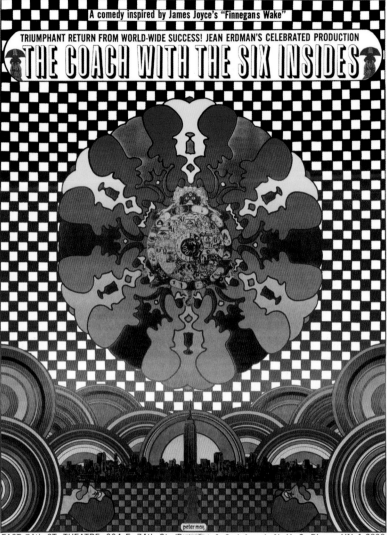

A comedy inspired by James Joyce's "Finnegans Wake"

TRIUMPHANT RETURN FROM WORLD-WIDE SUCCESS! JEAN ERDMAN'S CELEBRATED PRODUCTION

THE COACH WITH THE SIX INSIDES

peter max

EAST 74th ST. THEATRE, 334 E. 74th St. (Bet. 1st & 2nd Aves.), N. Y. C. Phone UN 1-2288

RIGHT "Kaleidoscopic Lips," 1967, poster, 36 x 24"

OPPOSITE *Panopticon I–Girl & Flowers,* 1964, 12 x 12"

FOLLOWING SPREAD *Panopticon II–Umbrellas & Cameras,* 1964, 12 x 12"

mandala art of Tibet. As devoted as I was when I studied realism, I was even more consumed by developing collage works. Inspiration was everywhere—in the pages of art and graphic design magazines, in comic books, and on movie posters and billboards.

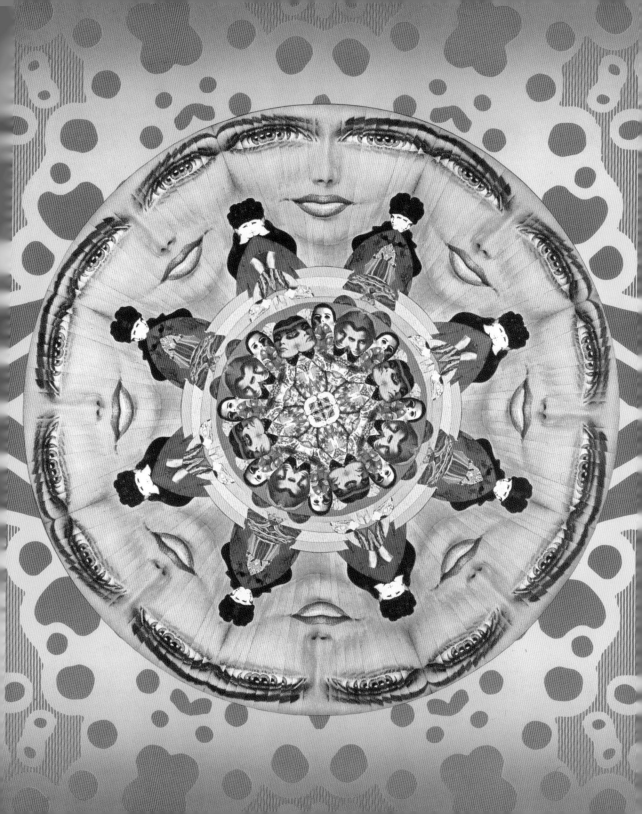

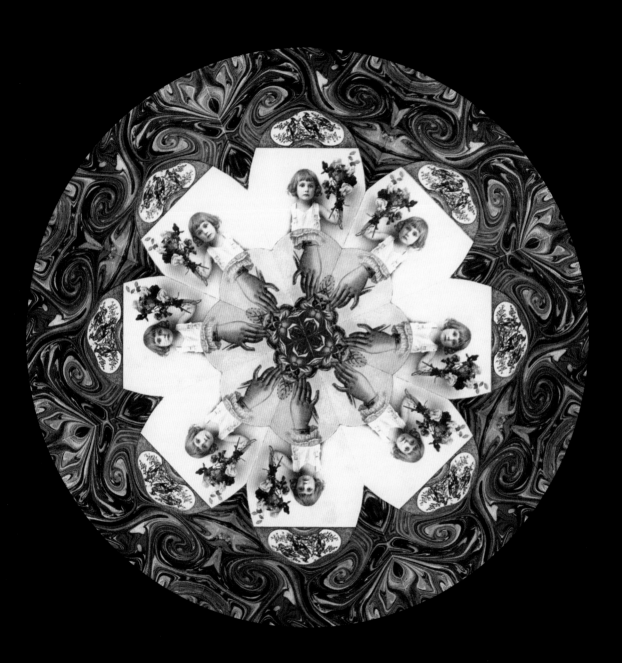

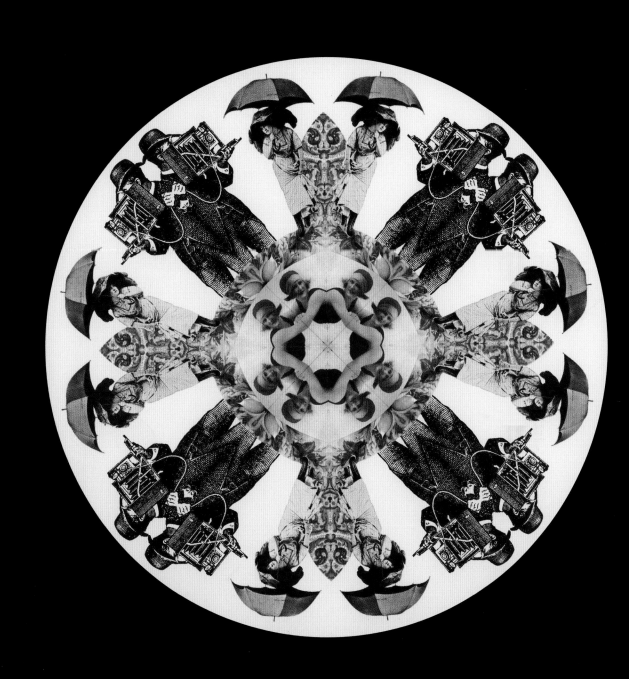

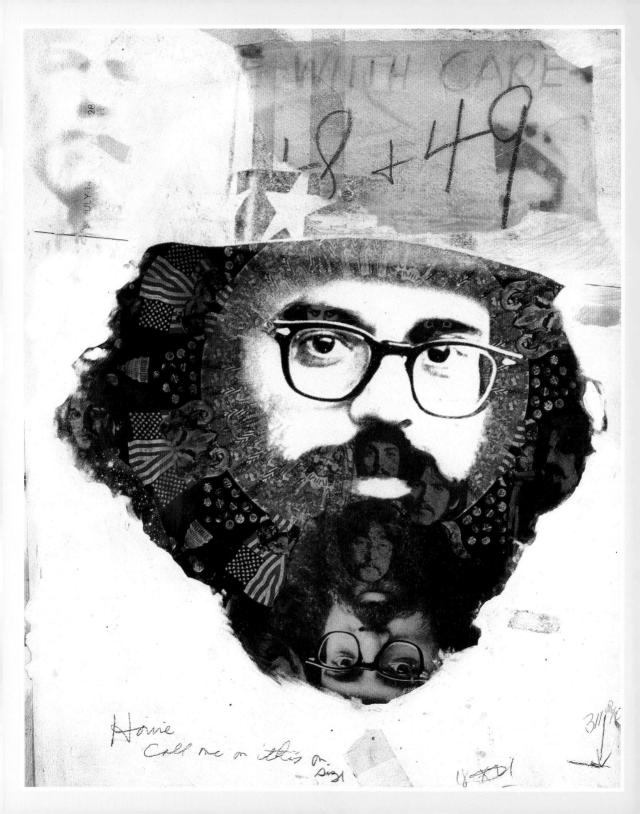

Modernism in the 1960s

The innovative techniques of Modernism in art reflected the intense creativity of New York City's Greenwich Village arts scene in the 1960s. Having evolved from the Beat Generation, which itself had roots in the Bohemian and underground culture of Europe, this new generation of young Bohemians, Max included, embodied a freethinking lifestyle and radical experimentation in art and music. As the decade progressed, the Bohemians gave way to the hippie subculture. Allen Ginsberg bridged the gap between the Beat generation and the hippie movement, and he and Max became good friends. A practicing Buddhist, he reminded him of his early childhood experiences in the Far East.

Eastern culture soon began to permeate the Hippie movement—Indian sitar music and the scent of incense emanated from Hippie pads in the Haight-Ashbury section of San Francisco and NYC's Lower East Side.

As The Beatles began to reflect Indian influences in their music, Max began to reflect them in his art. A new consciousness was emerging and Max was feeling its cosmic vibrations. It led him to deepen his quest for transcendence, and for the time being, the collage was his medium to try to attain it through his art.

Max's spiritual quest led him to the Indian guru, Swami Satchidananda, six months before The Beatles were to discover Maharishi. In both instances, however, the rock stars and the artist helped transcendental meditation and yoga to become important catalysts for the 1960's cultural "evolution."

ABOVE "Prana," 1967, poster, 36 x 24"
OPPOSITE *Allen Ginsberg,* 1963, collage, 19.2 x 16.625"

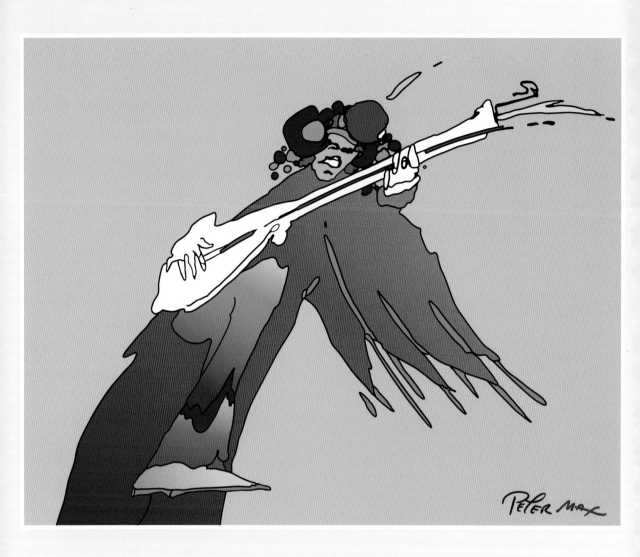

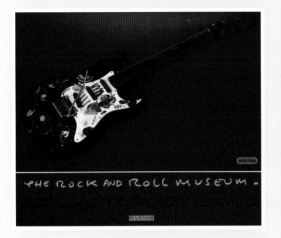

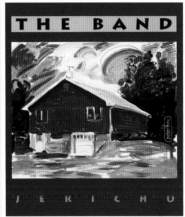

Good Vibrations

Max first saw Bob Dylan perform with an acoustic guitar and harmonica in the early 1960s at the Café Wha?. Whereas Dylan was a pro on the acoustic, Jimi Hendrix ruled the electric guitar. Max first met Hendrix at his friend Albert Grossman's recording studio in Bearsville, near Woodstock, and the three of them would occasionally have brunch on weekends. Albert Grossman managed artists such as Bob Dylan, Janis Joplin, Richie Havens, Peter, Paul & Mary, and The Band. Many of these artists would show up in Bearsville, and Max got to hang around with them, exploring the natural intersection of music and art. One of his best friends, Ron Merians, owned a restaurant called the Joyous Lake, where musicians like Bob Dylan and Levon Helm of The Band often performed. Rock 'n' roll was more than just a passing experience for him. The music consumed him and instilled its vibration into his art. He created a giant collage with images of Hendrix, the Beatles, the Grateful Dead, Frank Zappa, the Mamas and the Papas, and other rock 'n' roll legends. Then I he made a poster of the collage and titled it Audio DNA; he felt that the music had become part of his generation's DNA. Without it, they did not exist.

ABOVE LEFT "The Rock and Roll Museum," 1988, poster, 26.25 x 31"
ABOVE RIGHT "The Band," 1993, poster, 31.88 x 24"
OPPOSITE *Jimi Hendrix*, 1972, serigraph, 22 x 30"

peter max

THE COSMIC COLLAGE

As I continued to experiment with collage, I searched for new textures to expand its dimensions. I worked with colored inks on rice paper and created inkblot patterns, which, coincidentally, were later reflected in the 1960s tie-dye craze. I was enchanted by fine Italian marble as well as marbleized patterns, such as those used in the endpapers of antique books from Venice and Florence. I discovered that by using children's finger paints I could create my own style of marbleization. During this period, I pursued my collage art with relentless passion.

For two years I was in a space of creative exploration, rising at dawn to begin work on my collages and reappearing from the studio ten hours later. I would forget everything but the emerging work in front of me. Sometimes I wanted to challenge my senses while I worked, so I listened to the electronic music of Edgard Varèse, played at fast or slow speed or even backward. I had two television sets in the studio, one stacked upside down atop the other.

I remember late one night putting my energy into a collage that grew enormous. Though it radiated out in four directions, taking up the entire expanse of my studio floor, it failed to communicate the sense of vastness and complexity I sought to express. Eventually, I added large mirrors, creating a giant kaleidoscope. The collage was mirrored over and over in infinite reflections, but I was still unsatisfied. After working for sixteen hours a day for three days, the collage was complete—my vision of the universe. I was hoping the piece would give me a glimpse into the grand scheme of things and the meaning of life. I felt that I was trying to symbolize a cosmic truth. In an effort to see the whole picture, I got the tallest ladder I could find and climbed to the top of it.

OPPOSITE "Siblings," 1968, poster, 34 x 26"
FOLLOWING SPREAD "Midget's Dream," 1967, poster, 24 x 36"

peto

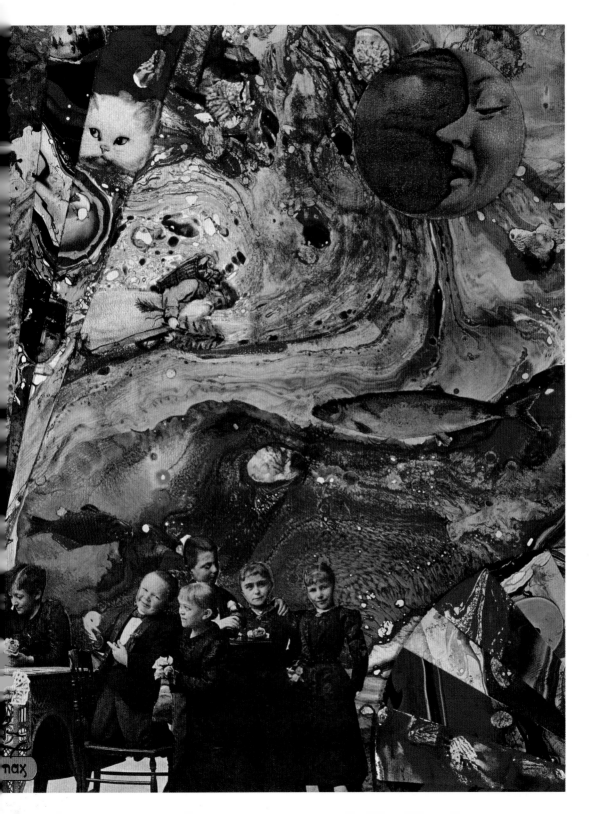

nax

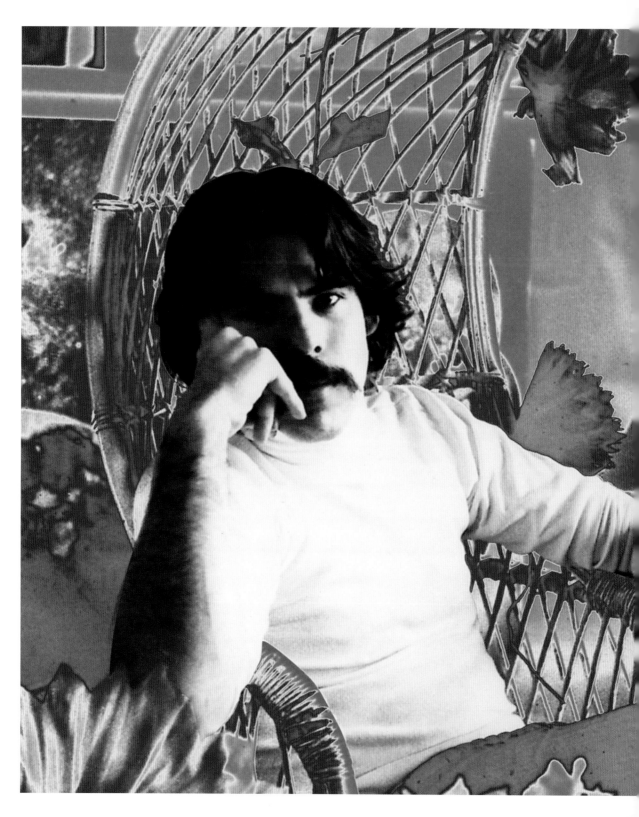

Yet I still could not gain knowledge or release from what I saw and felt frustrated and wanted to scream. Then I closed my eyes. In my mind's eye, I saw a cloud. The cloud began to open, and hidden within its cottony folds I saw the face of a man with a white beard. He wore an expression of infinite compassion. He nodded to me as if to say, "It's all right. I will come."

This vision relaxed me completely. I was not a religious person, not in an orthodox sense, and to me, the vision seemed more like a man from a fairy tale or myth. But the serenity he imparted was unshakable. I put aside my collage and for the next few days I was immersed in thoughts about my vision. I felt deeply relaxed, anticipating something wonderful about to occur.

Artist in Wicker Chair,
1968, mixed media (detail),
24.5 x 36.25"

ENLIGHTENMENT AND COSMIC ART

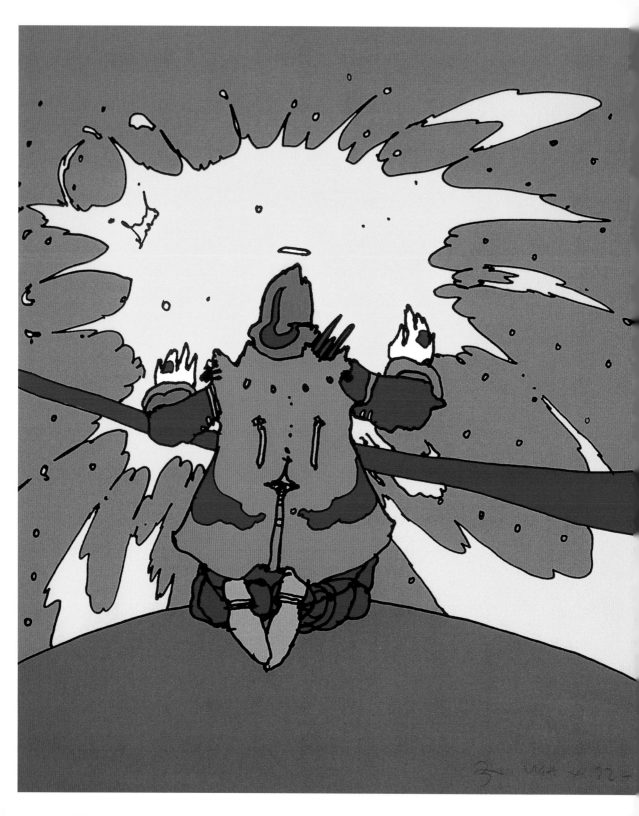

A week after my visionary experience, I received a phone call from a man I'd never met. His name was Conrad Rooks, and he was about to invite me on a life-changing journey.

AN AMERICAN IN PARIS

Heir to the Avon Cosmetics fortune, Rooks said he was filming a movie in Paris called *Chappaqua*. Despite having extraordinary footage of Allen Ginsberg, William Burroughs, Ravi Shankar, and Man Ray discussing spiritual matters, he admitted that the film lacked structure and an overall aesthetic. Having heard from a close friend that I could transform the film into something visually spectacular, he offered me a nice fee and all expenses paid to fly to Paris for a week to work with him, but I politely declined his offer.

Two days later, there was a knock on my door. Behind it stood a man wearing a Zorro-style hat and a trench coat that hung to his ankles: Conrad Rooks. He said that when I refused his offer on the phone, he decided to fly to New York to meet me in person. He again pleaded with me to work on the film. I was appreciative of his gesture to fly to see me, but I once again declined, since my son Adam was recently born and I was working on a commissioned artwork. Then he said, "Allen Ginsberg and William Burroughs are waiting downstairs to tell you about my film."

I thought he was putting me on, but I went down with him, and sure enough, there were Ginsberg and Burroughs sitting on a bench across the street from Riverside Drive playing the bongo drums and chanting. When Rooks and I approached, they stopped playing and

OPPOSITE "His Holiness," 1967, poster (detail), 24 x 36"
CHAPTER OPENER *Swamiji*, 1971, serigraph, 22 x 30"

proceeded to tell me about the film and tried to persuade me that it needed my creative input and that I should go to Paris. The whole thing was unfolding like a magical mystery tour. But I was still reluctant to go. Rooks then took me aside and wrote out a very large check, enough to support my family for a year, in return for only ten days' work. I finally agreed. Rooks and I would depart the following day.

When we arrived at the Paris airport, Rooks went to pick up his car, and soon pulled up to the waiting area in a shiny black Mustang convertible. He was playing the music of a new British rock band, the Moody Blues, and their music set the pace for an enchanting drive through the City of Light. Memories of my earlier discovery of Paris as a teenager drifted in and out of my current experience, made even more mysterious by the evocative chords of the Moody Blues. Rooks told me that I was about to meet a remarkable man, whom he simply referred to simply as "Swami."

After arriving at the Hotel Napoleon, the Avon heir and I sat down for breakfast. Rooks picked up the house phone and said, "Swami, the young artist is here with us for breakfast—please come down."

SWAMI

Since I was becoming increasingly interested in Eastern mysticism, I was eager to meet this "Swami." When the waiter brought our juice, I looked over toward the elevator, and a tall man with long black curls to his shoulders, a beard, and a beautiful orange-colored robe exited. Rooks waved to him, and he walked over to our table with a smooth but rhythmic gait. The Swami had an extraordinary presence. His eyes were as warm and brown as coffee, and his smile lit up the room. Though utterly unique, he seemed familiar to me. In the next moment, I sensed

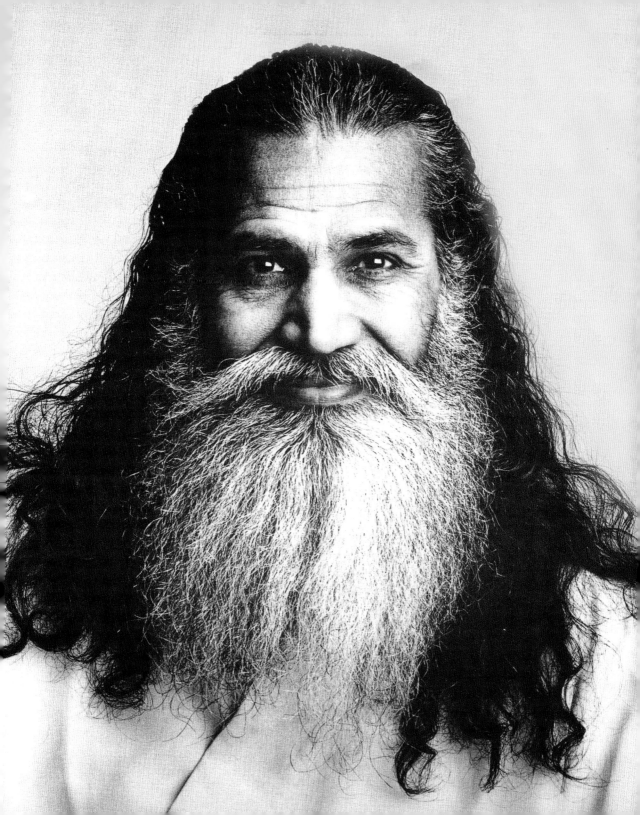

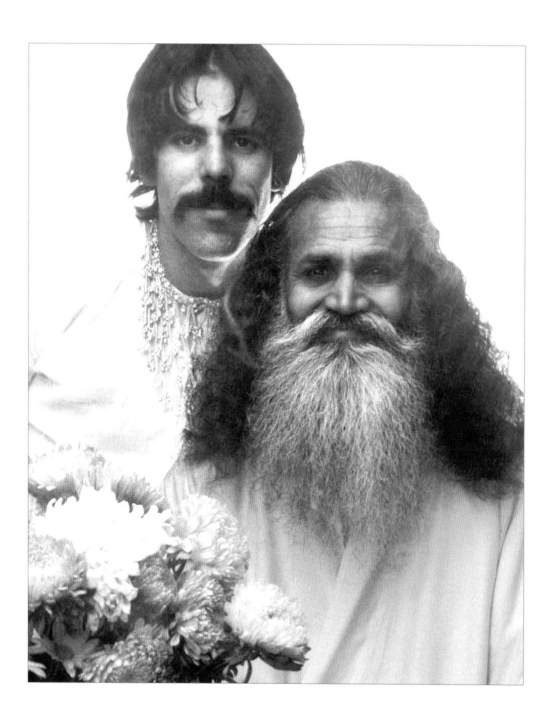

that this was the man I had envisioned when creating my cosmic collage! He was not an exact physical match for my vision—his hair was not white but a dark chocolate brown like his eyes—but it was him.

OPPOSITE Max and the Swami, 1967

Introducing himself, he told me that his full name was "Swami Satchidananda," conferred upon him by Swami Sivananda of the Himalayas. "Satchidananda," the Swami explained, "is made of three Sanskrit syllables: *Sat* [existence], *Chid* [knowledge], and *Ananda* [bliss]." Breaking it down into those three syllables made it easier for me to remember and pronounce.

After breakfast, we all went to see a rough cut of the film. It documented Rooks's journey of self-discovery from the hell of heroin and alcohol addiction to rehabilitation, and ultimately to his meeting with a man whose love and affirmation saved his life. As we watched the footage, the camera zoomed in on a large banyan tree. A man was chanting, "Om Shanti, Om Shanti, Om Shanti, Om."

It was the Swami sitting under the tree chanting. When I looked over at him, he smiled and said, "That's me." I still had no idea what he did, but everything about him was wonderful.

My task was to view the film footage and apply my sense of graphics and colorization where appropriate. I treated the material as a montage, adding elements of surrealism to dramatize the drug experiences and withdrawal, and tints of radiant, warm orange colors whenever the Swami appeared.

When I was not working on the film, I spent as much time as possible with the Swami. I began to practice yoga, and the Swami guided me through the asanas. Noting the expression of bliss on the Swami's face while he meditated, I was convinced that there was a higher state of consciousness to be attained.

Toward the end of my visit, I begged the Swami to come back to America with me, explaining that a whole

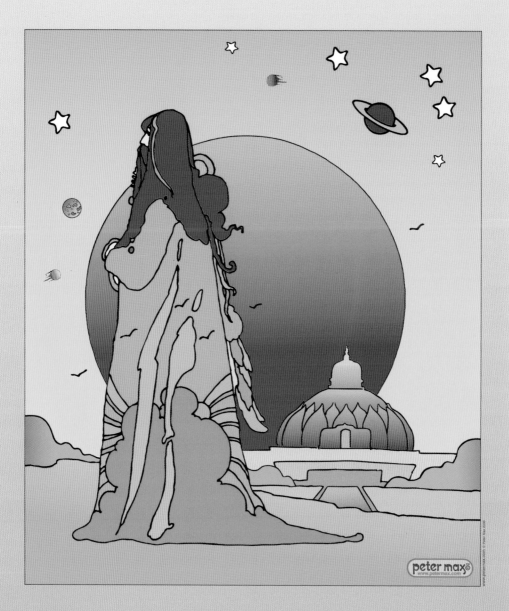

 THANK YOU, SRI SWAMI SATCHIDANANDA,
FOR BRINGING THE GIFT OF YOGA
TO MILLIONS.

CELEBRATING 40 YEARS OF INTEGRAL YOGA 1966-2006

generation of young people were searching for spiritual answers and trying to find them through psychedelic substances, when they could be leading a more peaceful life simply by following the Swami's yoga teachings.

Swami Satchidananda agreed to fly to New York City a couple of days after I arrived home. The day he arrived, I invited my friends to meet him. That evening, about forty people showed up. The Swami was sitting on a large white sofa in the lotus position. As he started to speak in his soft, gentle voice, the whole room grew quiet and was filled with a sense of anticipation and wonder. After speaking for about an hour, the Swami answered questions for about fifteen minutes, then closed his eyes and silently led us into our first yoga meditation. Afterward, we all went into the kitchen and shared our experiences and discussed what we could do to keep the Swami in New York.

One of my friends put his hands in his pockets, reached for whatever bills he had, and dropped them on the table. Everybody followed the gesture and dropped five- and ten-dollar bills until, among us, we had collected about five hundred dollars—a first month's rent for an apartment at 500 West End Avenue, where the Swami began teaching yoga classes. Eventually, we bought a large six-story building at 227 West Thirteenth Street, which still stands as the headquarters of the Integral Yoga Institute. Today, there are many Integral Yoga centers worldwide, and the beautiful Satchidananda Ashram, Yogaville, in Buckingham, Virginia, the ashram's L.O.T.U.S. temple (Light Of Truth Universal Shrine) is dedicated to the Swami's interfaith teaching: "Paths are many, but the Truth is one."

OPPOSITE "IYI 40," 2006, poster, 24 x 18"

YOGA AND MEDITATION

One of the important lessons I got from Swami was about the word *guru*. The word, he explained, is made of two Sanskrit syllables: "gu," meaning ignorance, and "ru," meaning remover. So a guru is one who removes ignorance. I loved it when he put it another way: He said that a guru is like a laundryman. You bring a laundryman your shirt, which was once pure white but has accumulated dirt, and he makes it white again. How? Not by adding white but by putting in detergent. Similarly, the guru offers you a mantra, an asana, and other methods to help remove the residue and restore purity to your mind.

Sri Swami Satchidananda was a man of grace, wisdom, wit, love, and compassion. He was an embodiment of all that he spoke. And he spoke eloquently. His talks were engaging and filled with humorous anecdotes, as he had a great sense of humor. He even laughed at his own jokes more heartily than did those of us he told them to. He said, "I am often as surprised as you are by what I say, because I am hearing it for the first time too." And then he gave a hearty laugh.

He also loved to dissect words to make us aware of their true meaning. For instance, "When you say you got disappointed, it's because you made an appointment, and when it didn't happen, you got dis-appointed. So don't make appointments and just accept whatever comes,

ABOVE *Sat Guru Teacher of Light*, 1972, serigraph, 16 x 18.5"
LEFT "Sat Guru Om," 1972, pen and ink on paper (detail), 11 x 14"

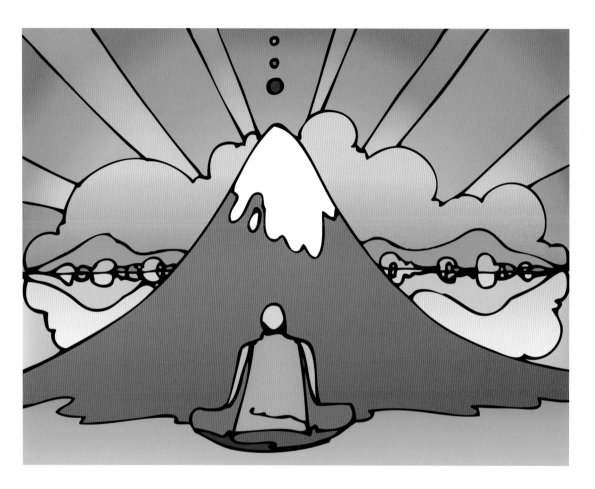

ABOVE *Himalayan Monk,* 1972, mixed media, 10 x 13"
OPPOSITE "National Library Week," 1969, 36 x 24"

and you will never be disappointed." Or, "Disease is the absence of ease. So always keep yourself at ease, with meditation or asanas, and you will not lose your ease and get dis-ease."

Not only did bringing the Swami to America enrich my sense of well-being, it was also the most spiritual and patriotic thing I have ever done. He was not the first yoga master to come to America, but with the creation of the Integral Yoga Institute, he definitely helped contemporary yoga take firm roots here, and I'm proud to have played a part in it.

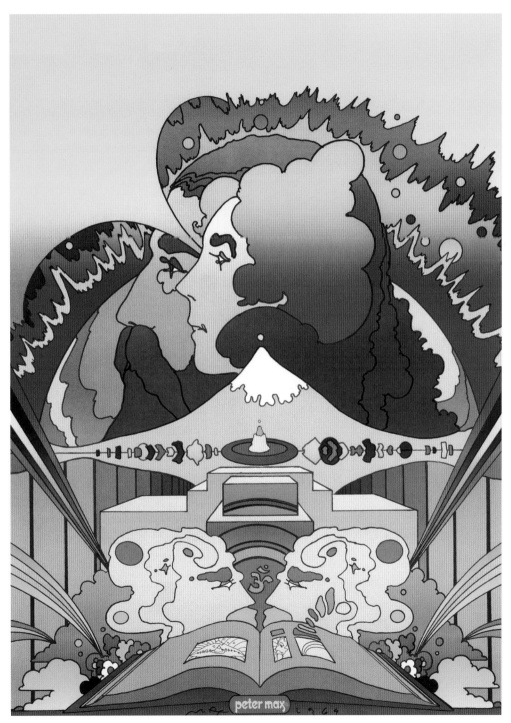

THE UNIVERSE WITHIN

As my yoga practice deepened, I began to acquire a powerful focus through meditation, and my art began to change remarkably. While the outer cosmos had always been fascinating to me, the Swami revealed to me, through meditation, that a whole universe could be found within. This newfound interior space seemed just as vast as the enormity of outer space, and, in fact, they seemed to be one and the same.

I had tapped into a vast creative reservoir that now gushed forth with an unimpeded flow of artistic energy. I discovered that whenever I wanted to draw a subject, artistic visions came to me from out of nowhere. Art was no longer a thing that I *did*: images occurred spontaneously whenever I picked up a pen or a brush. I had spent years in art schools learning how to draw and paint in a realistic fashion, but yoga opened me up to insights I had never learned before: creating composition and balance in the mind as well as in art. Meditation taught me how to be a channel and to let creativity flow through me. The incredible costumes the figures in my paintings wore also came to me through inspiration.

Before I met the Swami, I drew with a preconceived idea, trying to re-create on the drawing board what I had been thinking of a few hours before, which was very difficult because where I had been a few hours ago was not where I was in the present moment. In other instances, when the drawing would not come out exactly as I anticipated, I would get upset. But once I developed a

Flower Flyer and Two Sages, 1971, mixed media, 8.5 x 11"

meditative mind, I could let myself go. I learned that even
with drawings that were not going well, something new
and exciting could happen.

While I was drawing in a cab one day, the cabbie
hit a bump and my pen line shot up to the top of the page.
Instead of thinking my drawing was ruined, I used the
inclined line and turned it into a mountain peak. In art,
or writing, when you're in the flow and something unex-
pected happens, welcome it. It can open up a whole new
opportunity for creative discovery.

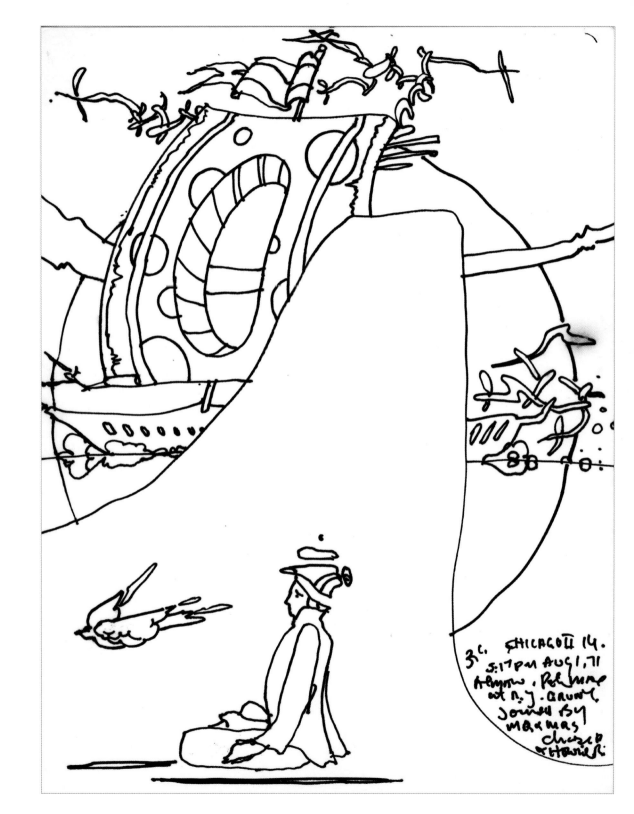

BELOW "Sufi Sun Worship,"
1978, pen and ink on
paper, 6 x 9"
OPPOSITE "Sitting on
Head," 1970, pen and ink
on paper, 12 x 16"
FOLLOWING SPREAD
"Arabian Nights City," 1971,
pen and ink on paper,
10 x 16"

If you're not in the flow, or not feeling that you are, do not resist it; be with that too. Drawing is like sailing. Sometimes you have to sit very quietly and patiently wait for a breeze, and then suddenly a breeze comes along and your sails billow and you glide across the water effortlessly. Even when I'm not inspired, I still sketch and keep my hand moving until suddenly, like a breeze, something moves through me, and a beautiful new drawing emerges.

THE FLOW OF THE LINE

As the influence of yoga sparked a flow of creative expression, a new drawing instrument made it even more possible to transfer that creative expression onto paper. The

Pentel was a felt-tip pen invented by a Japanese pen designer in the 1960s. It allowed me to draw a continual and smooth line for as long as I wanted to.

Before the Pentel, in order to draw with ink on paper, I would have to stop very often and dip the pen in ink. A fountain pen helped to eliminate the problem, but the metal point of the pen would often snag on the paper, whereas the Pentel allowed for a smooth and unbroken line, and drawing became as smooth as skating on ice.

Before using the Pentel, I had only experienced that flow with an ebony pencil on smooth newsprint. But with a felt-tip pen, I could even draw smoothly on a tablecloth or linen napkin, which I often did. (I would sometimes offer the manager or owner of a restaurant a drawing as a gesture of appreciation. Sometimes, if I ran out of paper in a diner, I would even draw on a menu or a cloth napkin.)

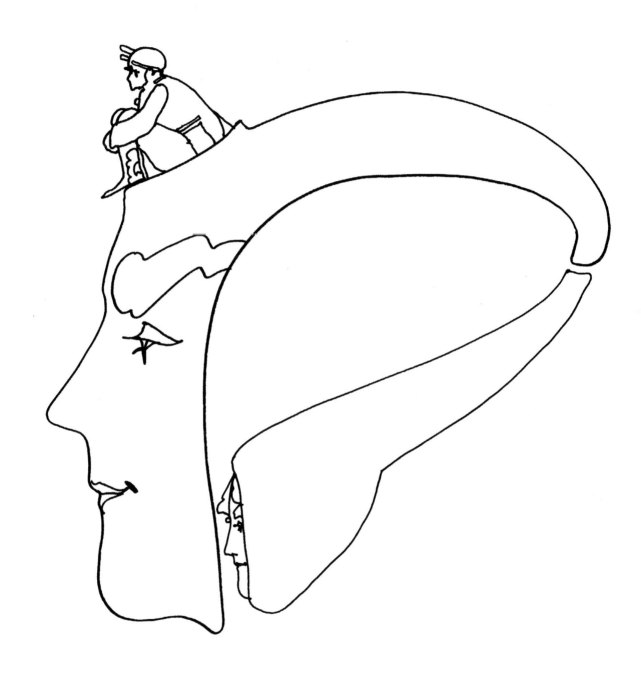

"Our Gang," 1967, poster,
24 x 36"

Drawing had become like a dance for me. I had developed a flowing movement in my wrist from my childhood days when I was taught to paint with a brush by my nanny in China, and by emulating the movements of the monks. Now, it had suddenly come back into play again. Once I picked up a Pentel, I couldn't stop dancing on paper.

And then, when I started to add colors to my 1960s drawings, it was as though I had entered the land of Oz. The colors began to occur as spontaneously as the drawings had. Of course, it helped that I studied Fauve painting and color juxtapositions, but this experience was unique, and I had discovered a whole new way to express myself with color.

A breakthrough in color usage happened on the printing press at the same time. A European printer showed me the "split fountain" printing technique on a two-color press. Instead of using only one color of ink in each of the rollers, I discovered that I could split the roller with plastic or cardboard wedges and use three different colors between the wedges. As the different colored inks hit the roller, they would spread, creating a smooth color blend that not only contained the different colors but also the whole range of colors that the blend itself created. Into the other roller I would pour in different colors— using my knowledge of complementary color combinations—and would end up with the effect of a full-color poster, printed on a two-color press.

RIGHT "Self-Portrait," 1968, poster, 24 x 36"
FOLLOWING PAGES *Sun Angel*, 2004, acrylic and silkscreen on canvas, 19.25 x 13"; "NBC—a Beautiful Summer Day," 1969, poster, 36 x 24"

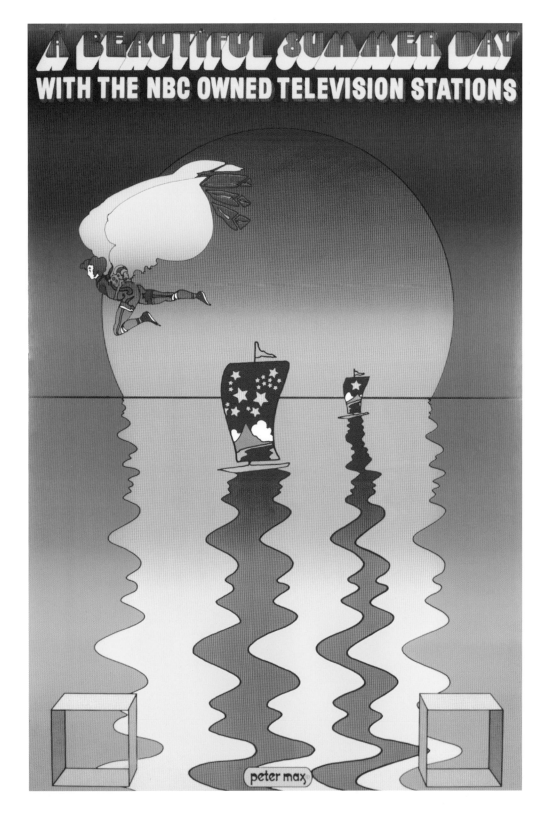

I loved the purity and integrity of the colors when I printed this way because the colors were solid, not made up of dot patterns as when color-separated in the traditional fashion. When I saw the first split-fountain poster roll off the press, I was excited beyond belief. I knew I had stumbled onto something new, fresh, and exciting.

In addition to this new fabulous look, it was also an ingeniously cost-effective way to print at that time; using two-color presses was far less expensive than printing on a four-color press. Soon after, I was working with a new printer on Varick Street in New York on a two-color press and asked him if I could work the split fountain. As I got on top and worked the presses, he looked at me with a sense of wonder. When I came down from the press and we started to print, his eyes bulged as we watched the prints roll off the press.

"Young man, I'm Shelly Stein," he said. "Do you do a big poster business?"

"Not yet, Mr. Stein, I am printing for myself, but I see a poster revolution coming full steam ahead like six giant locomotives!"

"Six giant locomotives?!" he exclaimed with raised eyebrows.

"Make it seven," I replied with a smile.

We struck a deal right then and there. Shelly Stein and I went into business fifty-fifty on a handshake, but the poster revolution I told Shelly about turned out to be more like a dozen of those giant locomotives. In six quick months after becoming partners, we had sold more than a million posters. I will never forget my sense of wonder when I received my first check. I felt like I had just won the lottery.

ABOVE *Flyer with Flower,* 1969, mixed media, 4 x 8"
OPPOSITE Max in 1969

AGE OF AQUARIUS

As I was undergoing a spiritual and creative transformation, the countercultural movement was also transforming New York City. The Age of Aquarius was nearing full bloom. A few days before Easter Sunday in 1967, one of my friends called and told me that he was organizing a big happening in Central Park, and asked me if I could do a poster to publicize it. Since I had a credit for ten thousand posters from a previous job with one of my printers, I offered to design and print the posters for free if my friend could find the people to distribute them around the city.

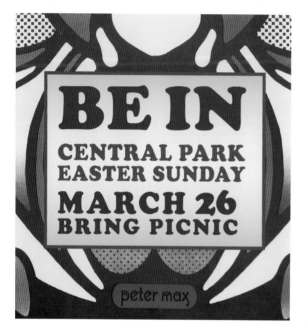

Having only a few days to design and print the poster, I created the image but had to use existing type since there was no time to have new type set. I had the word BE left over from one poster and the word IN from another. I placed BE IN across the top of the composition in very large letters, and then I added CENTRAL PARK beneath it in smaller letters, with the date of Easter Sunday at the bottom. Feeling that ten thousand posters were not enough, I reduced the poster to the size of a leaflet and had it replicated so that sixteen would fill the sheet. This way, 160,000 flyers could be distributed around the city.

On Easter morning my friend called me and said, "Hey, Peter, you won't believe what's happening at the Be-In!"

"What's a Be-In?"

"That's what you called it on your poster, man. There's a half-million kids in Central Park."

I hurried over to Central Park. The air was fragrant with incense. A group of Hare Krishnas was chanting, dancing, and clanging cymbals. Musicians were

ABOVE "Be-In," 1967, flyer, 8 x 6"

OPPOSITE "DeYoung Museum: Summer of Love," 2007, poster, 24 x 18"

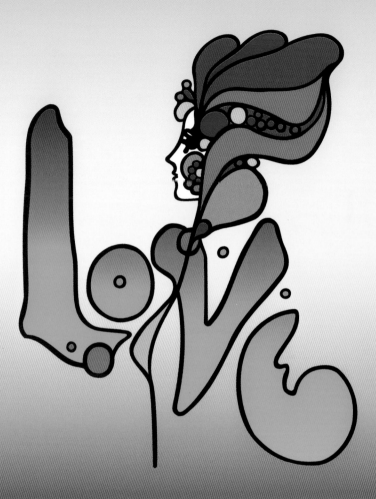

August 31 – October 28, 2007

de Young
Fine Arts
Museums of
San Francisco

And The Summer Of Love

peter max™©
www.petermax.com
© Peter Max 2007

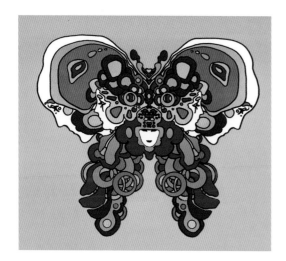

ABOVE "Butterfly," 1969, poster (detail), 36 x 24"
OPPOSITE "De Young Museum: Summer of Love," 2007, poster, 24 x 18"
FOLLOWING PAGES
Runner with Rainbow Loop, 1967, mixed media, 10 x 8"; *Hippie Angel Girl*, 1967, mixed media, 10 x 8"

playing guitars and tambourines. There were acrobats and astrologers, clowns and sooth-sayers. It was the largest gathering of young people before Woodstock, and because of my large letters for "Be-In," it established a new category for a 1960s happening.

Throughout this wonderful period, I was consumed by the idea of innocence as well as that of transcendence. I drew the faces of my flower children to be sweet and full of wonder, like the young hippies of New York's East Village and San Francisco's Haight-Ashbury.

I thought of them as the new generation of Bohemians: harbingers of the Age of Aquarius calling for a world of peace, love, and higher consciousness. They ate granola, wheatgrass, and macrobiotics; promoted ecology and animal rights; and practiced yoga. I portrayed my flower children in multicolored costumes, floating free of gravity. Their carefree adventures were not without counsel of the wise. I brought in sages, gurus, gods, and goddesses to guide and light the way, to give Shakti (spiritual power) and to remove ignorance.

My cosmic art subjects were always euphoric: Himalayan sages levitating under a shower of flowers beside snowcapped mountain peaks; faces and flowers exploding into a symmetrical cosmic butterfly; mirrored lakes and mountains with a cascade of stars and planets; flowers in perpetual states of organic growth, blossoms begetting blossoms. My inspiration came from the new youth movement in America and in return spoke to it. Also, for the first time, I made posters affordable to everyone, not just wealthy collectors My posters began to appear in college dorm rooms, in recording studios, in art galleries, and eventually in museums.

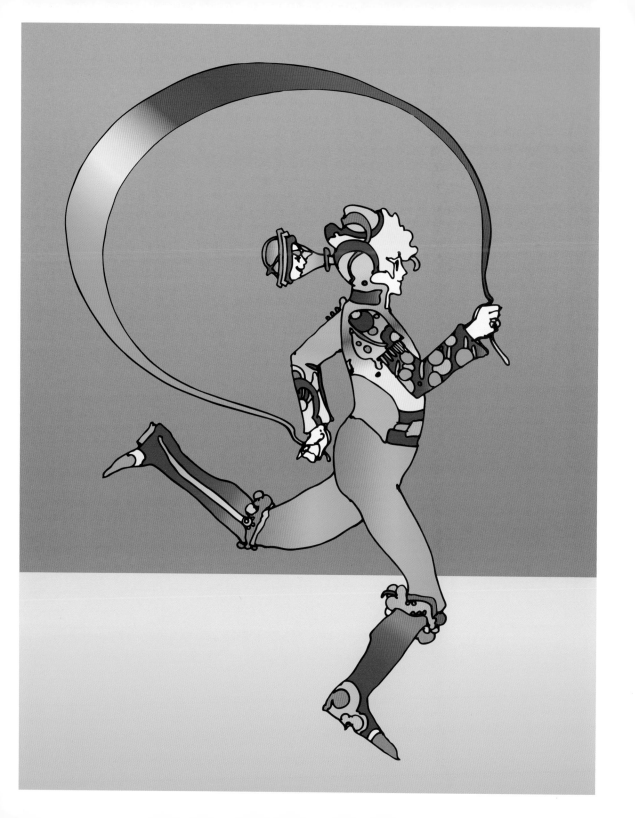

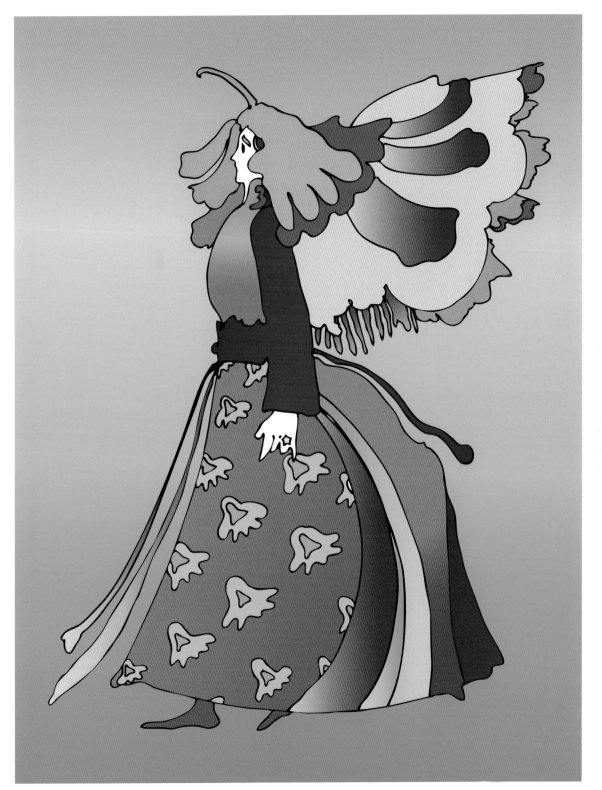

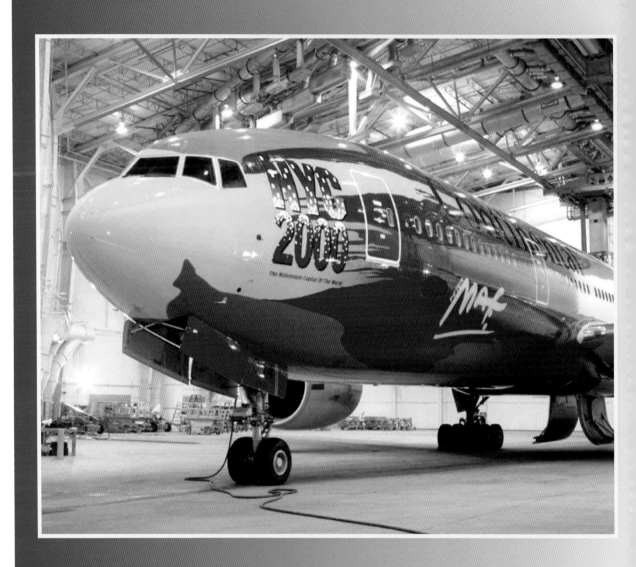

FROM THE 1960S TO THE NEW MILLENNIUM

As a child in Shanghai, my first awareness of America came from seeing rows of comic books and magazines on the carts of street vendors. Their vibrant colors and bold text beckoned to me, leading me toward a land of promise and endless possibility.

LIFE AS ART

I never imagined that one day my own face would appear on the cover of *Life* magazine. But by sharing my creative vision with others and learning from them, I set in motion an unexpected sequence of events. All the planets lined up for me, and I encountered my first taste of true fame as an artist.

In the early 1960s, while I was drawing and painting, I was also very aware of new media, such as posters. I loved posters as an art medium. I was not the first: Other artists such as Picasso and Toulouse-Lautrec had long championed the poster. I was gratified with the idea that my artwork could be accessible to everyone from a college kid to a high-level executive in a boardroom.

My poster work eventually caught the attention of a General Electric executive who loved my art. He was interested in printing some of my graphic work on clocks using a new method of printing on Mylar or plastic and wrapping the graphics around the face of the clock. For me, these clocks were an exciting opportunity to test a new form of art media that deviated from the limitations of a square or rectangular canvas or poster and turned it into a circular piece of functional artwork. The clocks were an enormous success and led to the development of a line of other pop art products.

CHAPTER OPENER "Continental Airplane," 2000, spray paint on airplane exterior. Photo by Joe Derenzo. **OPPOSITE** Max posing with the G.E. clock design, 1969 **FOLLOWING SPREAD** Max poses for *Life* magazine, 1969

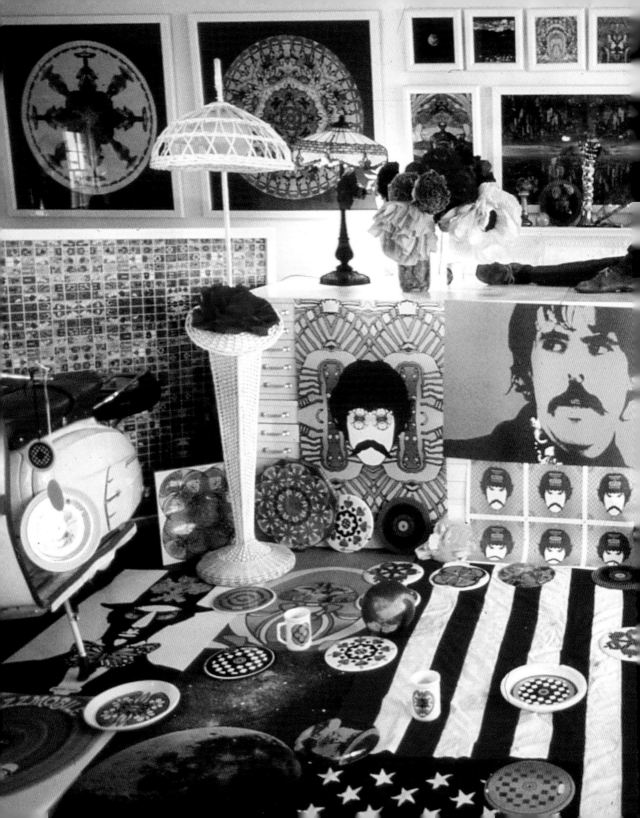

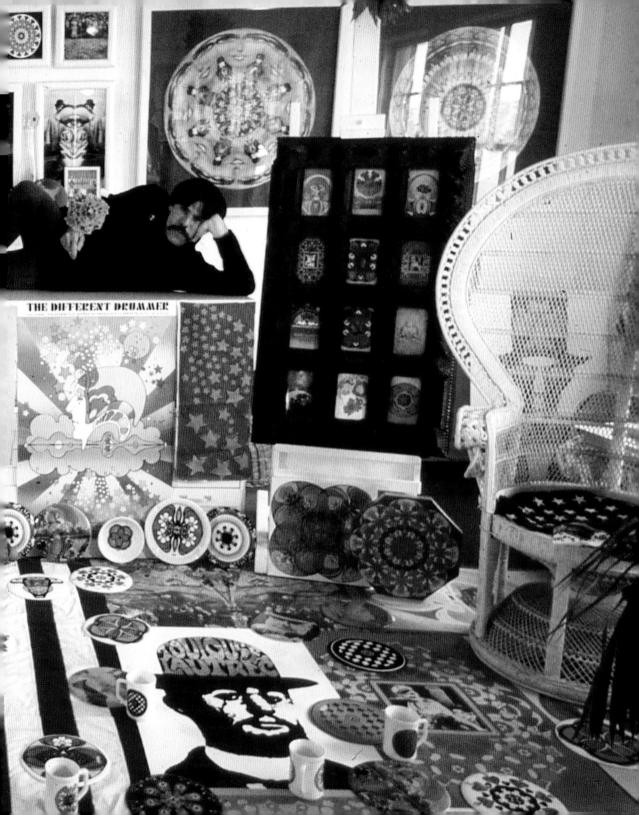

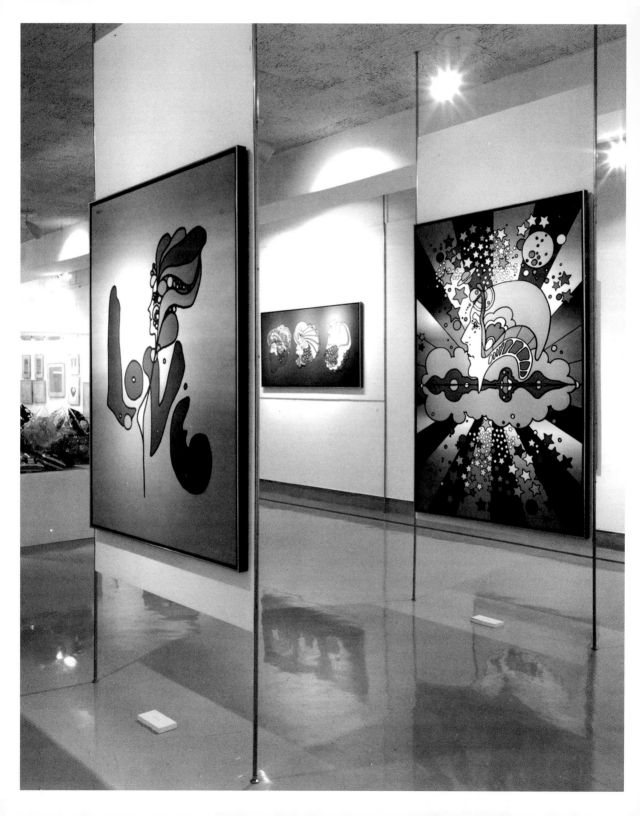

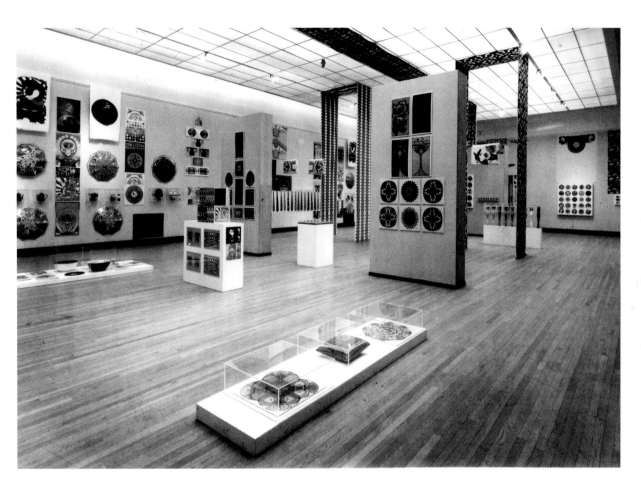

I was a little concerned that the products would distract from my fine art, but at the peak of their success, I was invited to mount a one-man museum show, *The World of Peter Max*, in San Francisco at the de Young Museum. In fact, it was *because* of my pop art products that I was given this exhibition space. Elsa S. Cameron, the curator, devoted a large section within the museum to display my art objects, while several smaller galleries included my original drawings, sketches, paintings, lithographs, and posters.

ABOVE De Young Museum Exhibition: "Gallery Two," 1971
OPPOSITE De Young Museum Exhibition: "Gallery One," 1971

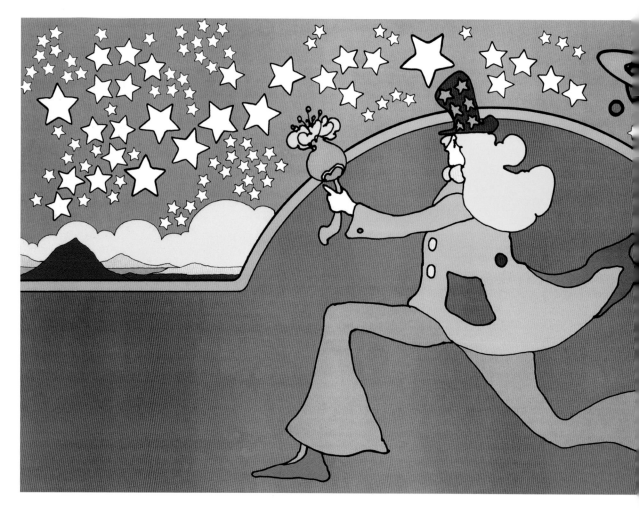

As I continued to draw and paint, and produce new works on canvas for my upcoming gallery and museum exhibitions, I was approached by Metro Transit to create posters using my colors and images to draw attention to the sides of buses and streetcars as an advertising medium in New York, San Francisco, and other large cities. I saw the bus posters as moving art galleries that the general public could see, and agreed to the use of my artwork on public transportation.

Immediately after the Metro Transit posters, an editor from *Life* called. *Life* had done two articles on me before—a full-page and a double-page spread. Now the magazine was looking to do a larger story. A journalist interviewed me, and a photographer took pictures; I didn't give much thought to the meeting. A few weeks passed, and I was walking along Broadway on the Upper West Side of Manhattan with my son, Adam, who was five years old. We passed a newsstand and Adam suddenly shouted, "Daddy! Daddy! That's you!" He pointed to rows of

ABOVE "Smile—Mini Long,"
1969, bus poster, 6 x 21"
BELOW "Star Runner,"
1969, bus poster, 7 x 16.5"

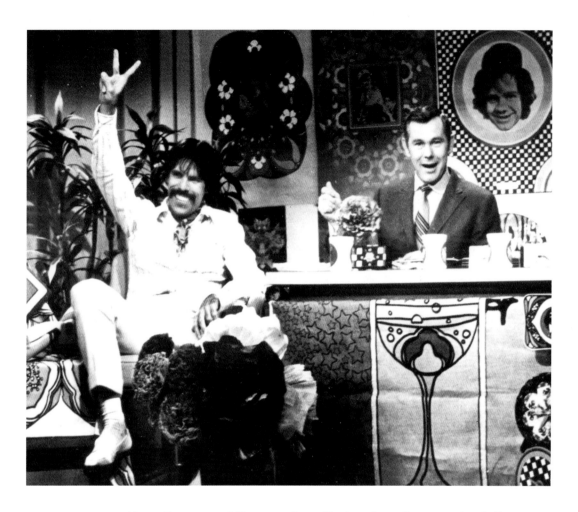

ABOVE Max on *The Johnny Carson Show,* 1969

OPPOSITE *Life* magazine cover, 1969

Life magazines displayed on the newsstand. I was on the front cover. Elated, I quickly felt like I had started something—a snowball rolling down the side of a mountain—that I could not stop, the inevitable avalanche. The cycle felt never-ending. I had not taken a vacation in years; *Life* was overwhelming my life. Once again, I sought retreat, this time taking my family with me to a villa once owned by the great movie star John Wayne in Acapulco, Mexico. It was the perfect place to get some peace and quiet, and to rejuvenate myself and explore new creative possibilities.

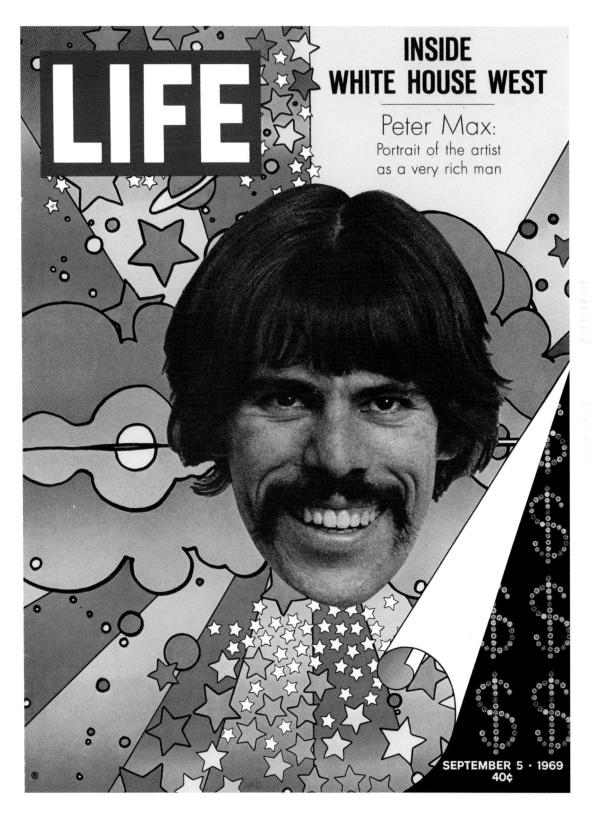

LIFE

INSIDE WHITE HOUSE WEST

Peter Max:
Portrait of the artist
as a very rich man

SEPTEMBER 5 · 1969
40¢

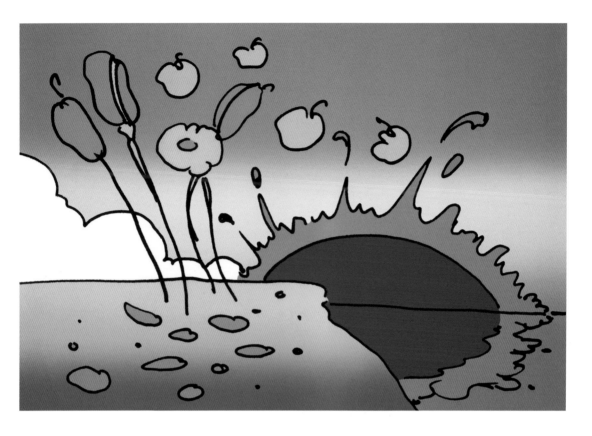

RETREATING INTO A NEW EXPRESSIONISM

The breathtaking vistas of Acapulco awakened vivid images from my early days in Shanghai, Tibet, and Israel, stirring up the expansive feeling that had been the wellspring for my creative energy. I had been so busy managing a studio that I had taken very little time to paint and draw for myself, without any project commitments. Slowly I returned to my core self, and my creativity began to flow, inspiring a series of drawings with a totally different look than my cosmic 1960s style.

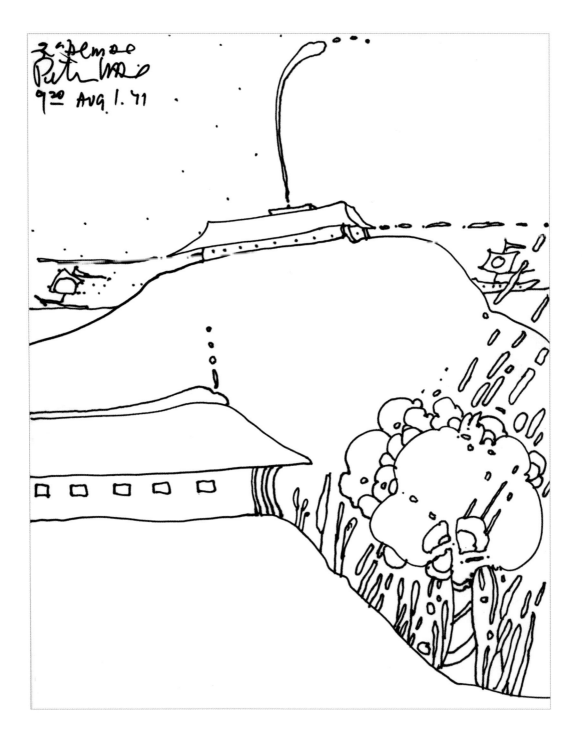

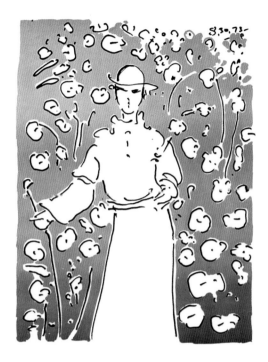

Instead of drawing a solid line—a signature element of my work in the 1960s—I began to minimize my line and break it up so it became more suggestive rather than solid and continual. It was a little more Matisse-like and Picasso-esque, without my trying to make it so. All I knew was that something new was emerging, like a new expressionistic feeling, and it was as inwardly refreshing as the tropical breezes from the Pacific were externally nurturing.

ABOVE *Monk in Garden*, 1974, serigraph, 26 x 31"
LEFT *Jamaica*, 1974, serigraph, 31 x 25"

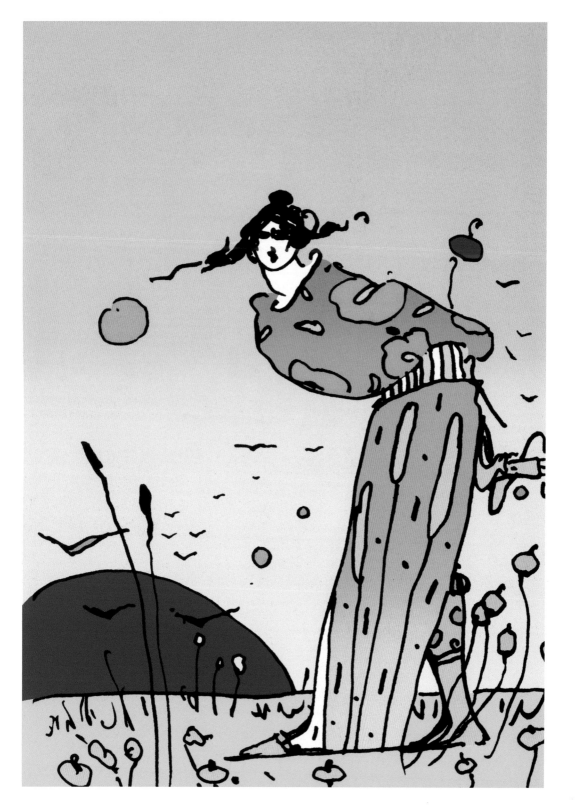

As my new style of drawing emerged, I began to move into abstraction and composition. On occasion, a spare Oriental style or a variation of cubism emerged. As in my earlier days, I took pen and paper with me and drew everywhere I went—while at a café or on a solitary walk or listening to music or meeting with friends. I do not know what other artists go through when they move from one period of their work into another, but for me, when a new wave of inspiration comes along, I tend to follow it. Such was what had happened when I went into my collage period. And then when I met the Swami, I was inspired to create my cosmic art series. On this phase of

ABOVE *The Dancer,* 1982, lithograph, 21 x 30"
OPPOSITE *Spring Day,* 1978, serigraph, 26.75 x 19"

Tibetan Scene, 1979,
lithograph, 21.13 x 28"

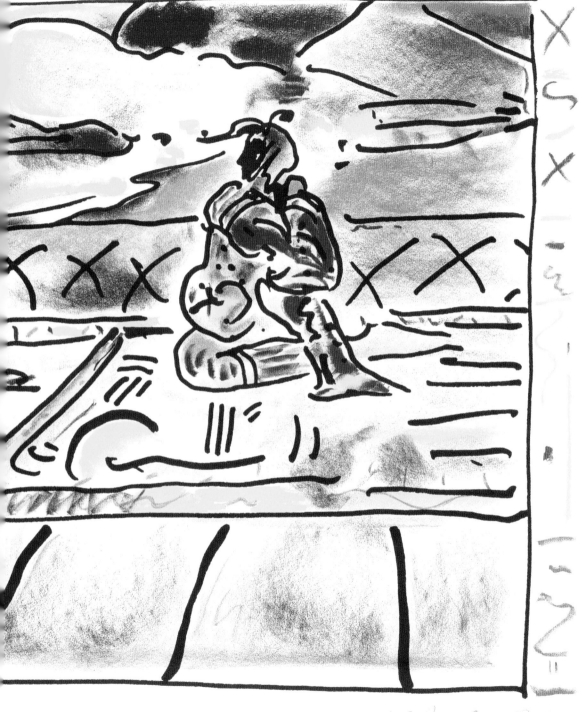

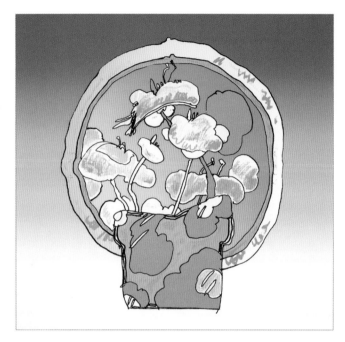

my odyssey, I felt a new wellspring of expressionism aris-
ing. I was compelled to go with it.

Wanting to keep my inspiration flowing when I
returned to New York, I began to wind down my com-
pany. I spent more time with my wife and our two young
children, Adam and Libra, dividing our time between
New York, Fire Island, and Woodstock.

Throughout this transition period, I gravitated to a
whole new expressionistic style, embracing minimalism

ABOVE *Flowers in Circle*,
1979, serigraph, 30 x 23"
RIGHT *The Flower
Garden*, 1981, serigraph,
10 x 14"

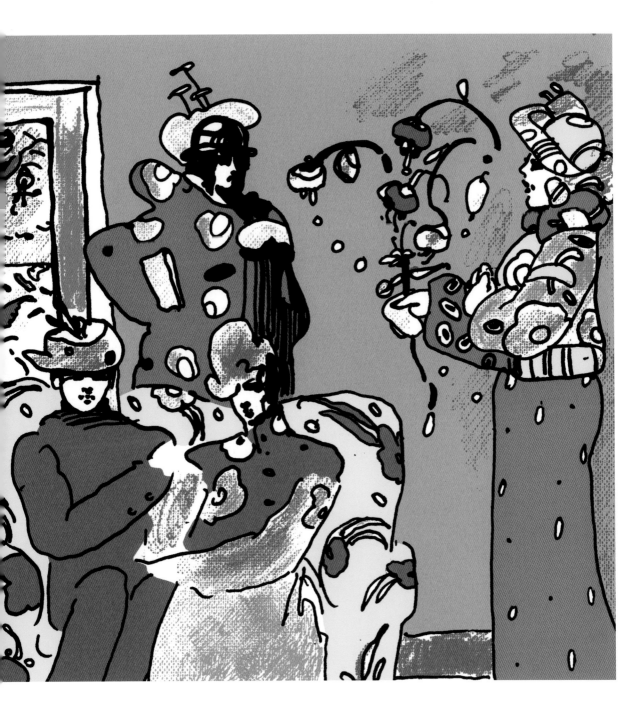

while I continued to create drawings and paintings in my cosmic 1960s style. Then I met a master silk-screen printer and created a new series of limited-edition graphics. The colors and color blends were pure and vivid. I fell in love with the whole art of printmaking and created numerous editions, employing a vast diversity of art styles.

When I started to paint again, I wanted to be as spontaneous as I was in my drawings. In order to free myself up, I ordered sixty canvases at once and lined them up as though they were one large drawing pad. Then I arranged the paints in a way that would make them immediately accessible, so that when the urge to paint arose I was ready to paint in a free, improvisational style. It was like playing jazz on canvas.

I also began working with larger canvases and using large brushes, which required the movement of my whole body. When I had painted in the realist style, I used only the movement of my wrist; now I was using my arm, elbow, and shoulder. Painting became more like a dance, and the movement that was formerly confined to my wrist, hand, and fingertips now involved my whole body. I was reminded of my childhood experience of watching the Buddhist calligraphers paint in Shanghai. The paintings now had a kind of fluidity to them; the colors appeared to move across the canvas.

Abstract Tree, 1996, acrylic on canvas, 10 x 14"

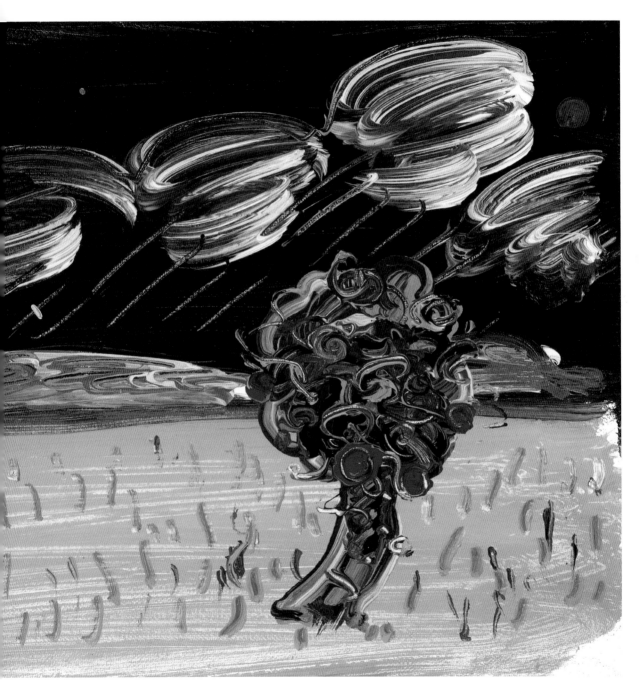

My new method of expressionism was exciting. When painting realism, I had worked with oils; now I was using acrylics. Just as the felt-tipped pen had allowed me to draw smoothly and spontaneously, acrylics allowed me to work with a similar spontaneity. I mixed colors right on the brush and painted them on canvas in bold, impromptu strokes. Acrylics were quick-drying, so they allowed me to move quickly, and I could paint wet-on-wet.

Sometime later during a gallery show of my new paintings in SoHo, I was sitting in a café when the painter Larry Rivers walked in. I had long admired Larry's work. "I just saw your new paintings," he said. I love your wet-on-wet."

I could not have gotten a better compliment.

LEFT *Running Angel,* 1994, acrylic on canvas, 8 x 10"
FOLLOWING PAGES
Ascending Angel,
1994, acrylic on canvas,
36 x 24"; *Zen Boat with
Red Sky and Cloud,* 1990,
acrylic on canvas, 20 x 16"

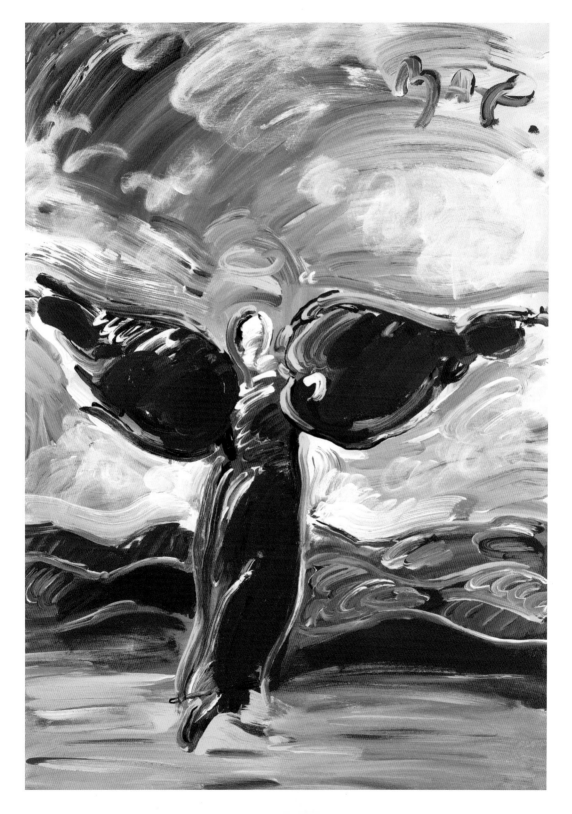

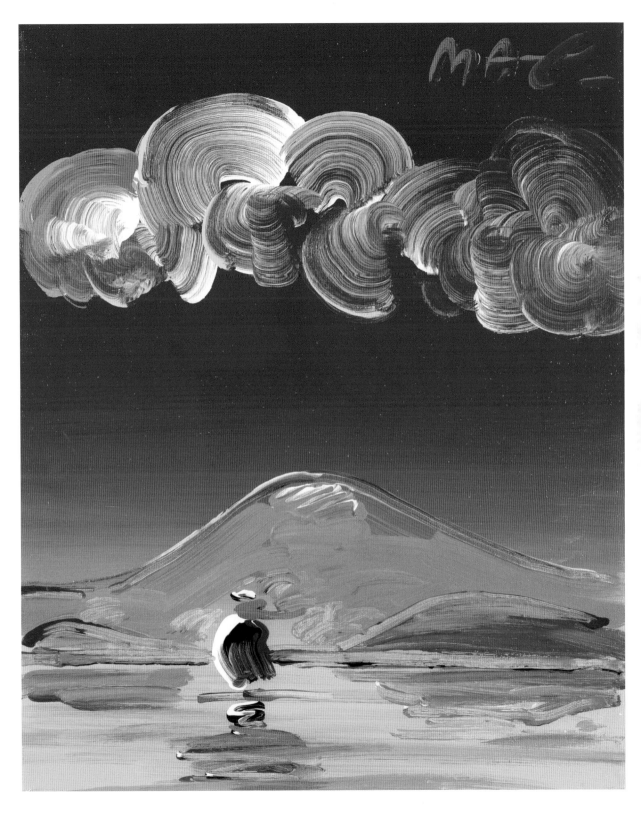

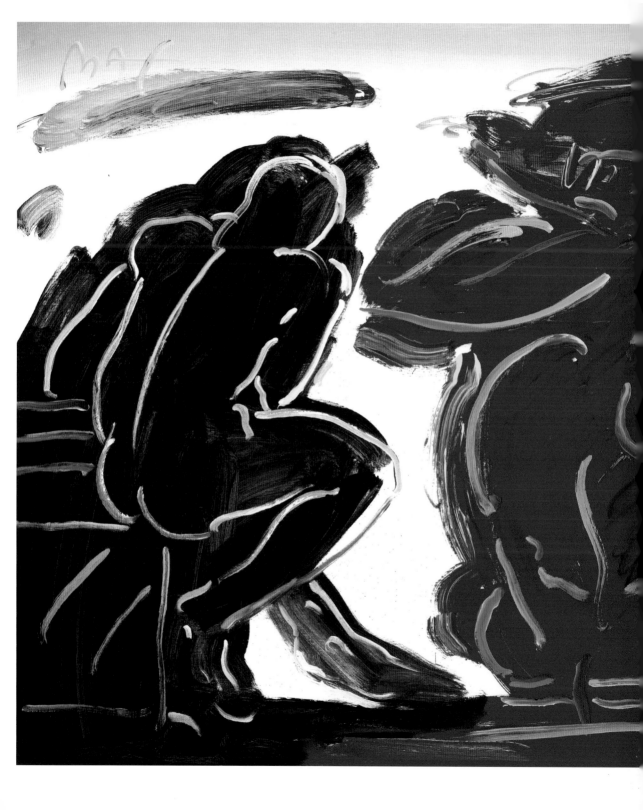

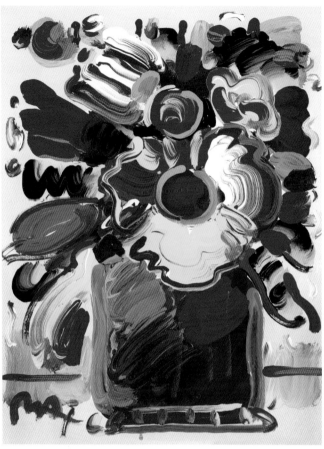

ABOVE *Abstract Vase*,
2007, acrylic on canvas,
20 x 16"
LEFT *Blue Man and Red
Vase*, 1998, acrylic on
canvas, 48 x 60"

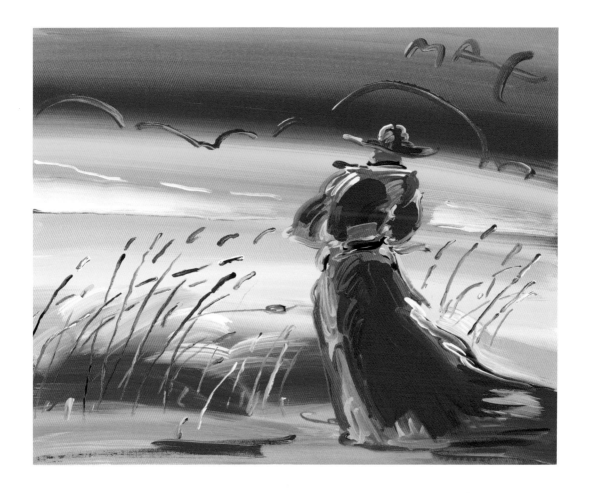

ABOVE *Monk in Reeds,* 1994, acrylic on canvas, 12 x 16"
OPPOSITE *Umbrella Man at Sunset,* 1995, mixed media, 12 x 10"

COSMIC CHARACTERS

As I continued to paint using my new freestyle techniques, I allowed myself the freedom of painting just for the sake of abstraction, composition, and color combinations, when something else began to emerge. Themes and iconic figures developed, much as my cosmic figures did when they mysteriously appeared in my 1960s drawings. I gave my new painted figures names like "Dega Man," "Zero Megalopolis," "Umbrella Man," "Sage with Cane," and "Blushing Beauty."

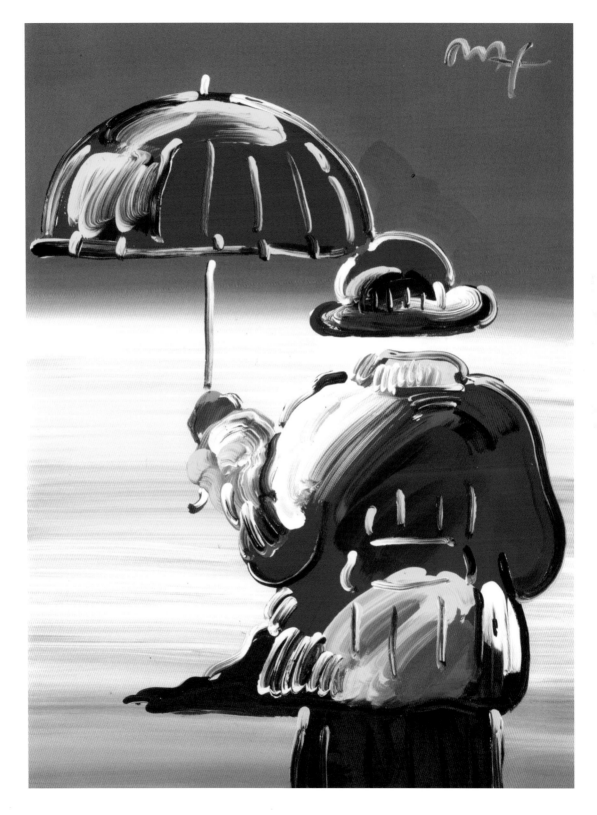

These "characters" are figurative in an abstract way and appear randomly in various color combinations. They emerge after I begin a canvas with a few brushstrokes, with nothing in mind. Over the years, these iconic figures have become constant companions on my canvas. I start painting abstractly and then a character emerges without my planning it. "Oh, it's Zero! How do you do?"

"Lady Profile" has become my favorite signature icon, and I often draw one when signing my books or when dedicating a canvas on the brown paper backing. My lovely wife, Mary, is my main source of inspiration for my lady profiles—her own stunning profile has influenced many of my recent drawings and paintings.

ABOVE "Innocent Lady," 1982, pen and ink on paper, 10 x 8"
RIGHT *Blushing Beauty*, 1994, acrylic on canvas, 36 x 28"

My first wife, Liz, was a former North Carolina beauty queen, and her beautiful looks and sparkling personality have also been a great inspiration to me. And my daughter, Libra, is also a stunningly beautiful woman who got her great profile from her mother, Liz, and from my mother, Salla.

My first inspiration for drawing lady profiles was my girlfriend Rosie Vela. The contours of her brow, nose, lips, chin, and neck were perfect, and it was no surprise to discover that she was a *Vogue* cover girl and a top Ford model. Eileen Ford, the director of the Ford modeling agency, gave me the greatest compliment when she said, "Peter Max not only has an eye for beauty, he also has the mastery to capture a beautiful lady's profile in a minimalistic style that is reminiscent of Matisse and Picasso. Max's profiles are as lovely as my most beautiful models."

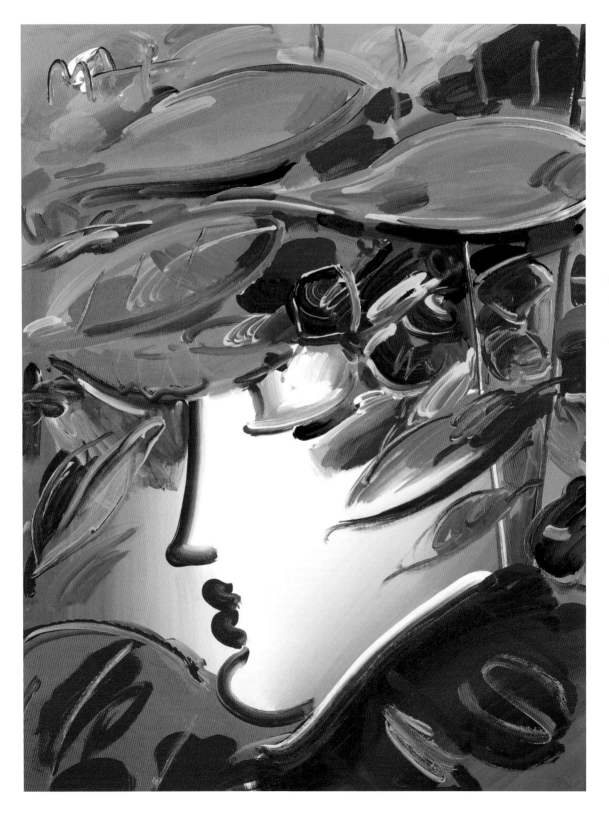

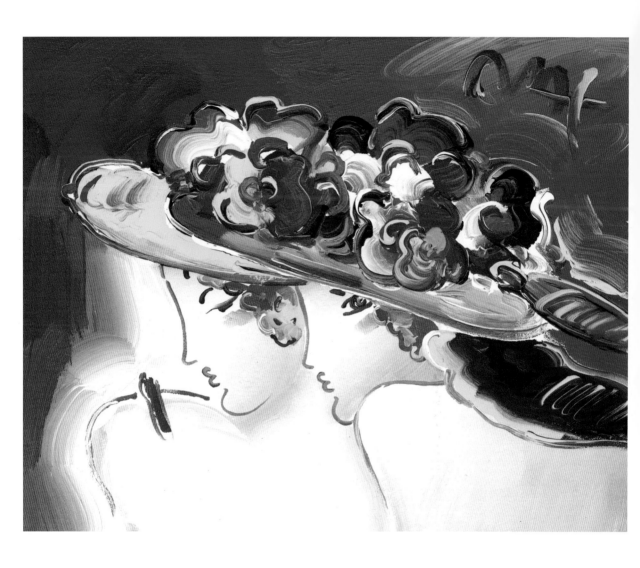

ABOVE *Friends*, 1999,
acrylic on paper, 20 x 24"
RIGHT *Profile on Black*,
2000, acrylic on canvas,
24 x 18"

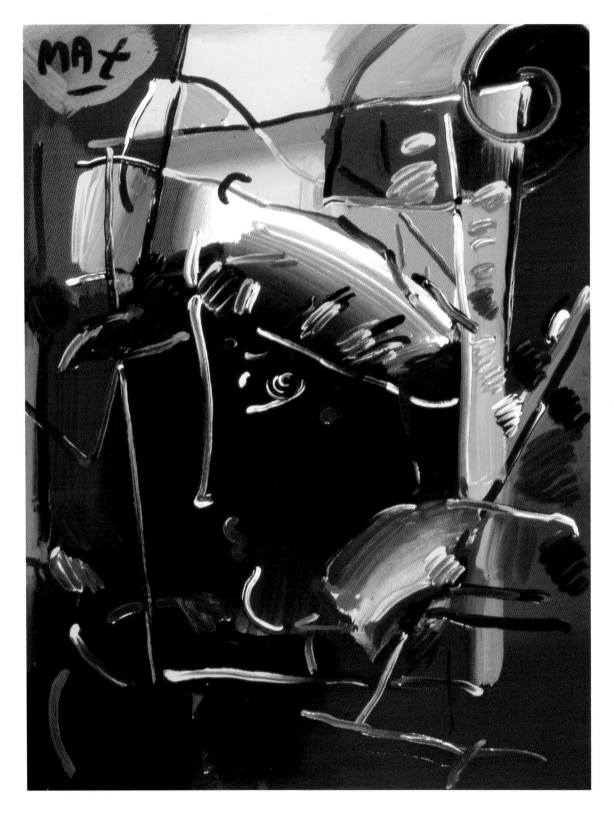

Zen Boats

Peter Max's Zen Boats series expresses the balance of nature: being at one with the water, earth, and air.

Max has been fascinated with boats since his childhood. As a young boy, he watched junks and sampans sail across the port of Shanghai. Later, in the mountains of Western China, he observed long wooden boats gliding effortlessly across pristine mirrorlike lakes.

Whether Max's boats are rendered in his Cosmic 1960s style of drawing, which depended heavily on solid lines, or in pen and watercolor, they are decidedly Eastern in their form. As his drawing style evolved, the lines became broken, the boats rendered in minimalist strokes. Regardless of the style, Max's boats aren't en route toward a physical destination; they are sailing into a state of transcendence, creating rhythmic ripples in rainbow spectrums.

On occasion, Max's Zen Boats are caught in the tempestous forces of nature, and in contrast with his usually placid boats, are painted with fierce brushstrokes using an intense Fauve palette, with angry reds and crimsons. Such works are aptly titled *Stormy Sail*.

The art of sailing is akin to the ancient Chinese Taoist philosophy Wu Wei ("the watercourse way")—flowing with the course of nature. Max approaches much of his own life in the same manner. When he approaches the canvas, he does so with spontaneity, allowing the

BELOW *Zen Boat & Sun*, 1997, mixed media, 6.25 x 9"
OPPOSITE *Zen Boat & Heart*, 1988, mixed media, 5 x 7"

brush or pen to flow into the moment, uninhibited by the constraints of preconception. Only as he begins to work does he see the form, the line behind his movements. Only then does he permit the absence of line to share the wealth of the space.

TOP *Profile with Red Bows*, 1996, mixed media, 12 x 12"
BOTTOM *Profile Pastel*, 1998, mixed media, 10 x 12"
RIGHT *Daydream*, 1996, lithograph, 30 x 40.25"

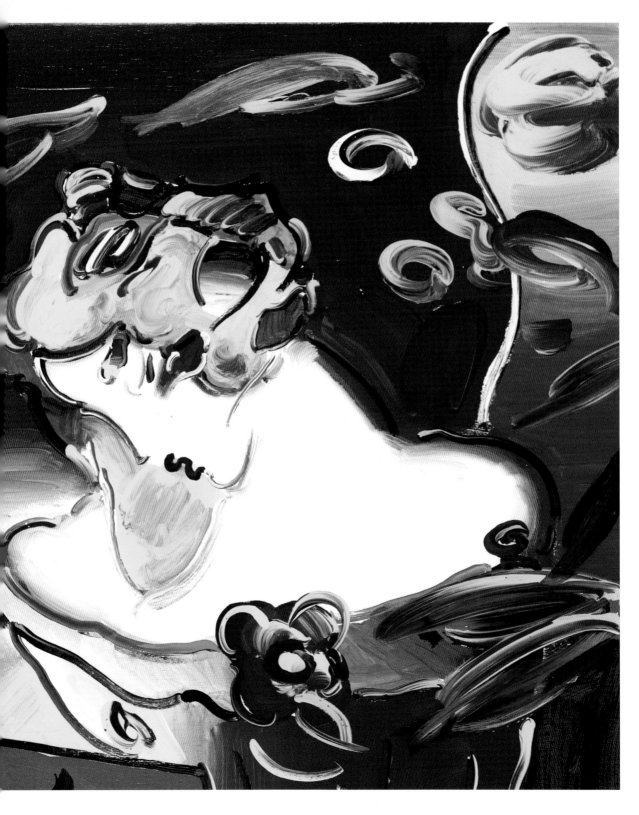

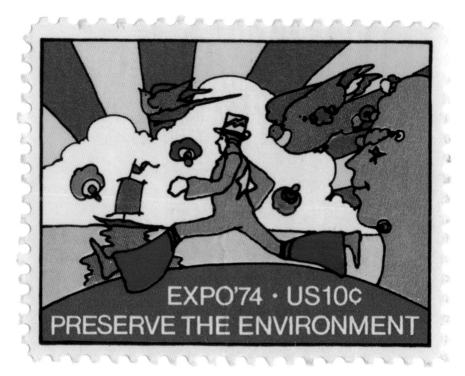

THE FIRST TEN-CENT U.S. POSTAGE STAMP

ABOVE Expo '74 U.S. Postage Stamp, 1974

OPPOSITE, ABOVE Expo '74 First Day Issue–"Lady Profile with Angel," 1986, mixed media on envelope, 4.1875 x 9"

OPPOSITE, BELOW Expo '74 First Day Issue–"Lady in Repose," mixed media on envelope, 4.1875 x 9"

In 1974, the U.S. Postal Service approached me to create the art for the first ten-cent postage stamp. I could not refuse this honor. The new denomination of U.S. stamp was meant to celebrate the environmental movement, and I was selected to create it because of the artwork and posters I had done to support events such as Earth Day. The stamp commemorated Expo '74—the first environmentally themed world's fair in Spokane, Washington—with the theme "Preserve the Environment."

The postage stamp was like a new canvas for me; a new way to bring my artwork to the public. When the stamp was released, I also received "first day of issue" envelopes. Using them as drawing paper, I created a new series of mixed-media works with pens, watercolors, and colored pencils.

"PETER MAX PAINTS AMERICA"
AND A GALAXY FAR, FAR AWAY

In the spring of 1976, ASEA, the energy corporation of Sweden, commissioned me to create a limited-edition book on behalf of Sweden to commemorate the United States Bicentennial. The book, *Peter Max Paints America*, was published by Acropolis Books in Washington, D.C.

I painted fifty images of the fifty states, and applied my techniques of collage and mixed media to create the whimsical artwork. I let my associations of each state's unique character dictate the images. For example, for the entry on Utah, I cut out a photo of the Mormon Tabernacle Choir and inserted it among the spires of Bryce Canyon. The double meaning in the caption reads: "The choir in spires." For New York, I used my longtime favorite icon—the Empire State Building—and employed my "kaleidoscopic postcard technique" by repeating multiple images of the Empire State Building butted up against a mirror image. The repeated images of the building and the sky created a pattern of electric energy.

I painted brushstrokes over black-and-white archival photos, and in other cases I applied colored dyes with cotton—a technique used by colorists to convert black-and-white images to color on early postcards. For the cover of the book, I did an overpainting on Gilbert Stuart's famous unfinished Athenaeum portrait of George Washington, which was the basis for the image of Washington that appears on the one-dollar bill.

At the United States Bicentennial celebration on July 4, 1976, King Carl XVI Gustaf of Sweden presented *Peter Max Paints America* to President Gerald Ford and incoming president Jimmy Carter at the White House. Little did I imagine as a little boy growing up in China, and falling in love with American movies, jazz, and comic books, that I would one day be standing in

RIGHT "Peter Max Paints America," 1976, book jacket, 11 x 8.5"

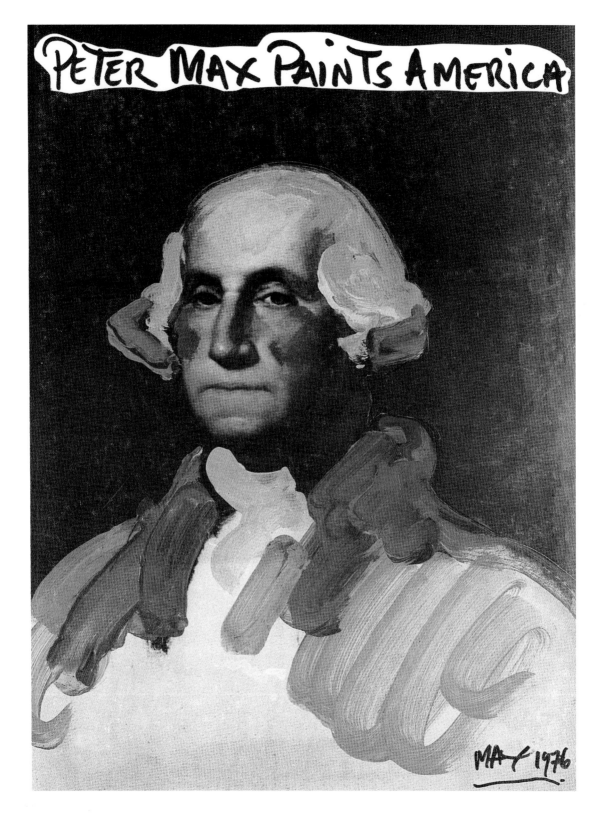

PETER MAX PAINTS AMERICA

MAX 1976

the White House where a book of my own art was being presented to two presidents of the United States.

Upon meeting with the King of Sweden at the White House, I invited him to visit my studio. Though he was unable to come to New York at the time, he said he would do me the honor at a later date. The next spring I received a call from the king's office informing me that he was going to be in New York City on May 25. It was 1977.

We arranged to have a reception at 2 p.m., and my staff members and caterers began planning for the event. When the day arrived I was excited for a very different reason: *Star Wars* was debuting at the Loews Eighty-sixth Street movie theater at noon. I wanted to see the film because of my fervent interest in all things related to space but was unsure if I would be able to return in time to greet the king. Nevertheless, I risked it, and had my driver wait for me, so I could rush back after the show.

When I arrived at the theater, there was a long line of people circling the block with folding chairs and sleeping bags—the movie already had rabid fans! I quickly ran into a phone booth across the street and called the theater, asking to speak to the manager. When he picked up the phone I said, "Hi, I'm the artist Peter Max. I just arrived at your theater and saw the big line. Is there a possibility you could give me a seat?" Fortunately, he was a fan of my work and agreed.

Seconds after I hung up the phone, a man in a tuxedo emerged from the theater looking for me. I walked over to him, gave him my business card, and invited him to my studio. He then ushered me into the theater and directed me to a reserved seat.

As soon as the end credits rolled, I rushed back to the studio. The king was already there with two aides. I apologized for being late and told him that I just could not bear to miss the premiere of *Star Wars*.

"*Star Wars?*" asked the king. "What is *Star Wars?*"

OPPOSITE "Outer Space," 1967, poster, 36 x 23"

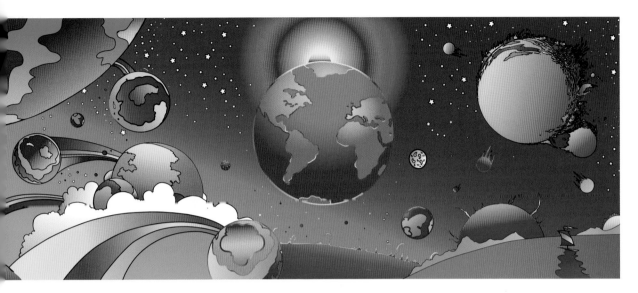

When I told him about the movie, he was very interested, since he had been in the Swedish Air Force and also loved to race Porsches, Ferraris, and other fast cars. The movie sounded like fun to him.

I called the manager of the movie theater again and said, "Hi, it's Peter Max again. I'm with the king of Sweden and two of his aides. Can you save us four seats for the next show?" The manager was thrilled and anxiously awaited our arrival. So after giving the king a quick tour of the studio, we rushed over to the theater, where the manager escorted us to our seats. As soon as we were settled, I excused myself and quickly returned with four bags of popcorn just in time for the opening prologue: "A long time ago in a galaxy far, far away. . . ."

The king was completely astounded by the movie and loved it as much as I did. In fact, he actually gave me a thumbs-up and a high-five several times during the show. Shortly after the visit, I received a letter from him, thanking me for receiving him at my art studio and taking him to see *Star Wars*.

ABOVE *Space Mural #2,* 2010, mixed media, 17 x 84"
OPPOSITE *Flying Saucers and Two Suns,* 2006, mixed media, 10 x 12"

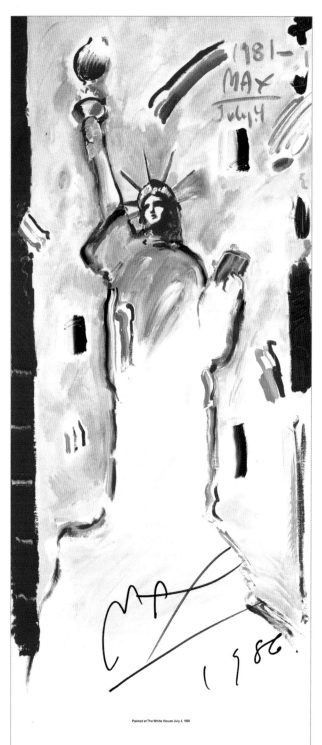

Painted at The White House July 4, 1981

THE CORCORAN GALLERY OF ART
WASHINGTON, D.C.

POSTER REPRODUCTION MADE POSSIBLE BY A GRANT FROM GHTA GENERAL CORPORATION

"Statue of Liberty #3,"
1981, poster, 25.5 x 12.5"

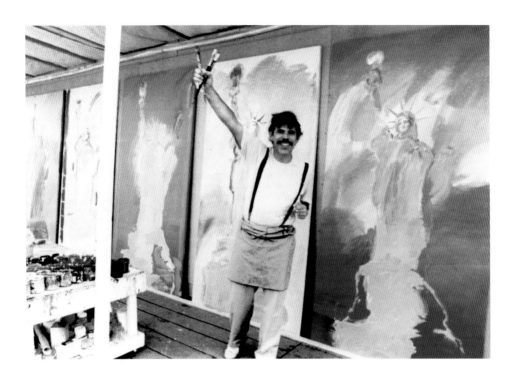

PAINTING LADY LIBERTY

To celebrate the Bicentennial, on July 4, 1976, I painted my first portrait of the Statue of Liberty on Independence Day. It became an annual tradition, and each year since I have painted her in an increasing number: in 1977, I painted two portraits; in 1978, three; and so on. In 1981, I was delighted when Nancy Reagan invited me to paint six portraits of the Statue of Liberty at the White House for that upcoming July Fourth. It was Ronald Reagan's first year in office and it was the sixth year of my Liberty painting tradition; she said they would be honored if I would paint for them.

For this momentous occasion, I brought six eight-foot-high canvases. We set up a painting pavilion on the White House lawn. A raised platform held my paints and

TOP Peter Max at the White House, 1981
BOTTOM *White House*, 1997, acrylic on canvas, 13 x 18"

easel and was, in essence, a gigantic stage. The president's guests—my "audience"—sat in folding chairs ten rows deep to watch me paint.

While I painted, the guests stood up one by one and moved closer to watch me work. When I turned around, I noticed the familiar famous faces: Clint Eastwood, Burt Reynolds, Jane Fonda, Robert Redford, and many others. (After all, Reagan was the "Hollywood President.")

As I completed painting the sixth Liberty portrait, President Reagan joined me onstage and, gesturing to the jar of brushes, said, "May I?" I nodded, and he picked up one of the brushes, dipped it in paint, and applied a small stroke onto the painting.

■ ■ ■

A few days after I returned from Washington, D.C., a man named Bob Grace appeared at my door. He admired my Liberty paintings, and asked me whether I was aware of the deplorable condition into which the Statue had fallen. He showed me photos of the crumbling, cracked monument and the statue's rusted interior. Grace assumed that I had a direct line to the White House and wondered if I could call the president and ask that the statue be restored, but frankly I didn't feel comfortable asking the Reagans for government funding.

A few days later, coincidentally, I received a thank-you call from Mrs. Reagan. She told me that the President had been thrilled to apply the last brushstroke to my sixth Liberty painting. She jokingly added that he was setting up an easel and painting area in the White House. I was overjoyed to be called personally by the First Lady, and although I was somewhat hesitant, I brought up the issue of restoration for the Statue of Liberty. Mrs. Reagan complimented me on my patriotic concerns, but regrettably informed me that the White House would not be able to fund such a venture and that

financial support would have to come from the private sector—corporate funding.

After our conversation, my mind raced: Which corporation might have the funds, the interest, and the prominence to begin a Statue of Liberty renovation project? I called a friend of mine in advertising and he recommended that I contact Kenyon & Eckhardt, the agency that had the Air France account. Since it was France that had given the Statue of Liberty to the United States, perhaps Air France might be interested. Well, it just so happened that I knew the president of Kenyon & Eckhardt: Leo-Arthur Kelmenson. I reached out to him and explained that I had a great idea for one of his clients. Kelmenson invited me to his office.

When I got to the agency, I realized that the photos I had brought of the Statue of Liberty in disrepair weren't very pleasant to look at. I realized that I should have created a more positive presentation of the Statue of Liberty restoration project. While sitting in the reception area, I grabbed a felt-tip pen and a paper napkin, and quickly sketched the Statue of Liberty surrounded by scaffolding. I stuck the napkin in my pocket. I had no intention of showing the hastily done sketch.

Mr. Kelmenson called me into his office, and we reminisced about our meetings at the Central Park Zoo café and other places during my days at the Art Students League. He had been a young advertising guy then, and we both had black portfolios. His was a small black leather one; mine was huge and filled with paintings.

As we were speaking, a call came through and Kelmenson excused himself to take it. I could hear from his conversation that he was having a difficult time. When he hung up the phone, he wiped his brow with a clean white hankie and said, "That was Lee Iacocca, chairman of the Chrysler Corporation. He's happy with our advertising campaign but very upset that we can't get him a

"Liberty Sketch on Napkin," 1982, pen and ink on napkin, 6.25 x 5.75"

better PR project than speaking at a boys' club in Detroit, Michigan.

Then he sighed and asked, "So, Peter, what did you have in mind?"

At a loss for words, I sheepishly pulled out the paper napkin from my pocket and held it up to him. As he looked at the sketch, I said, "The Statue of Liberty renovation. I thought it could be a good fit for Air France."

His eyes widened, and he immediately pressed the intercom on his phone and called the account manager for Chrysler, not Air France. "Bill, come in here. I've got something for Lee!"

THE STATUE OF LIBERTY RENOVATION

Kelmenson told Iacocca about the Statue of Liberty renovation project, and soon the restoration efforts were under way. Afterward, I thanked Mrs. Reagan for her advice, telling her that I had found someone from the private sector to help restore the Statue of Liberty—Lee Iacocca. She was thrilled.

OPPOSITE *Liberty Head,* 1994, acrylic and silkscreen on canvas, 36 x 36"

FOLLOWING PAGES *Liberty Head,* 2003, acrylic and silkscreen on canvas, 12 x 12"; *Liberty Head,* 2004, acrylic and silkscreen on canvas, 12 x 12"

In May 1982, President Reagan appointed Lee Iacocca to head the Statue of Liberty–Ellis Island Foundation, which was created to raise funds for the renovation and preservation of the Statue of Liberty. Iacocca and the Foundation raised the money, and I stayed deeply involved.

After four years of work and planning, July 3–6, 1986, was designated Liberty Weekend, marking the centennial of the statue and its reopening. President Reagan presided over the rededication on Governor's Island, with French President François Mitterrand, Lee Iacocca, and many other notable people in attendance. I was proud to be among them, as a guest of honor.

Once again, we set up a painting area for me to work in. I brought eleven large canvases to paint

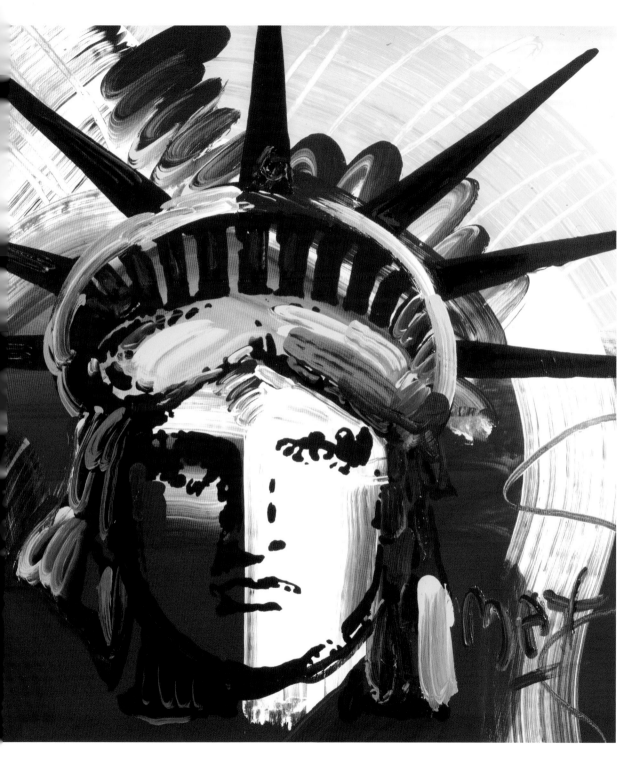

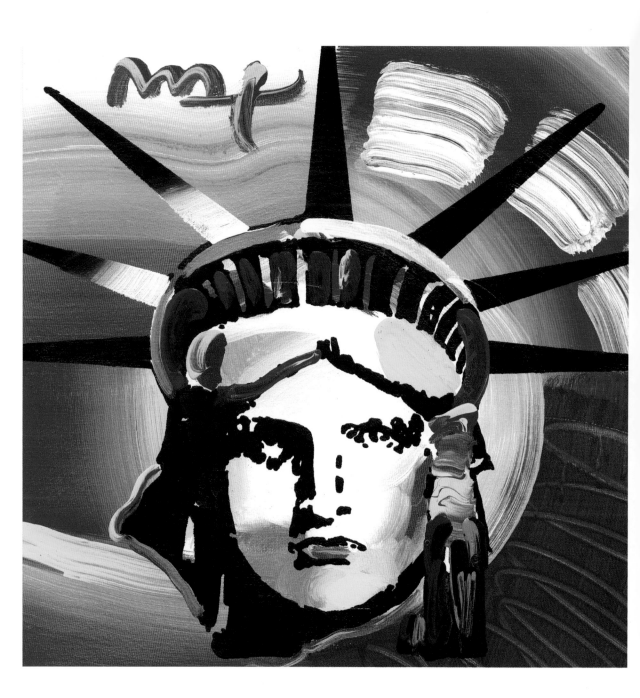

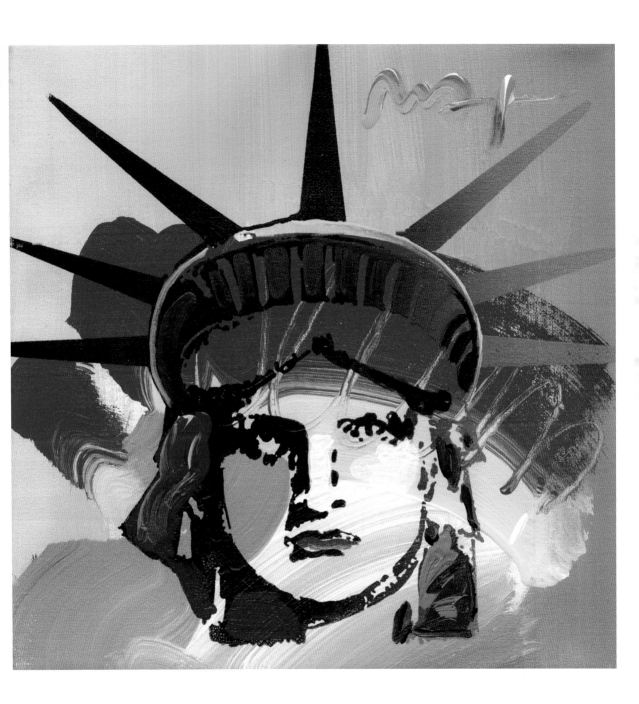

portraits of the Statue of Liberty's head; it had been that many years since I had done the first portrait. As the statue was unveiled, fireworks exploded in the sky. The bold flashes of color inspired me to paint the portraits in a whole new color palette akin to the Fauvist techniques of my earlier studies. The next day, when reading the media's coverage of the event, I was so pleased when a reporter recognized the source of my inspiration and labeled my new paintings "Neo Fauve."

DISCOVERING A NEW ART MEDIUM: THE FAX MACHINE

The Liberty Weekend event marked a turning point in my career. I had a few gallery shows where I presented my new "Neo Fauve" works. Soon thereafter I moved into a large art studio near Lincoln Center. When I first moved into the top floor of my new studio, it was a large 25,000-square-foot empty shell with skylights. We set up an office with a couple of fax machines in one corner of the studio and a large painting atelier in another.

The fax machines were the first of a new breed—small enough to fit on a desktop—and I was fascinated by the technology. It was a whole new way that I could send a copy of a drawing or receive a copy of a contract without having to wait for the postal service.

Fax machines were already in use by legal, financial, and business firms, but I saw them as a new art medium. To test my idea, I did a drawing of a lady profile and sent it to a friend in Washington, D.C., for his wife's birthday. Minutes later, I got a fax back: "Thanks, Peter. I love it. Now I don't have to buy her a gift!"

It was June, and I was thinking of what to do differently for my annual Statue of Liberty painting tradition. I created a fax form titled "Max Fax America," with a request to fax back a response to the question: "What

makes America great?" The replies could be anything—a statement, poem, quote, or a drawing—that the recipient liked. For as many faxes that I sent, I received just as many responses from a wide variety of people: Paul Simon, John Denver, Nancy Reagan, New York City Mayor Ed Koch, Senator Ted Kennedy, Senator Jack Warner, Senator David Pryor, New York Governor Mario Cuomo, Kenneth Cole, Jim Henson, Charles Schulz, Jim Davis, and Mel Brooks, to name a few.

As I collected the faxes, I noticed that the fax machine printed on a large eight-and-a-half-foot-wide by eighty-five-foot-long thermal paper drum, and I would have to tear off the sheet on the machine's cutting edge when the printing was completed; it was not like today's single sheets. I wondered: *Would it be possible to tape eighty-five single-sheet faxes together into one long eighty-five-foot sheet and send it through a fax and have it come out as one single eighty-five-foot-long sheet of paper?*

I experimented by carefully taping together about ten drawings on eight-and-a-half-by-eleven-inch paper and sent it from one fax machine to the other. After a few paper snags and corrections, it worked. On the other end, we got one ten-foot-long sheet.

Once accomplished, my next idea was to take my favorite eighty-five responses, tape them together, and send them as one long fax to the White House on the Fourth of July. The White House agreed, and we set up some preliminary tests. As the big day approached, I had the idea to hire a yacht on the Hudson

Max poses with his faxed message, 1987

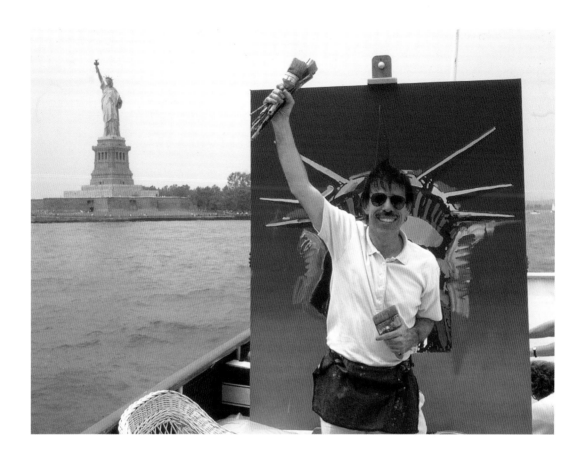

ABOVE Max in front of the Statue of Liberty, 1987
OPPOSITE, ABOVE Max posing with the Moscow Peace Festival sign, 1989
OPPOSITE, BELOW The Moscow Music Festival stage, 1989

River and send the giant fax from aboard the yacht while cruising in front of the Statue of Liberty. Since mobile phone service was still in its first generation, it took some doing to make sure we could fax from aboard the yacht, but thanks to Sprint, we were able to make it work. So on July 4, 1987, an eighty-five-foot-long roll of statements, poems, and drawings about what makes America great was faxed to the White House from a boat circling the Statue of Liberty. Afterward, I did another portrait of the Statue of Liberty while cruising in front of the actual statue.

TO RUSSIA, WITH LOVE

As the 1980s gave way to the 1990s, my most revered ideals of peace and liberty were spreading around the world in dramatic, unexpected ways. In the spring of 1989, a music producer and a PR person for Bon Jovi and other rock bands asked if I would accept a commission to create a Peter Max stage for the Moscow Music Peace Festival.

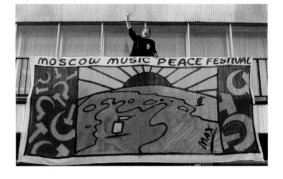

The concert was to celebrate the twentieth anniversary of Woodstock, while also promoting world peace and establishing international cooperation between the United States and Russia. It was an era of momentous change in the Soviet Union and its move toward democracy and capitalism, so I immediately accepted the invitation. When I received the dimensions and specifications, I learned that this was to be the largest rock 'n' roll stage ever created, so I enthusiastically got to work.

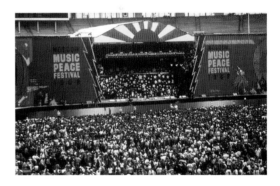

I was thrilled to be part of this great rock-music event, and attended with Bon Jovi, Mötley Crüe, Aerosmith, Ozzy Osbourne, Cinderella, Skid Row, and the Scorpions. The young Soviets loved heavy metal bands, and the show provided a great bonding between cultures. I loved meeting young Russian people, and it was awesome to see hundreds of thousands of them—dancing and rocking out to the music in front of the giant stage.

The Moscow Music Peace Festival was made possible by the efforts of Mikhail Gorbachev through his policy of perestroika, and after returning to New York I wanted to pay tribute to this great leader by painting his portrait. At first I was going to paint four portraits and name them "Four Gorbys," but somehow and for some

reason this did not sound right. I thought, *What rhymes with Gorby?* Not much. The closest I came to a word that resonated with "Gorby" was "forty." Hence I titled my installation of forty portraits of Gorbachev *Forty Gorbys*.

In October 1989, I unveiled the installation to Premier Gorbachev and his wife, Raisa, at their suite at the Waldorf Astoria. He was so surprised by the installation that he did an impromptu *kazachok,* the Russian folk dance, his arms folded and his legs kicking out from a series of squats. It was a moment I will never forget. Raisa blushed and I laughed out loud, as did Gorbachev.

BEYOND BOUNDARIES

In 1990, the Hubble Space Telescope was carried into orbit by a space shuttle, expanding our vision and imagination, and allowing us to see deeper into space and time than we ever had before. As an avid enthusiast of astronomy, I was excited by this great new technological achievement; it opened my mind to new possibilities of our expanding universe.

As our universe was expanding, so was my global reach as an artist. In February 1990, I was selected to receive a seven-thousand-pound section of the Berlin Wall, which was installed in the Intrepid Sea, Air & Space Museum in New York City. Using a hammer and a chisel, I carved out a dove of peace from within the stone—freeing it, so to speak—and placed it on top of the wall. It was an ironic placement—a dove of peace on a warship—but the installation dramatized the end of the Cold War. I was soon recognized as a kind of cultural ambassador for a new age of warming relations between the United States and Russia.

In June 1990, I was approached by a delegation of officials from Russia, on behalf of Mikhail Gorbachev,

OPPOSITE *Gorby in Red,* 1989, acrylic and silk-screen on canvas, 12 x 12"
FOLLOWING SPREAD Max presents *40 Gorbys* installation to Mikhail Gorbachev

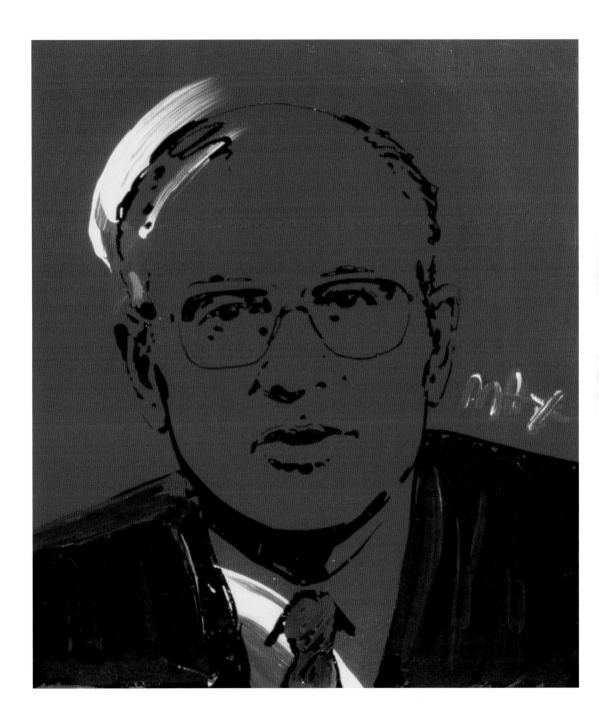

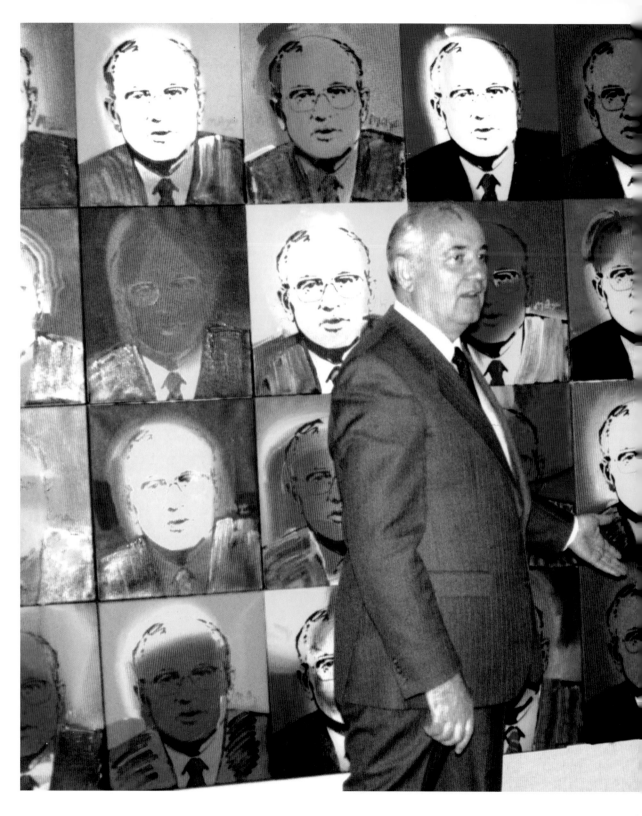

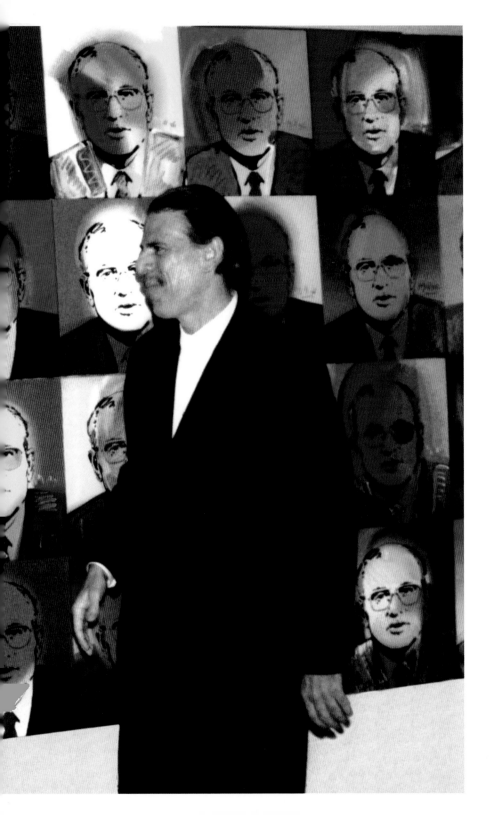

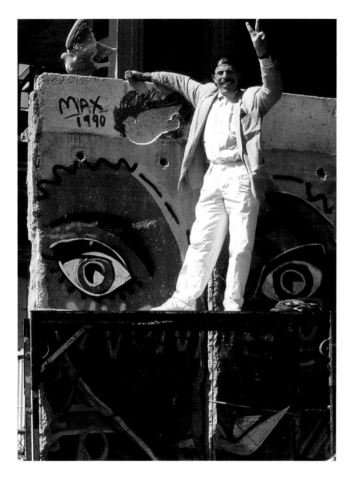

ABOVE Max chiseling the dove from the Berlin Wall, 1990
OPPOSITE "Flag with Heart Leningrad," 1991, poster, 36 x 24"

who proposed a Peter Max retrospective exhibition to tour Moscow and St. Petersburg (then called Leningrad). The exhibition was presented by the State Hermitage Museum, one of the oldest, largest, and most prestigious museums in the world. It opened at the Hermitage Central Exhibition Hall in May 1991, and almost fifteen thousand Russians attended the exhibition on opening night, making it one of the largest turnouts for an art exhibit in Russian history.

My greatest thrill was that as I entered the museum, I was greeted by thousands of young Russians dressed as American hippies. They were holding up their hands, making a V peace sign with their fingers, and chanting, "Peace . . . peace . . . peace," as I walked by. I was so moved by it that my eyes welled up with tears.

The Hermitage exhibition included more than three hundred original works of art: paintings, drawings, and lithographs, including some of the most famous images I had created during the 1960s. The show had another purpose in addition to art: It re-created America's cultural experience during the legendary era of the 1960s and helped to usher in the period of glasnost and perestroika.

ЦЕНТР СТАСА НАМИНА, ФИРМА «СТАНБЕТ» ПРЕДСТАВЛЯЮТ

PETER MAX

ТУРНЕ ПО МУЗЕЯМ ВОСТОЧНОЙ ЕВРОПЫ

EASTERN EUROPE MUSEUM TOUR

1 9 9 1

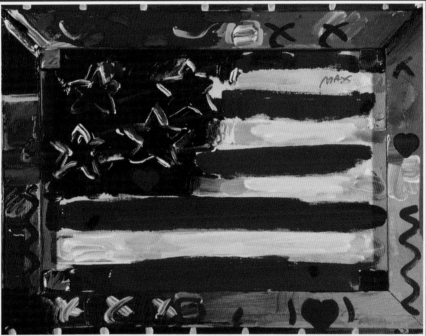

L E N I N G R A D

ЛЕНИНГРАД

Государственный Эрмитаж
Центральный Выставочный Зал

24 мая – 21 июня 1991 г.
10.00 – 17.00

STANBET

В сотрудничестве с Хэнсон Гэлериз

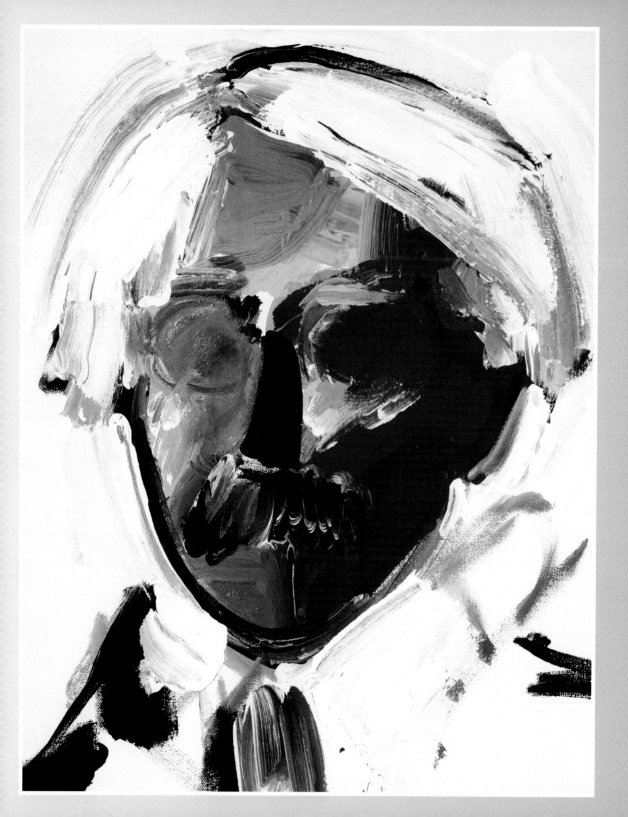

Andy with a Mustache

It was 1989 and Peter Max was, in his usual weekend tradition, having brunch at the Regency Hotel. As he prepared to leave, he spotted a mop of white hair—a blur, really—crossing Park Avenue. Max recognized that signature white blur—Andy Warhol.

"Hey, Andy," Max shouted.

Andy turned around. "Oh, I love your white suit. Where are you going?"

"Kaleidoscope," Max said.

"More cookie jars?"

"Thought I'd beat you to it."

"Not on your life," said Warhol. "I'm coming with you."

They shared a taxi, directing the driver to Horatio Street. As they entered the shop, Max said, "I picked first the last time. It's your turn today, Andy."

"Gee whiz, Peter, it's so nice you remembered," said Andy. "Of course, I would have reminded you if you didn't." He quickly grabbed a large ceramic cookie jar in the shape of Woody Woodpecker. "This one is great. Your turn."

Max picked a jar in the shape of a French chef, complete with hat. Warhol picked a yellow duckling. Peter picked Popeye; Andy, a Dutch milkmaid; Peter, Howdy Doody, and so on. They each left with two huge shopping bags.

Inside his cab, Max arranged his treasures on the floor. The cabdriver watched him intently and finally burst out, "You're that famous artist—Andy Warhol!"

Max explained, "No, I'm the other one. I'm Andy with a mustache."

The driver laughed. "Oh, yeah. Peter Max," he corrected himself.

That night, Max painted a portrait of Andy, complete with his shock of white hair . . . and Max's own mustache. Max titled the piece "Andy with Mustache."

Then he unpacked his new cookie jars and added them to his collection, which to this day lines the high beams of his studio.

OPPOSITE *"Andy with Mustache,"* 1989, poster (detail), 39 x 25"

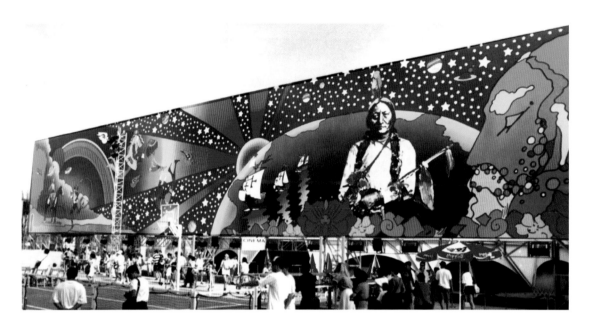

ABOVE The World's Fair mural, 1992

OPPOSITE "Make Every Day Earthday," 1992, poster, 27.5 x 24"

FROM LARGE-SCALE TO SMALL-SCALE ART

Early in 1992, I received a call from a Washington committee responsible for creating the U.S. pavilion at the upcoming World's Fair in Seville, Spain. Nancy Reagan had recommended that they contact me for my creative ideas on how to make the pavilion more attractive, perhaps by painting a mural on the side of the building. Undertaking such a job seemed highly impractical and time-consuming, especially when my Pop to Patriotism museum tour was opening. I also had exhibits at many new galleries. I began to think of other options, as I did not want to disappoint the First Lady.

Then I heard that John Kluge, the billionaire founder of Metromedia Broadcasting Corporation, had acquired a company that printed giant vinyl billboards—the kind that are now all over Times Square. I approached him with the idea of creating a giant mural for the U.S.

pavilion, and he graciously accepted. That permitted me to design the mural in my studio, in smaller scale, which could then be reproduced as a high-resolution digital image on a two-hundred-fifty-foot-long by fifty-foot-high billboard. The billboard would run alongside the pavilion and eliminate the need to paint a mural on the pavilion wall itself.

My mural was titled *The Age of Discovery,* and it depicted a globe of the Western Hemisphere, with Columbus's ships sailing toward America. Behind the globe, giant sunbeams radiated against a starry sky with my "Cosmic Jumper" icon symbolizing our age of discovery in space as well as on earth. To acknowledge America's indigenous roots, I placed an image of Chief Sitting Bull of the Sioux in the center foreground. To the right was a profile of a wise man, based on my drawing of Swami Satchidananda. And to the far left I depicted a Hollywood cowboy symbolizing the American West; looking over him was a blue goddess to represent Gaia and the feminine aspect of Mother Earth. It was a thrill to see this image blown up on such a large scale at the World's Fair. I was astounded with its actual size when I went to Spain for the opening and got up on a scaffold to sign it. My next major art installation was, by contrast, one of my smallest: a series of postage stamps.

In June 1992, the ecology movement, which had been in progress since Earth Day 1970, had finally made a global impact: The United Nations initiated the largest conference ever for global ecology—the U.N. Earth Summit in Rio de Janeiro, Brazil. Because of the popularity of my U.S. postage stamp and posters for Earth Day, the Peace Corps, Greenpeace, and numerous other ecology organizations, I was asked to be the official artist for the Earth Summit and to create a poster for the event as well as a series of twelve postage stamps.

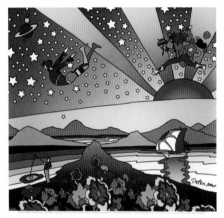

MAKE EVERY DAY EARTH DAY!
"I PLEDGE TO MAKE THE EARTH A SECURE AND HOSPITABLE HOME FOR PRESENT AND FUTURE GENERATIONS."

EARTH SUMMIT STAMP ISSUE BY PETER MAX. AVAILABLE FROM THE UNITED NATIONS POSTAL ADMINISTRATION • NEW YORK • GENEVA • VIENNA

EARTH SUMMIT
RIO DE JANEIRO, BRAZIL • JUNE 1992

I loved the idea of creating a series of stamps from a graphic perspective. I collected stamps as a child while living in China, and again when I was about twelve or thirteen years old and living in Israel. My parents had received many letters from Europe and America, and I loved the miniature artworks, especially when one image was reproduced in many color variations. At that time, there were only two colors to work with. Now I had my entire color palette. The series had twelve stamps arranged in three sets of four. Each stamp in a set of four stood independently as an image, while also interconnecting with the other three to create one larger image. Happily the stamps were a great success, and for the next two consecutive Earth Summits I was again asked to create a new series of twelve stamps for each.

BELOW *Seated Dega Man,* 1993, mixed media on envelope, 6 x 9"
OPPOSITE "Earth Summit," 1992, poster, 33.75 x 21"
FOLLOWING PAGES "Monte Carlo," 1992, poster, 33 x 23.25"; "Rainforest Foundation," 1992, poster, 25.5 x 18.5"

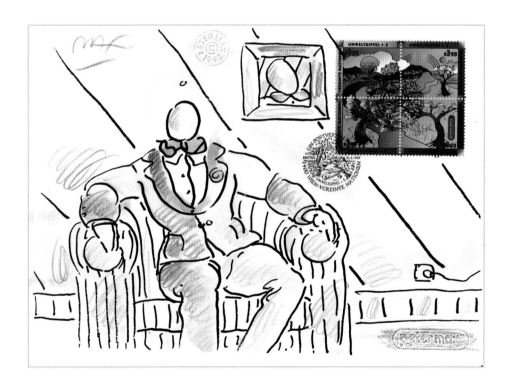

PETER MAX

AMBASSADEUR DE L'ART DES ETATS UNITS

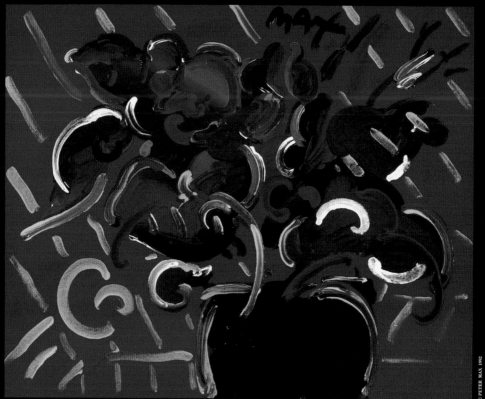

«BLUE FLOWERS» 16" x 20" ACRYLIC/CANVAS 1992

© PETER MAX 1992

EXPOSITION

A LA SALLE FRANCOIS BLANC AU SPORTING D'HIVER

PLACE DE CASINO

MONTE CARLO

DU 2 AU 9 JUILLET 1992

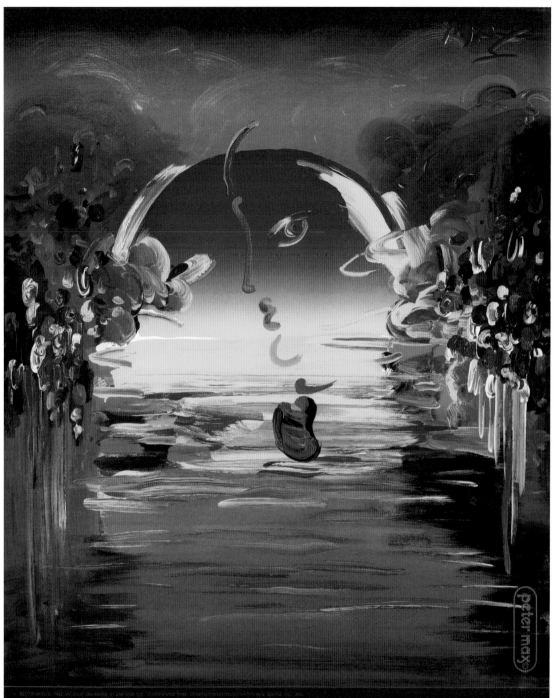

THE RAINFOREST FOUNDATION

3RD ANNUAL BENEFIT • CARNEGIE HALL • MARCH 12, 1992

STING • ELTON JOHN • NATALIE COLE • DON HENLEY • JAMES TAYLOR

The Lady with the Mystic Smile

The Mona Lisa is perhaps the most recognizable female face in Western culture and the most renowned portrait of all time. She has become a goddess of enigma and enchantment, a powerful symbol of feminine mystique. Max reveres the Mona Lisa and its ability both to endure and to transcend its period of origin.

In his series of Mona Lisa portraits (both head and full body), Max utilizes a wide range of colors and brushstrokes to add dimension to the iconic image, call attention to her beauty, and coax the viewer to see her anew.

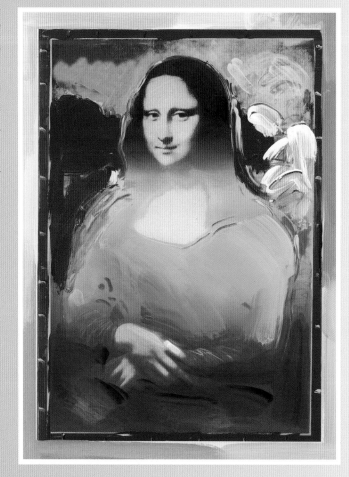

RIGHT *Mona Lisa*, 1994, acrylic and silkscreen on canvas, 32.5 x 31"
OPPOSITE "Mona Lisa Portraits," 1992, poster, 36 x 24"

PETER MAX

MONA LISA PORTRAITS

 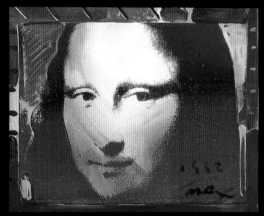

MONA LISA PORTRAITS, SILKSCREEN AND ACRYLIC ON CANVAS, 12 1/2" X 15 1/2" © PETER MAX 1992

EXHIBITION: FALL 1992

CALIFORNIA
NEW YORK

H·A·N·S·O·N
ART GALLERIES

AN AMERICAN REUNION
NEW BEGINNINGS RENEWED HOPE

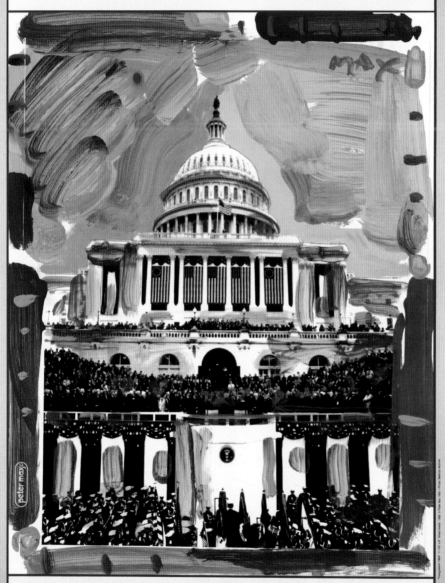

THE INAUGURATION OF WILLIAM JEFFERSON CLINTON AND ALBERT GORE, JR. • JANUARY 20, 1993

PRESIDENT CLINTON'S INAUGURATION

In December 1992, I was asked by the Democratic National Committee to create posters for President Bill Clinton's inauguration on January 20, 1993. I had two large museum shows coming up in the new year, but how could I refuse? When Mr. Clinton took office he was younger than Bob Dylan, Paul McCartney, and George Harrison. Having a young president who shared some of the ideals of the 1960s was wonderful—so many of those ideals are needed today for the preservation of our planet.

Consequently, when I was invited to create the official poster by the Presidential Inaugural Committee, I was thrilled. I decided to print not just one poster but three—one for the opening ceremonies, another for the presidential inaugural ball, and the third for the oath of office ceremony. It was a tight timetable, and I worked around the clock with printers and color separators. In addition, I designed flyers, which were distributed by the hundreds of thousands around Washington, D.C., to announce the inaugural events. I also designed and printed sixty-five thousand T-shirts in only three days. And all the while, I was busy painting Clinton's portraits in one hundred different color variations. My installation of *100 Clintons* was presented on Larry King's presidential special on CNN, and afterward mounted at the inaugural ball. Mr. Clinton and I have since become good friends, and in 2007, he invited me to mount a one-man exhibition at the William J. Clinton Presidential Center and Park in Little Rock, Arkansas.

As much as I enjoyed creating the paintings and

ABOVE Max and President Bill Clinton, 1993
OPPOSITE "American Reunion," 1993, poster, 36 x 24"
FOLLOWING SPREAD *100 Clintons* installation, 1993, acrylic on canvas (detail), 12 x 12"

posters to honor President Clinton, I was happy to return to my studio. The first item on my agenda was to select existing works and create new works for a thirty-year retrospective of my work to be presented at a Berlin museum. I still speak a little German and was able to communicate with the museum directors, as well as the Berliners who came to the opening. It was exciting to have a museum exhibition in the city where I was born; never in a million years would I have foreseen such an opportunity present itself in my life.

I LOVE THE WORLD

Throughout the late 1980s and early 1990s, there was a great outpouring of caring for the planet and our fellow humans, especially by the music community, with organizations, concerts, and charity songs such as Live Aid, "We Are the World," Farm Aid, and others. I began to think of the 1990s as "the decade of the heart" and started a series of expressionistic heart paintings, which I continue to this day.

A "heartfelt" image that I created in the 1990s was a poster called "I Love the World." It began as a drawing of an angel embracing the planet, inspired while I was hanging out backstage at the Live Aid concert in July 1985. I was moved by the greatest rock performers of the era giving their all to raise funds for the famine in Ethiopia, and the drawing came extemporaneously from my pen.

As we approached the new millennium, I created a poster titled "Peace by the Year 2000," with the "I Love the World" artwork exclusively for the United Nations bookstore. Unfortunately, that dream of world peace never became a reality, but I will never give up hope that one day it will.

"Peace by the Year 2000,"
1999, poster, 32 x 36"

PEACE

BY THE YEAR 2000

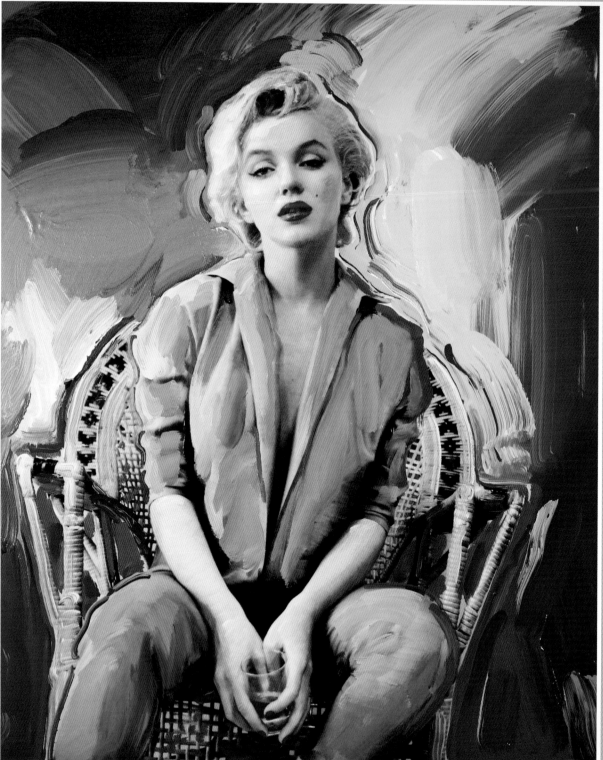

Peter Max Portraits

Peter Max's portraits, rendered with his signature brushstrokes and bold color combinations, have become as iconic as his other artworks.

His portrait roster reads like a who's who in pop culture.: the last six U.S. presidents; world renowned statesmen and stateswomen: Nelson Mandela, The Dalai Lama, Martin Luther King, Jr., Hillary Clinton, Queen Noor of Jordan, Prince Charles, Princess Diana, Yitzhak Rabin; U.S. state governors: Mario Cuomo, Christine Todd Whitman, Arnold Schwarzenegger, Jesse Ventura; and leading C.E.O.s, such as Sir Richard Branson, Sumner Redstone, and Ted Turner.

When it comes to sports, Max's portrait list is extensive: Muhammad Ali, Shaquille O'Neal, Michael Jordan, Jack Nicklaus, Mickey Mantle, Derek Jeter, Andre Agassi, Joe Montana, and Joe Namath.

In the domain of music, the list is endless: Clive Davis, Quincy Jones, Aretha Franklin, Bob Dylan, Bono, David Bowie, Elton John, The Beatles, Jon Bon Jovi, Taylor Swift, and many more. From the stage and screen, Max has painted the likes of Steven Spielberg, Jerry Seinfeld, Danny Aiello, Paul Sorvino, Brooke Shields, Michael Douglas, Nicolas Cage, Humphrey Bogart, and the inimitable Marilyn Monroe.

One doesn't have to be on the cover of *Time* or *Newsweek* to rate a Peter Max portrait. When the artist's schedule permits, he also paints portraits of private individuals and their families, with a portion of the proceeds to benefit charitable organizations.

ABOVE *Bono*, 2005, acrylic on canvas, 24 x 18"
OPPOSITE *Marilyn Monroe in Denim*, 2013, mixed media, photo by Milton Greene, 30 x 30"
PAGE 206 (clockwise from top left): *Ronald Reagan*, 1989, acrylic and silkscreen on canvas, 28 x 22"; *Yellow Dog*, 2002, acrylic and silkscreen on paper 32 x 26"; *Muhammed Ali*, 2001, acrylic and silkscreen on canvas, 38 x 32"; *Larry King*, 2006, acrylic on canvas, 36 x 32"
PAGE 207 *George Harrison*, 2003, colored pencil on paper, 9 x 7"

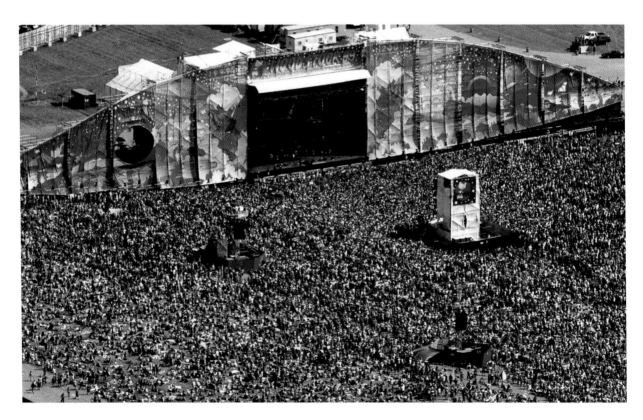

WOODSTOCK 1999 STAGE
600-FEET-WIDE BY 80-FEET-HIGH

In the early spring of 1999, my buddy Woodstock festival producer Michael Lang told me he was producing a thirtieth-anniversary Woodstock festival. He asked me if I would create the art for the stage and backdrop, similar to what I had created ten years earlier for the Moscow Music Peace Festival, which had celebrated the twentieth anniversary of Woodstock.

At the time, the stage for the Moscow festival was the largest ever created, but now I thought it was time to "upstage" myself and create something even bigger.

As I began to work, I envisioned a six-hundred-foot-wide by eighty-foot-high stage backdrop in an elliptical shape, like a large spaceship. But the challenge I faced was having it withstand the wind and other elements of nature; we didn't want it to come down in the event of a storm. While researching the project, I found a printer in Canada to print the images on porous canvas in long vertical panels, which allowed the wind to move through it and prevented it from coming down.

Being an artist in the twenty-first century in America has afforded me the opportunity to express myself both traditionally, with oil and acrylic paint on canvas, and in a pop and contemporary style, with larger-scale works. Both technique and innovation have played an important part in my expression. As much as I admire the works of Picasso and Matisse, I also admire the dynamics of contemporary artists who have worked on a large scale, such as Oldenburg and Christo.

For the past twenty years I have happily balanced my love of expressing myself in traditional art media with exploring new giant "canvases," such as the Woodstock stage, and in 2011, the entire hull of Norwegian Cruise Lines's *Norwegian Breakaway* ship.

OPPOSITE, ABOVE "Woodstock 1999," 1999, poster, 13 x 26"
OPPOSITE, BELOW The Woodstock stage, 1999

The Summer of Love Lives On

Peter Max's name is nearly synonymous with the 1960s. As such, he continues to get requests for art related to that era. Max views the 1960s as a giant wave of love and consciousness that swept over the youth of America. He explains, "The 1960s was an important cultural revolution in many ways. We suddenly became aware of our interde-

ABOVE *Love Panorama*,
2007, mixed media,
6.5 x 15.5"

pendent relationships with the whole earth—with one another and with the environment, plants, and animals." He sees the 1960s as one of the most positive, creative, and revolutionary decades in the history of our planet.

"The 1960s was a period of great transformation; its reverberations are still being felt today. Back then, I thought we were going to change the world—and we have to some degree. We certainly helped give

LEFT *Great Wave,* 1969, mixed media, 9 x 6"
RIGHT "Sustain, Comm World," 2008, poster, 24 x 18"

rise to a multibillion-dollar green industry—as evidenced by the giant health-food supermarkets of today and the boom in yoga's popularity. It's more than an industry, though; I call it the Green Wave Movement, and I think its seeds were sown in the 1960s. I am proud to have been involved in it from the start, and I continue to contribute my art to it."

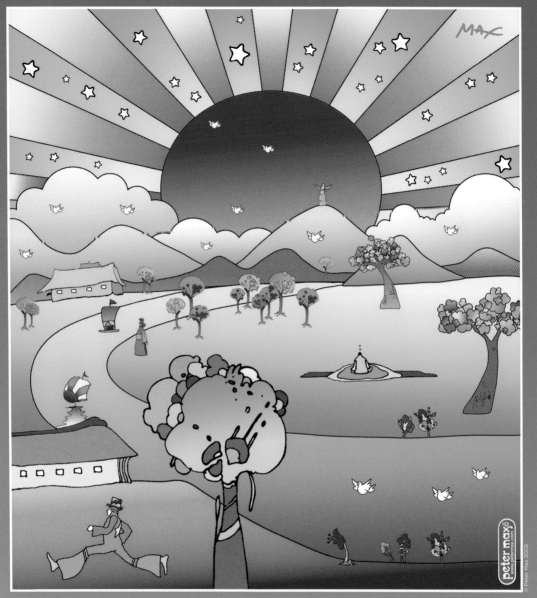

Our planet. Your move.

SustainCommWorld

The Business of Green Media Conference	The Green Media Show
Cal Poly, San Luis Obispo, CA • January 24, 2008	Boston, MA • October 1 & 2, 2008

This poster was created with the highest regard for the environment from its conception. The environmental attributes are a collaborative effort of the Peter Max Studio, SustainCommWorld & EarthColor.

This paper is U2:XG Gloss – an FSC-certified, elementally chlorine-free product that is 30% post-consumer recovered fiber and manufactured with electricity in the form of renewable energy (wind, hydro, and biogas). The inks are a product of INK Systems and contain zero VOC's and are cured without UV.

The poster was printed by EarthColor at a Carbon neutral location, using 100% green renewable wind power and sustainable manufacturing practices which include: green chemistry principles, recycling all residual materials and capturing VOC's from press wash via bio-oxidation.

www.SustainCommWorld.com

PLANES AND AUTOMOBILES

As 2000 was off to a start, I was commissioned to paint one of my largest canvases yet—a Continental Airlines Boeing 777 Super Jet.

This project came about a year earlier, when Gordon Bethune, then the CEO of Continental, was attending an event at my studio. As I was giving him a tour, he noticed a model airplane painted in bright expressionistic brushstrokes suspended by a string from the ceiling. Since he was a tall Texan he did not have to look up very far to see it, and he studied it from all angles. I explained to him that it was a model for a plane to fly hard-rock

bands and me to the Moscow Music Peace Festival in 1989. It literally never got off the ground.

As he looked at it with fascination, I asked, "Gordon, do you think it will ever fly?"

He looked me squarely in the eyes and said with his Texan drawl, "Heck, yeah."

My studio manager, Gene Luntz, whispered in my ear, "I think that meant yes."

The next year, I was flown to the Boeing plant in Seattle to supervise the painting of a giant $600 million titanium canvas. Mayor Rudy Giuliani christened it the *New York Millennium Plane* at the ribbon-cutting ceremony. Mayor Giuliani became a good friend of mine and

ABOVE "NASCAR 2000," poster, 18 x 24"
OPPOSITE Photograph of Max's artwork on the Continental plane, 2000. Photo by Joe Derenzo.

presided over my wedding to my beautiful wife, Mary, aboard a yacht in New York harbor.

The Continental plane was not the only moving canvas I painted in 2000. I also put my brush to Dale Earnhardt, Sr.'s NASCAR speedster. Dale told me, "Peter, your colorful brushstrokes make my car look like it's moving fast even when it's standing still!"

9/11

As we approached the new millennium, I hoped that the twenty-first century would fulfill many of our global dreams—world peace, end of world hunger, human care for animals, sustainability, and advancements in health care and technologies that could improve the quality of life around the globe. With this in mind, I started the year 2000 with a series of posters to express my sense of hope and to foster hope in others.

But only a year later, in 2001, the World Trade Center tragedy shocked the world. I had been a tried-and-true New Yorker since my arrival in the United States more than forty years earlier, so, like many others, I was profoundly affected by the attacks. I tried to do as much as I could to help the victims and raise money in support of them.

After making a series of posters to benefit the September 11 Fund, I also decided to create a portrait tribute to the 356 firefighters who lost their lives on that day. To attain this goal, I acquired photographs of each firefighter's face to make the portraits. The project was not only time-consuming but also emotionally very intense. Each photograph used for the portraits was a photo ID—with a frontal view looking directly into the camera. I screened each photo on canvas as a base to paint over, and as I painted them, it was as though their gazes were looking

OPPOSITE "Peace on Earth," 2001, poster, 24 x 18"

PEACE ON EARTH

directly at me. Their faces were different structures and complexions, with different eye colors, but a thread of humanity ran through them as I was painting, and in several instances, tears came to my eyes. They could have been my friends or my relatives, and were all my fellow Americans. And all heroes.

When I completed the series, the portraits were individually wrapped in an American flag and presented to each firefighter's family.

Although we are living in increasingly uncertain times, I try to maintain the same hope that I had at the beginning of the century and that I've gravitated to since the 1960s.

I renew this hope by painting and through committing to environmental causes, especially animal rights. I'm always ready to create art to help raise funds for important causes.

Swami Satchidananda inspired me when he said, "Our greatest purpose is to express what's in our heart. And those who have the talent should express it through their art." He pointed up and, using the masculine pronoun for God, said, "He plus art equals heart."

ANIMAL RIGHTS

Animal rights have been a big part of my life for many years, ever since I began practicing yoga and eating a vegan diet. Yoga made me aware of the beauty of eating healthily without causing violence to our animals, and this issue has become a family affair. My lovely daughter, Libra, has always adored animals and has been a great friend to them as well as a wonderful advocate for their rights. My wife, Mary, is also an animal-rights activist and has hosted numerous fund-raisers at my studio to support many animal-rights causes, vegan organizations, and nutritious school lunches. Over the years, I have created

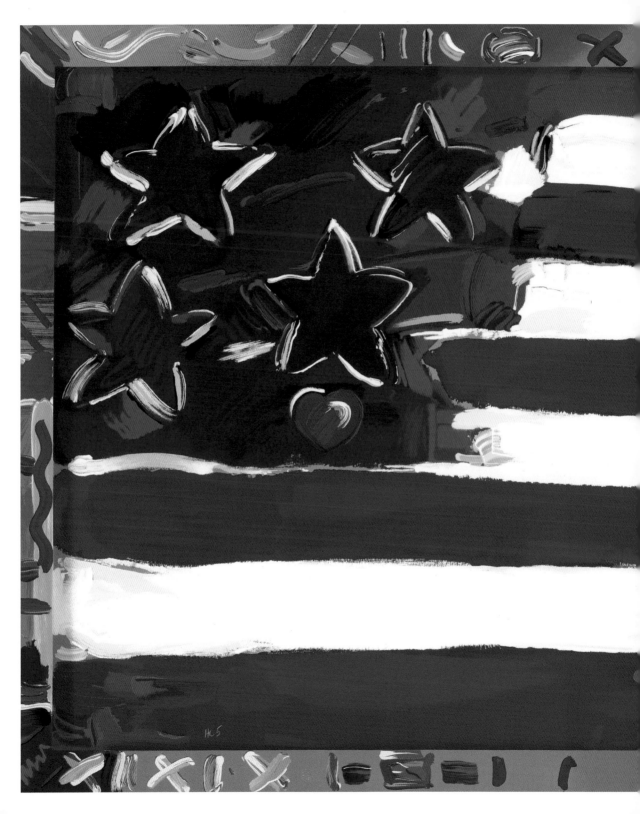

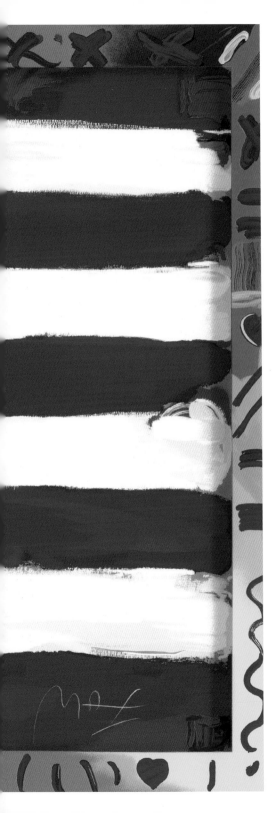

a number of posters for various animal-rights organizations, such as the Dolphin Project, Save the Whales, Save the Orangutans, and PETA.

My grandest gesture for animal rights was in 2002, when a cow in Cincinnati, Ohio, escaped from a slaughterhouse by jumping over a six-foot fence and eluded the authorities for eleven days. The cow was finally found foraging in Mount Storm Park in northern Cincinnati. I was so moved when I read the story that I immediately flew to Ohio and arranged to have the cow sent to Farm Sanctuary, an animal protection organization in New York State, to live out her life in peace. The cow was given the name Cincinnati Freedom, and I called her "Cindy Woo" for short.

Freedom is what I value most in life, and I'm happy to say that my lifelong goal of keeping myself in a space of creative and spiritual freedom has been met, even though at times it has been difficult. My dear father and mother's quest for freedom finally brought us to the United States of America—a country that has always prided itself on the idea that all people are free and equal, even though it has sometimes also been difficult for her to meet that lofty goal. In America I was given the opportunity to pursue my dream of becoming an artist and to follow the spiritual teachings of my choice.

Most recently, the election of President Barack Obama represents our country's capacity for, as he put it so eloquently, hope and change. I celebrated the election of our first African-American president with my portrait *Forty-four Obamas,* which, I hope, like all my work, is also a celebration of the spirit of creativity and freedom that makes this country great. Although we still have not attained everything we envisioned in the 1960s, I am still hopeful and continue to meditate on and work toward a better world.

An Artist of Uncommon Diversity

One afternoon in the mid-1980s, an elegant, elderly gentleman named Henri visited Peter Max's studio. Because the man had printed for Picasso, Max was concerned about Henri's evaluation of his art.

When Henri completed his appraisal, he exclaimed, "Pea soup and croutons!"

"Excuse me?" Max replied.

"I visit many artists whose work is excellent," said Henri. "But there is a similarity to the body of their work—like pea soup. But you have pea soup and croutons—something different, something unique."

They both laughed and Max invited Henri to accompany him to Edgar's, his favorite neighborhood café. Ironically—and deliciously so—the daily special happened to be pea soup and croutons.

Art gallery manager Malcolm Genet addresses the variety of Peter Max's work, saying, "Max is an artist of uncommon diversity. He commands such a wide range of styles, that any attempt to define him by a conventional school or movement is bound to fall short. It would require a multiplicity of terms to encapsulate him; you might have to say Pop-Abstract-Fauve-Expressionist.

There are elements of all these genres in Max's work. In his color usage, there is the influence of the Fauves, such as Henri Matisse, Maurice de Vlaminck and André Derain; in his brushwork, the influence of Abstract Expressionists such as Hans Hofmann and Franz Kline; in his posters, suggestions of Toulouse-Lautrec and Alphonse Mucha; and in his drawings, a touch of Picasso. In each case, however, the influence is taken out of its original context and transformed into something vitally new.

Hence, if one cannot place Peter Max in a traditional category, one can at least identify the timeless attraction of his art: it resides in an ecstatic sense of color, a flawless eye for attention-arresting design, a free and spontaneous improvisational technique, and an unerring ability to discover imagery that penetrates to the heart of our culture."

OPPOSITE "Peter Max Retrospective," 1993, poster, 24 x 18"

PETER MAX
RETROSPEKTIVE
1963 ——— 1993

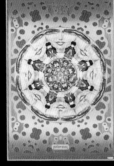

BERLIN · UNTER DEN LINDEN
AM STADTSCHLOSS IM PETER-MAX-PAVILLION
VOM 16. JULI BIS 3. OKTOBER 1993
GEÖFFNET TÄGLICH VON 10.00 UHR BIS 22.00 UHR
FREUNDE DER STAATLICHEN KUNSTHALLE BERLIN E.V.

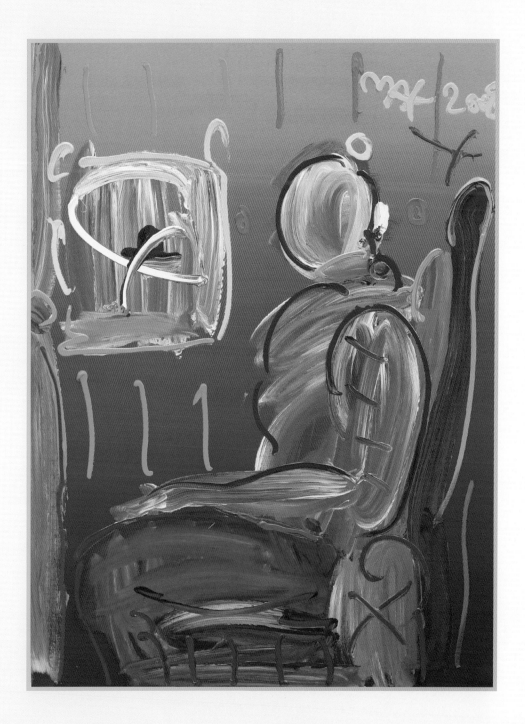

PLATES

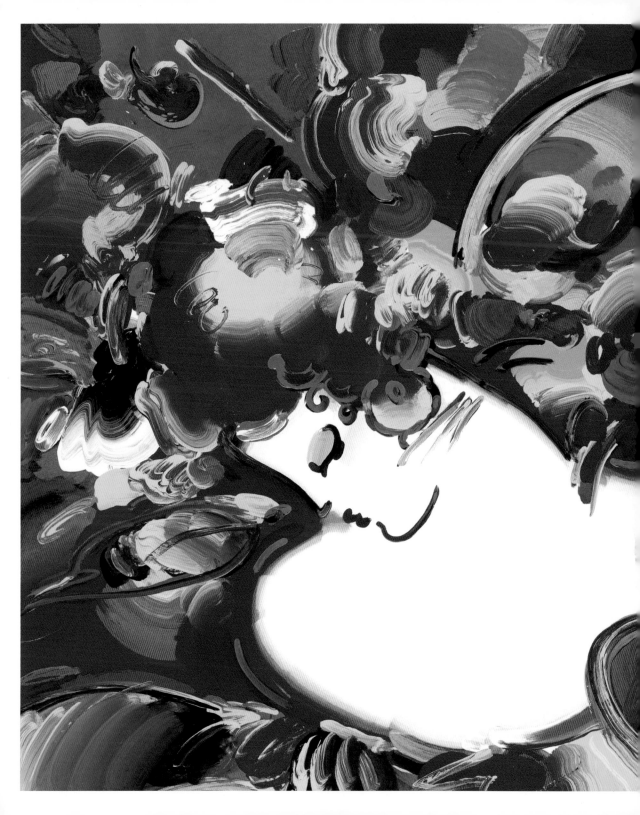

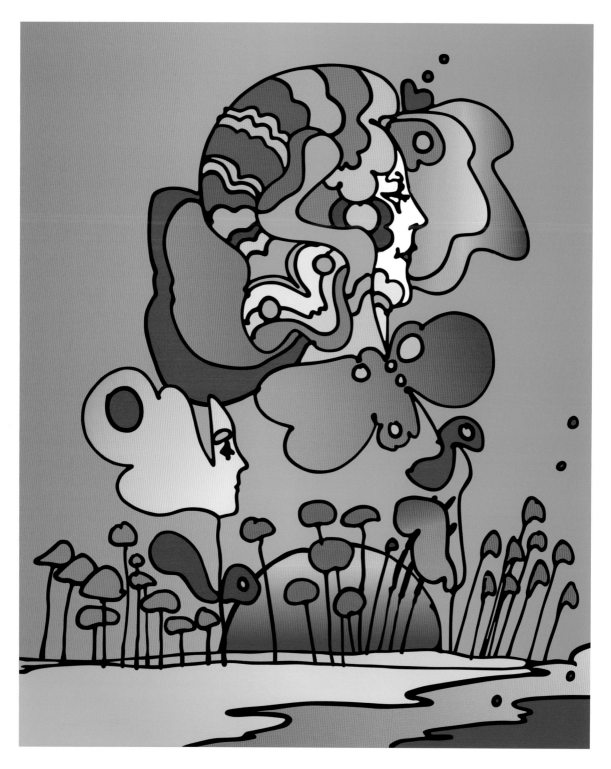

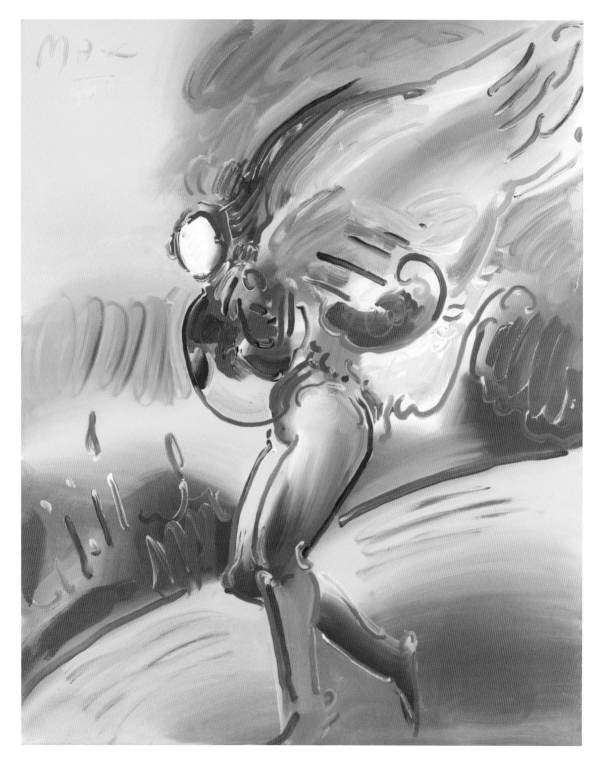

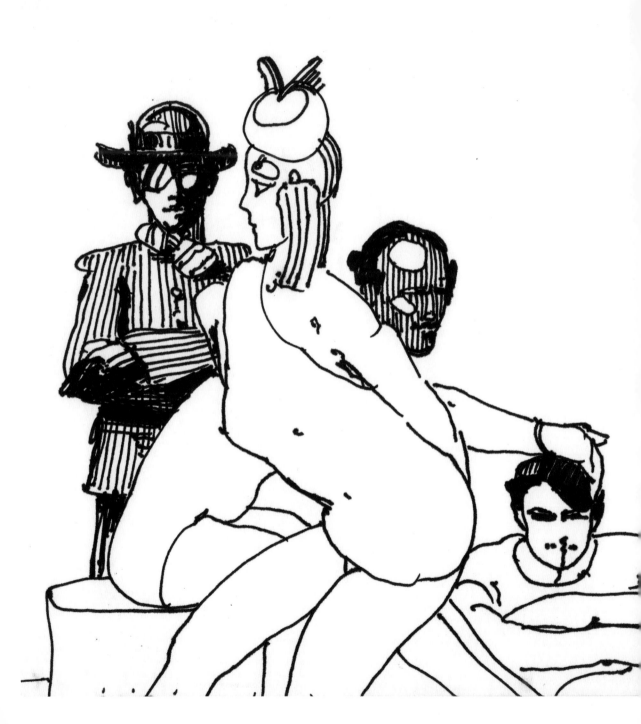

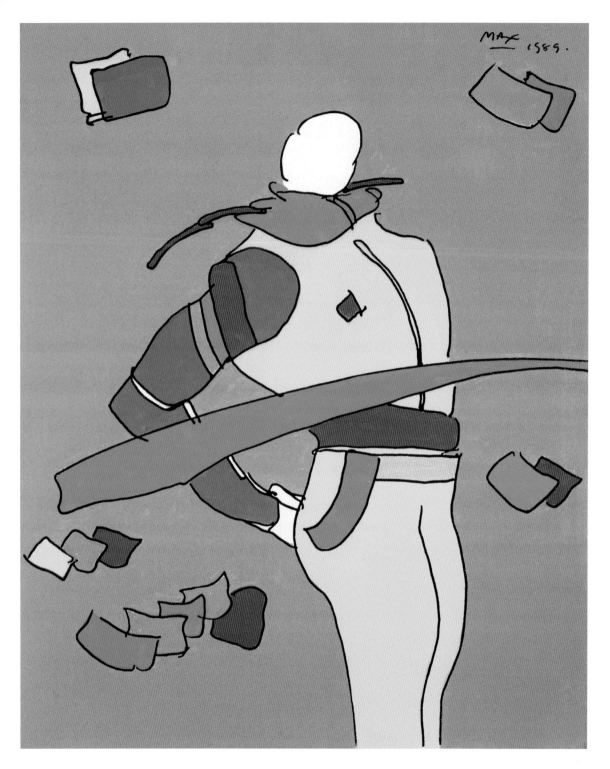

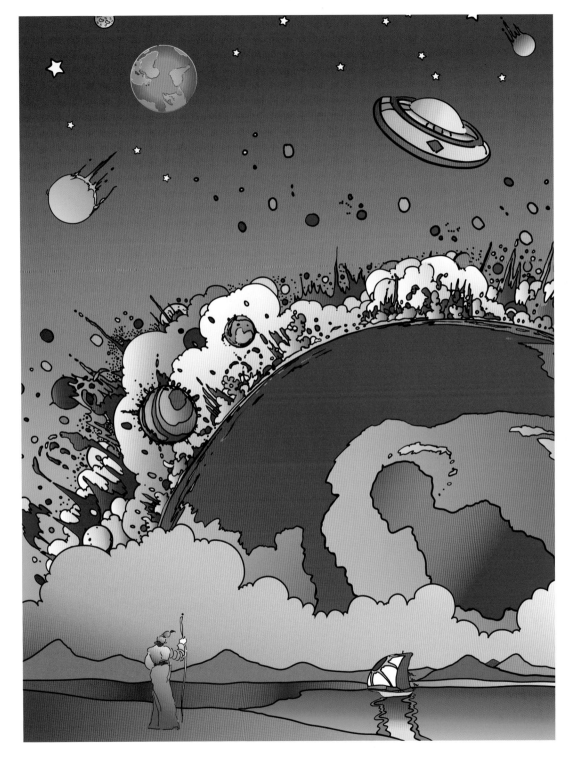

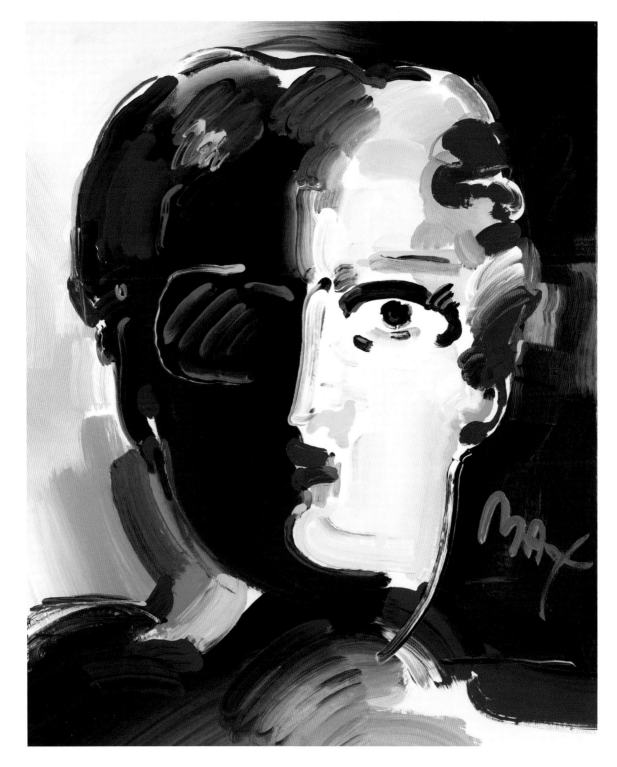

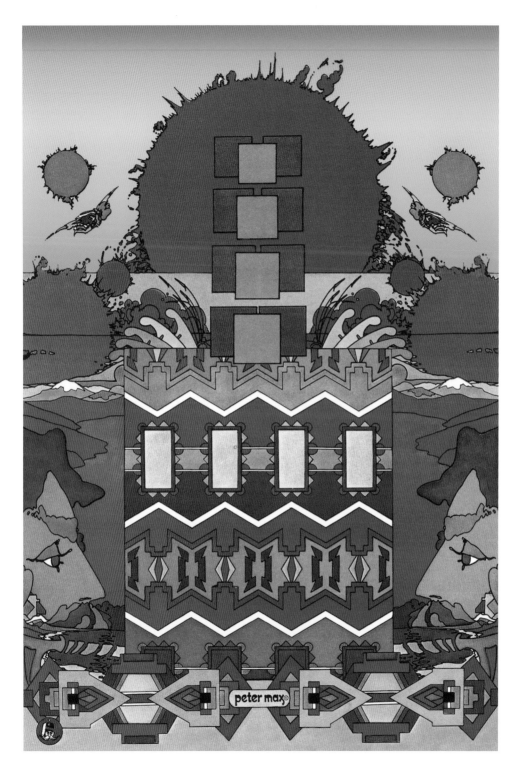

244

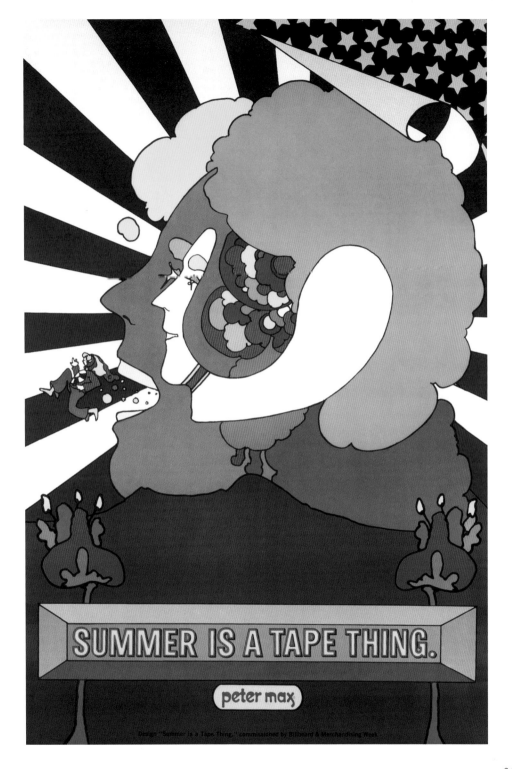

SUMMER IS A TAPE THING.

peter max

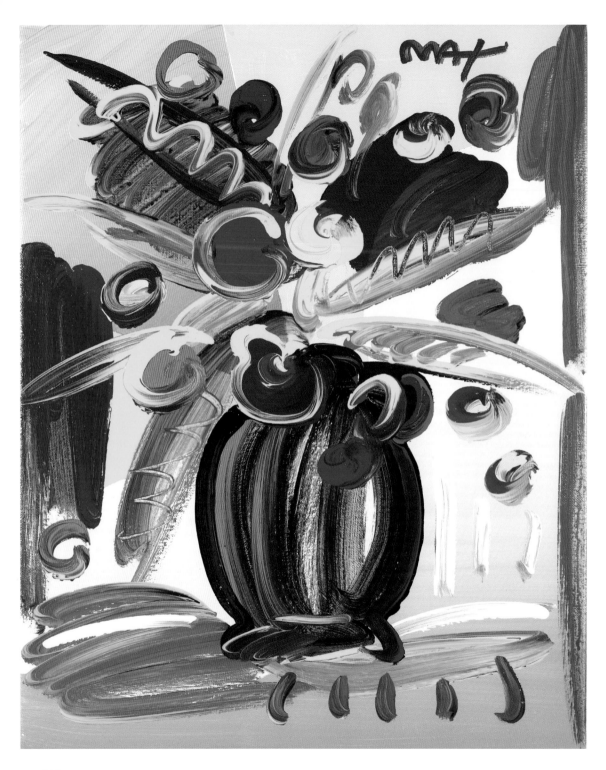

248

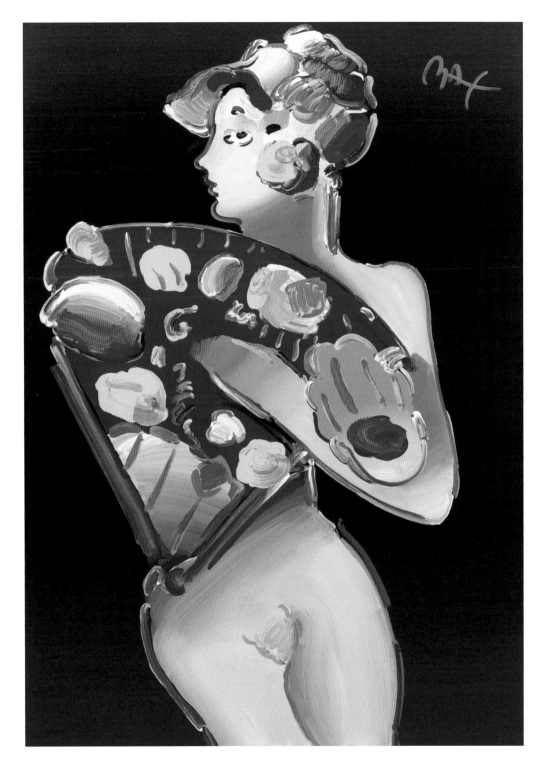

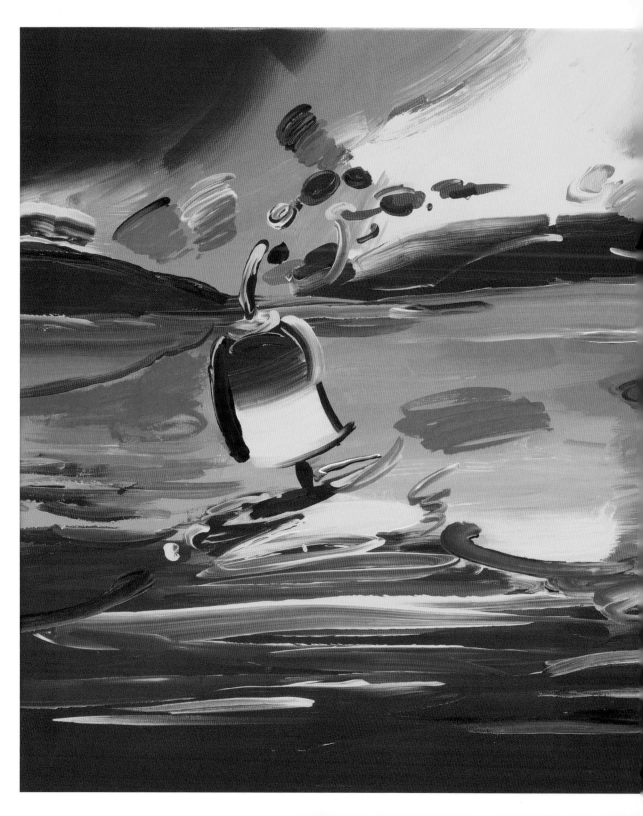

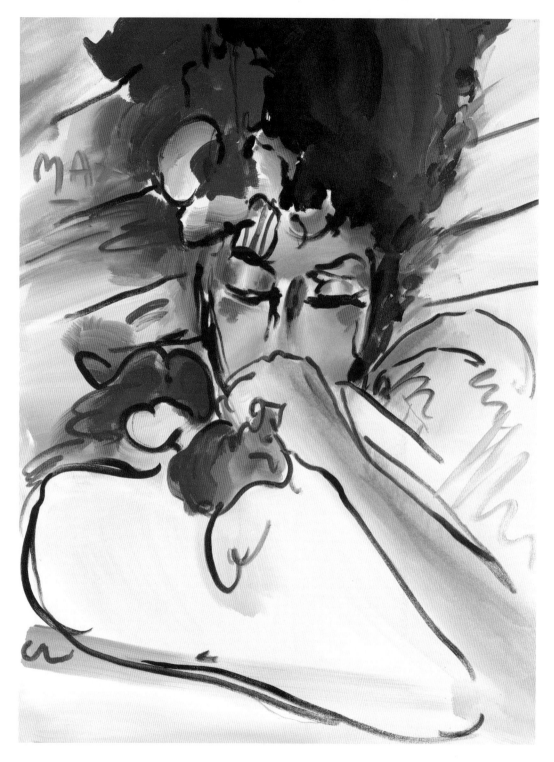

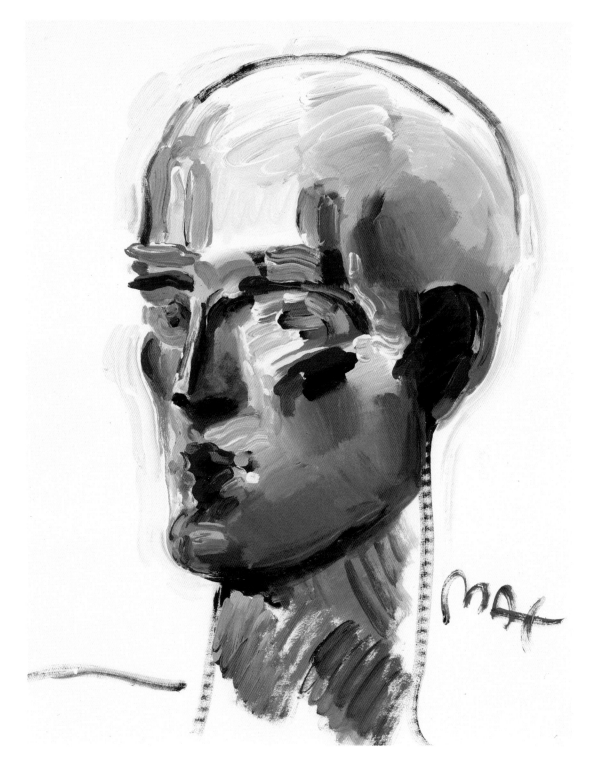

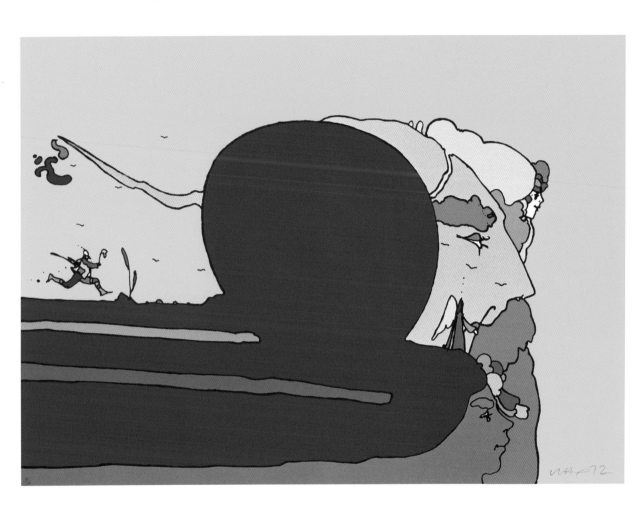

OV - for overpainting, remarks
or
color study only

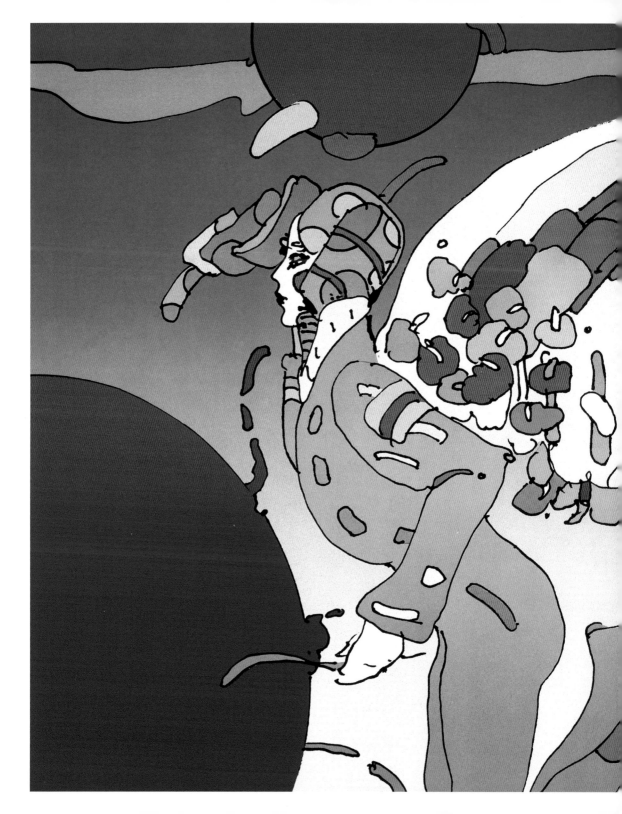

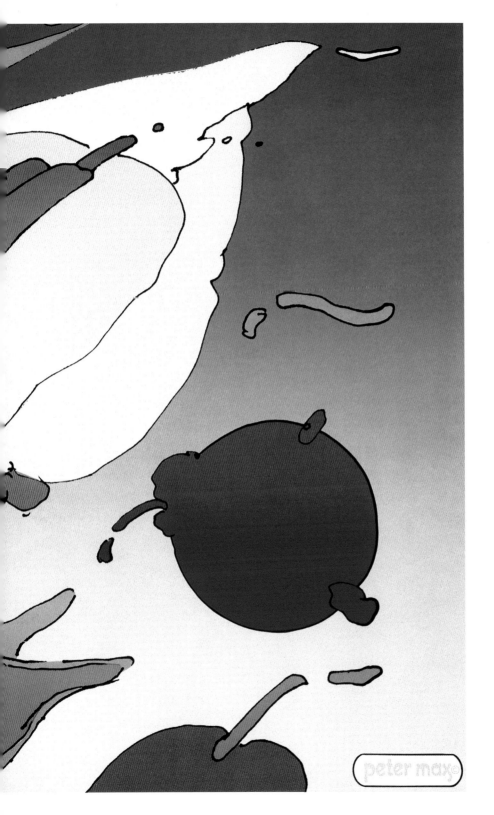

peter max

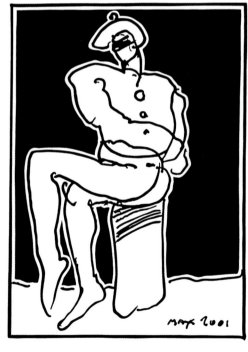

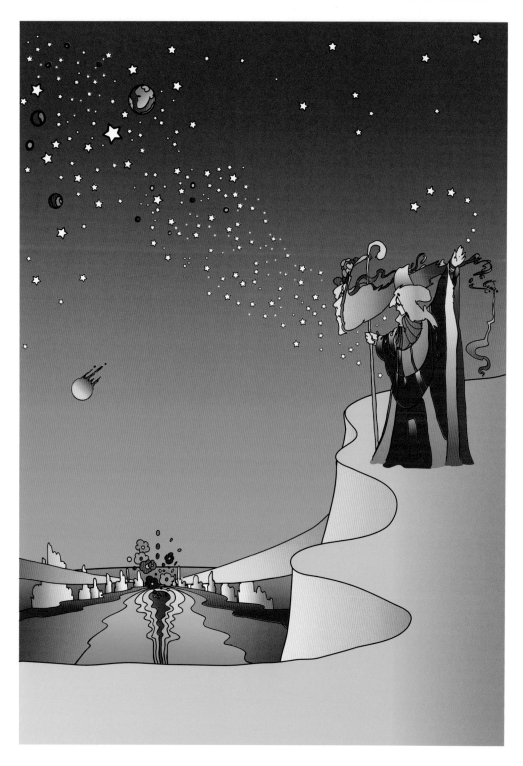

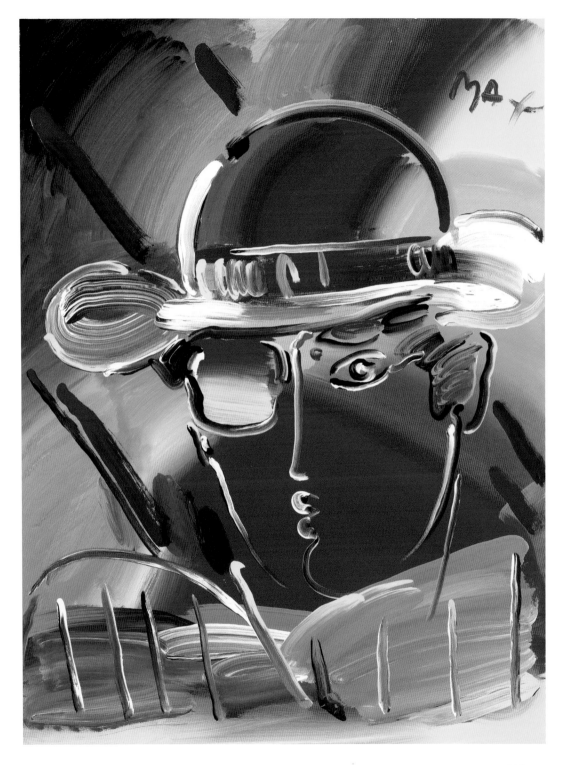

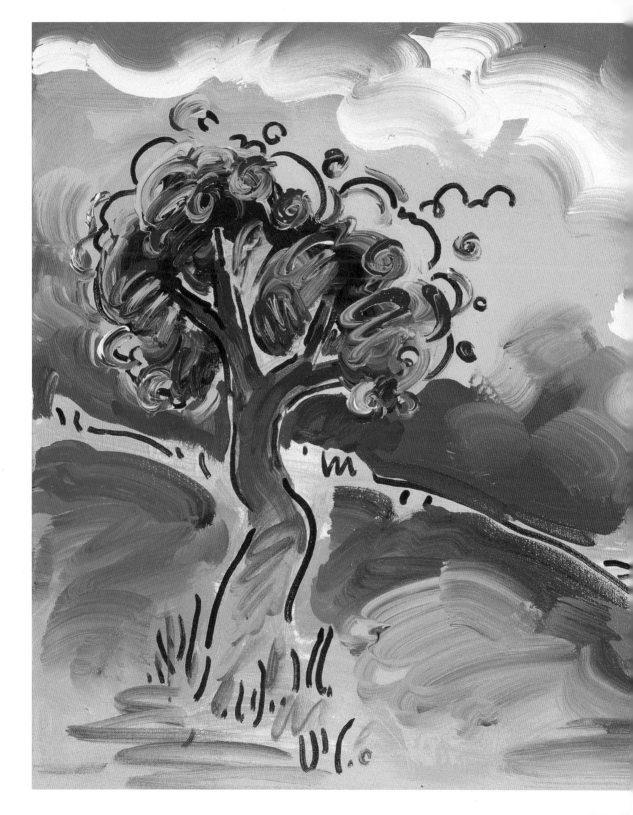

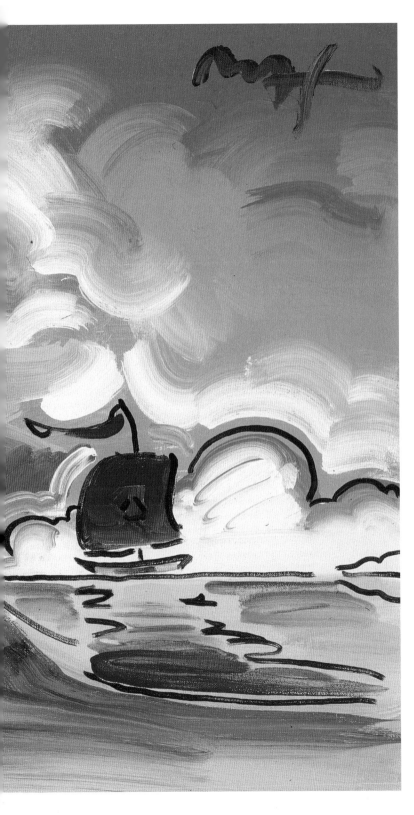

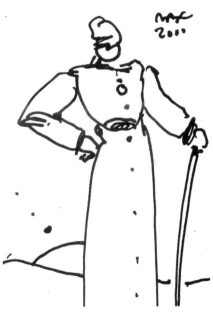

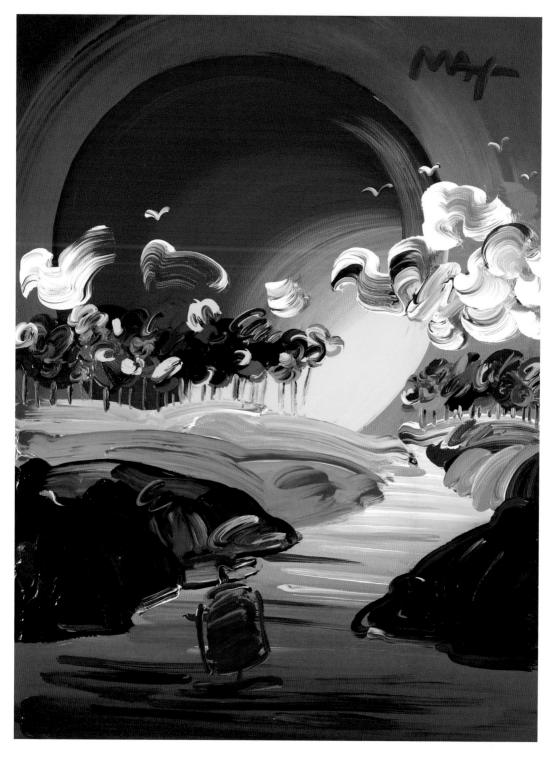

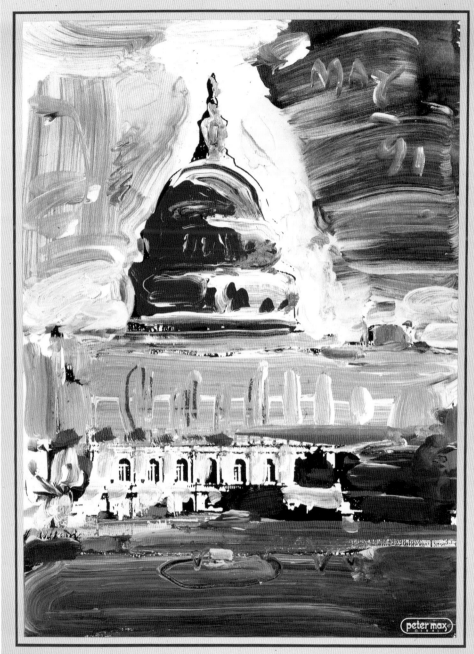

THE CONGRESSIONAL ARTS CAUCUS

PRESENTS AN ARTISTIC DISCOVERY
JUNE 1991 - MAY 1992 U.S. CAPITOL WASHINGTON, D.C.

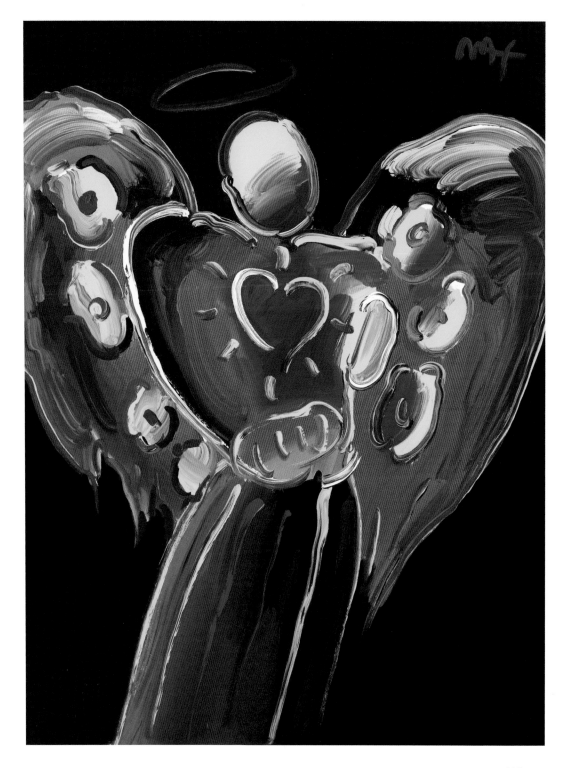

267

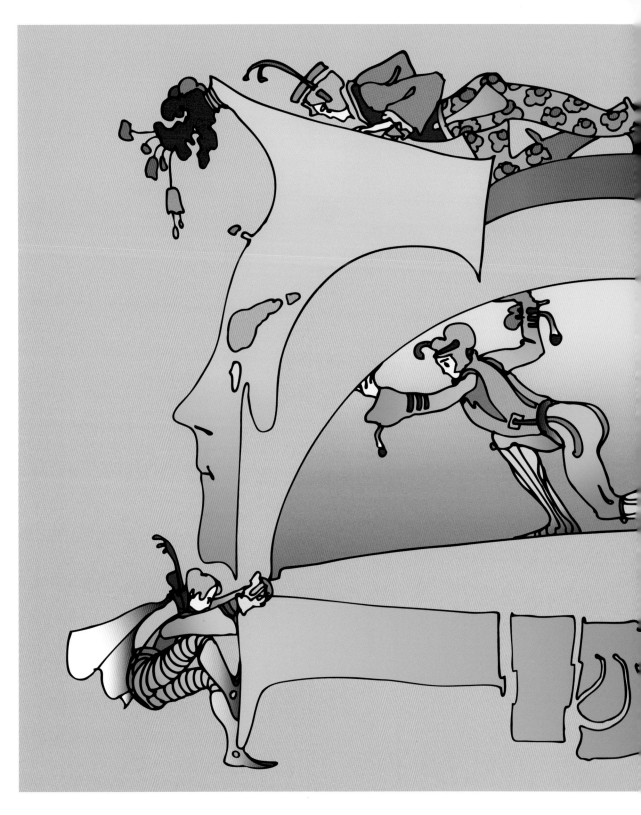

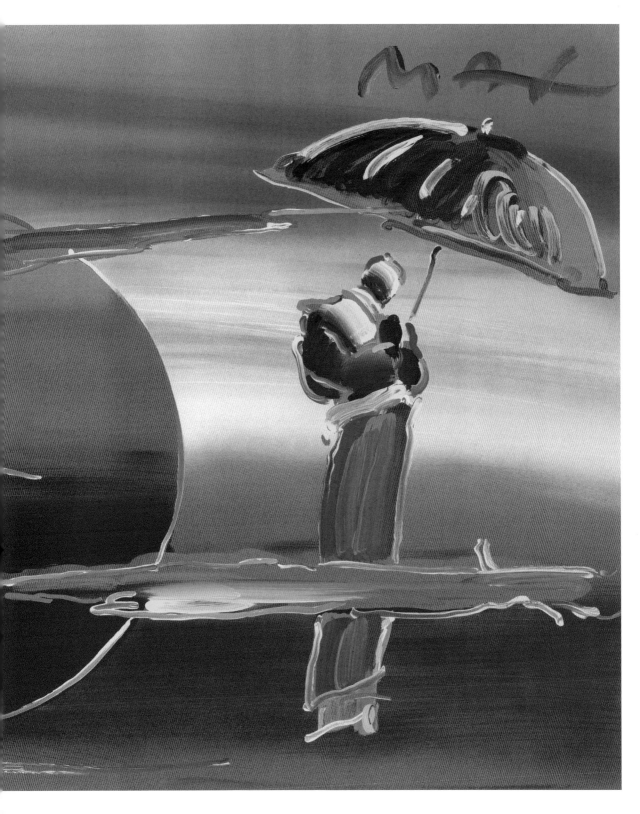

EXHIBITION JANUARY 11 - FEBRUARY 12, 1992
CUDAHAY'S GALLERY
1314 E.CARY ST. RICHMOND, VA (804) 782-1776

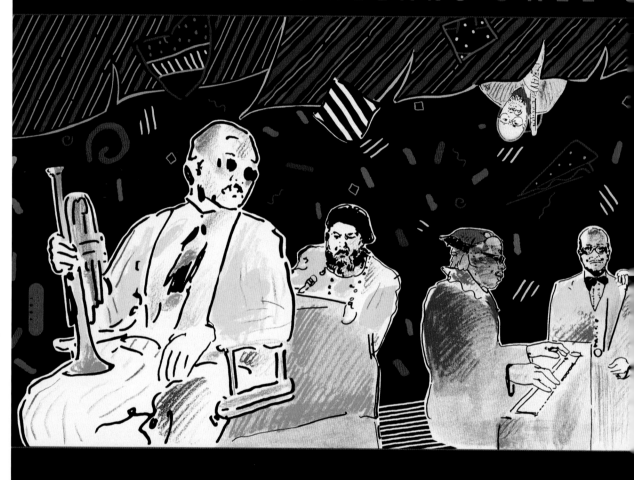

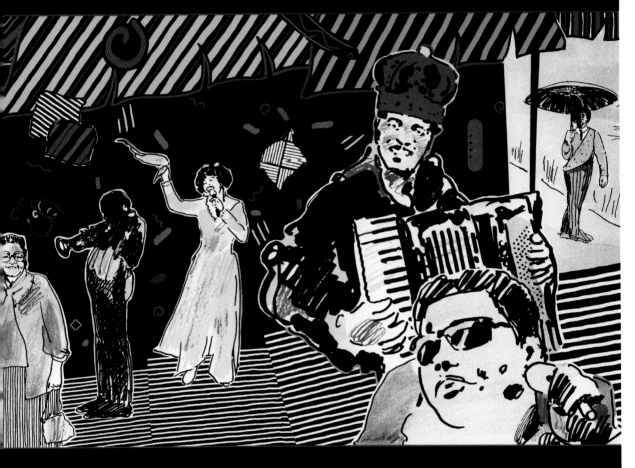

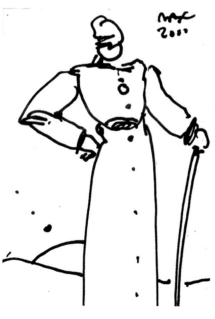

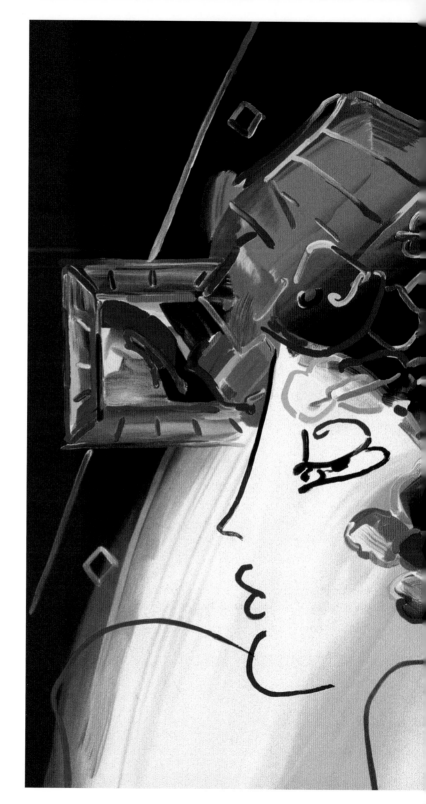

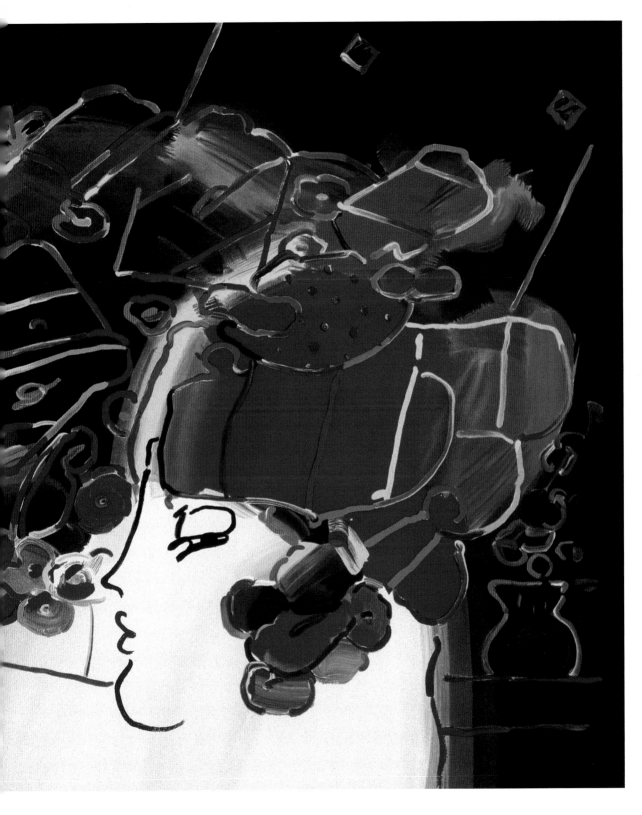

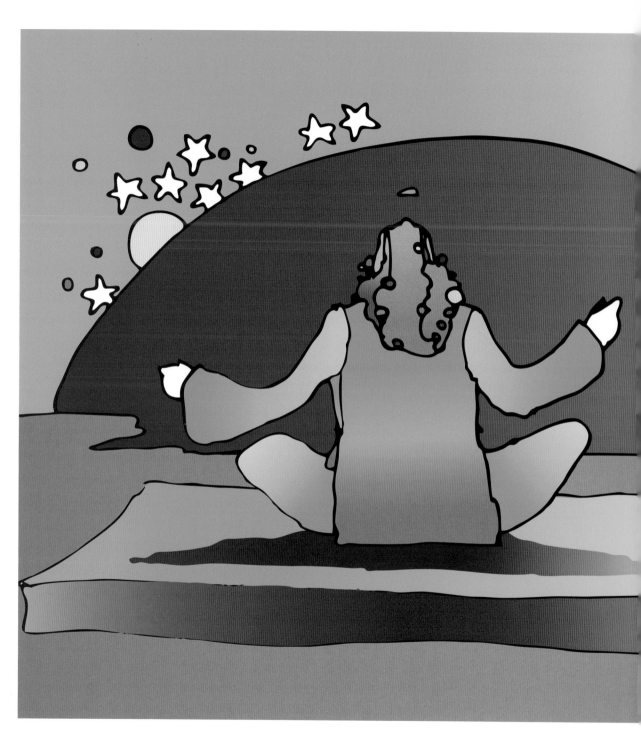

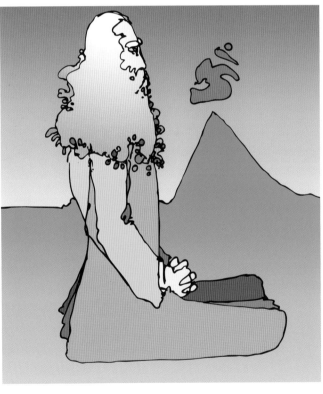

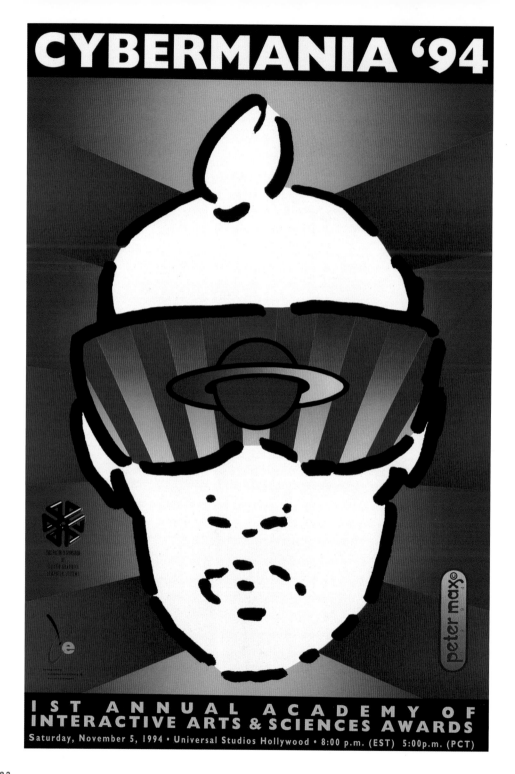

PLATES CREDITS

PAGE 224
Sitting Dega Man, 2008, acrylic on canvas, 48 x 36"

PAGES 226-227
Flower Blossom Lady, 1994, acrylic and silkscreen on paper, 30 x 34"
"Fashion Lady 1," 1982, pen and ink on paper, 7 x 5"

PAGES 228-229
Flower Faces 1, 1972, mixed media, 8 x 8"
Angel on Sun, 1994, acrylic on canvas, 60 x 48"

PAGES 230-231
"Dancing Angels," 1982, pen and ink on paper, 8 x 10"
Balls of Fire, 1972, serigraph, 22 x 30"

PAGES 232-233
"Ibiza Crowd," 1974, pen and ink on paper, 10 x 15"
"Mercury Dime Lady Profile," 1989, pen and ink on paper, 7 x 5"

PAGES 234-235
Modern Dega Man, 1989, acrylic and silkscreen on canvas, 20 x 16"
Solar Phenomenon, 2008, mixed media, 12 x 10"

PAGES 236-237
"Mexican with Flower," 1971, pen and ink on paper, 14 x 12"
"Lady Profile in Colored Pencils," 1980, colored pencil on paper, 9 x 7.24"

PAGES 238-239
Sunrise Flowers, 1978, lithograph, 22 x 30"
Night Flowers, 1978, serigraph, 22 x 28"

PAGES 240-241
Singularity Star, 2008, mixed media, 10 x 12"

PAGES 242-243
Abstract Vase, 2001, acrylic on paper, 9 x 7"
Fauve Head, 1994, acrylic on canvas, 60 x 48"

PAGES 244-245
"Canterbury Poster Book," 1970, book jacket, 11.25 x 16.5"
"Summer Is a Tape Thing," 1969, poster, 36 x 24"

PAGES 246-247
"Shakespeare Actor," 1987, pencil on paper, 10 x 8"
"Flower Man," 1988, pencil on paper, 10 x 8"

PAGES 248-249
Flower Vase, 2013, acrylic on canvas, 17.5 x 14"
Blue Fan Dancer, 1996, acrylic on canvas, 48 x 36"

PAGES 250-251
Stormy Sail, 1995, acrylic on canvas, 24 x 30"
"Morning," 1996, pencil on paper, 7 x 5"

PAGES 252-253
Suzin, 1994, acrylic on canvas, 40 x 30"
"Fauve Head in Blues," 1996, 26 x 20"

PAGES 254-255
Moving with Father, 1972, serigraph, 22 x 30"
Beyond Horizon, 1980, serigraph, 22 x 25"

PAGES 256-257
"Cosmic Trapeze—World's Fair," 1982, poster, 18 x 24"

PAGES 258-259
"Seated Figure," 1998, pen and ink on paper, 5 x 4"
"Matisse Lady," 1974, pen and ink on paper, 9 x 12"

PAGES 260-261
Spell Caster, 2008, mixed media, 14 x 11"
Zero Spectrum, 1994, acrylic on canvas, 40 x 30"

PAGES 262-263
Tree and Sailboat, 2006, acrylic on canvas, 24 x 30"
"Sage with Cane," 2000, pen and ink on paper, 7 x 5"

PAGES 264-265
Better World, 2012, acrylic on canvas, 36 x 28"
"WCBS Empire State Building," 1987, poster, 36 x 23.5"

PAGES 266-267
"Congressional Arts," 1991, poster, 36 x 26"
Angel with Heart, 2012, acrylic on canvas, 30 x 24"

PAGES 268-269
Astral Playground, 1970, mixed media, 10 x 12"
Rainbow Man, 2002, mixed media, 9 x 6"

PAGES 270-271
"Monk with Staff," 2002, pen and ink on paper, 5 x 4"
Umbrella Man with Large Sun, 1994, 27.75 x 10"

PAGES 272-273
"Cudahay's Gallery," 1992, poster, 36 x 24"
"Garrett Stephens Gallery," 1989, poster, 36 x 24"

PAGES 274-275
"New Orleans Jazz Festival," 1994, poster, 18 x 38"

PAGES 276-277
Right Now, 1970, 22 x 30"
"Sun," 1980, pen and ink on paper, 7 x 5"

PAGES 278-279
"Sage with Cane," 1998, ink on paper, 5 x 4"
Mondrian Ladies, 1989, serigraph, 26.75 x 35"

PAGES 280-281
Swami Sunrise, 1971, mixed media, 9 x 12"
Swami Om, 1971, mixed media, 11 x 7.5"

PAGE 282
"Cybermania," 1994, poster, 36 x 24"

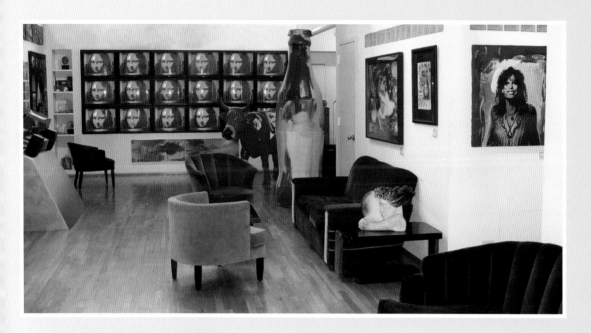

The Peter Max Studio

Manhattan is home to the Metropolitan Museum of Art, the Guggenheim Museum, the MoMA, the Whitney Museum of American Art, the Frick Collection, and a host of other museums and galleries.

Outside these museums' walls are the loft spaces and studios of New York City's most famous artists, some of which have become legendary, such as Andy Warhol's Factory—the birthplace of pop art.

The Peter Max Studio, situated near Lincoln Center for the Performing Arts, has been the nucleus for Max's creative work for more than three decades. The studio is virtually a museum of Max's art and collectibles. Under twenty-foot-high skylights, a jungle of trees and plants shares the space with an Art Deco conference room, a giant signing table, showcases of Roseville pottery, vintage cookie jars, statues, and, everywhere you turn, canvases ablaze in the Max color spectrum.

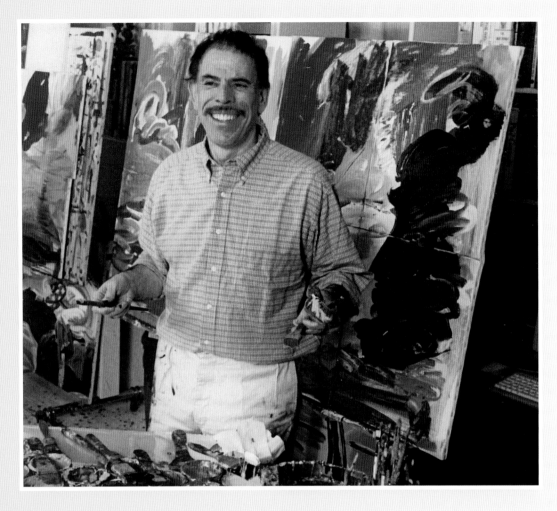

The space doubles as an events center. Over the years, the Peter Max Studio has welcomed countless guests from charitable organizations, environmental and animal-rights groups, and institutions for the arts and entertainment, and has served as an event space for such luminaries as Al Gore, Hillary Clinton, Senator John Glenn, Governor Mario Cuomo, Richard Branson, Steve Tyler, Ted Turner, Ringo Starr, Derek Jeter, Jack Nicklaus, Buzz Aldrin, Shaquille O'Neal, and Joel Osteen.

ABOVE The artist at work
OPPOSITE The Peter Max Studio

Epilogue

··

For many of us, life is a journey that comes around full circle. In fact, many of my childhood experiences have come back to me in unusual and often extraordinary ways. As a young boy growing up in Shanghai, China, my passionate interest in American art and culture, especially, has come back to me in ways that have exceeded my wildest imagination. None was more surprising than to see my own face on the cover of *Life* magazine—an icon of American media that I used to gaze at with wonder each week as a new edition would be placed on the Shanghai street vendors' newsstands.

Recently, in 2012, after an absence of more than half a century, I revisited Shanghai, and, of course, with its dazzling superabundance of skyscrapers, the sprawling megalopolis has left little of the past. Nonetheless, visiting the Hongkou district, where I had lived, brought back some poignant memories. One such memory was of my Chinese nanny who taught me my first art lesson. She was a young girl at the time and only a few years older than me, so I wondered if she was still alive.

Upon my arrival in Shanghai, I was greeted by members of the press. I told the reporters the story of my nanny, with the hope that if she were still living, she might notice and remember me. Despite the fact that the newspapers printed my photograph, along with a story detailing my reconciliation efforts, there was no response.

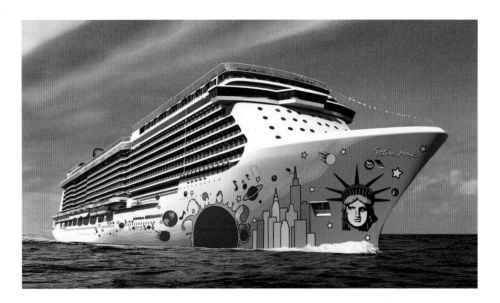

It was a great coincidence that shortly after my return to Shanghai, I was asked to paint the Norwegian Cruise Lines's *Norwegian Breakaway* ship. It launched in May 2013 and at the time of its launching, was the largest ship ever to make my home, New York City, its home port. I couldn't help but draw parallels to the *Conte Verde*, the giant ocean liner that carried me on my magical trip across the seas at the impressionable age of one.

My life is but one in a series of countless others. My story is but part and parcel of the hundreds, thousands, even millions of other stories that comprise life. And not just life on Earth; I love the quote that's on a plaque at the New York Public Library: "The universe is not made up of atoms; it's made up of stories."

ABOVE Peter Max artwork on Norwegian Line's *Breakaway,* 2013

■ ■ ■ ■ ■ ■ ■ ■ ■

I would like to thank Victor Zurbel, my dear friend for
forty-five years, for helping me to craft the story of my life
with great style and dexterity as well as for beautifully
curating my artwork.

And many thanks to all those at the Peter Max Studio and
HarperCollins Publishers who have contributed their time,
energy, and talent to help bring this book to fruition.

<div align="right">

Om Shanti,
Love, Peter Max

</div>

■ ■ ■ ■ ■ ■ ■ ■ ■

I would like to acknowledge Peter Max (Atman)
for being such a dynamic, creative force in the world of art,
and for fostering his visions of peace, love, charity,
democracy, human and animal rights, and global unity.
It has been a great honor to know you.
Om Shanti to you too, Bro.

<div align="right">

—Victor Zurbel (Arjuna)

</div>

■ ■ ■ ■ ■ ■ ■ ■ ■